Deutsches Museum

THE PHOTOGRAPHERS
Photographic direction: Hans-Joachim Becker,
Deutsches Museum
assisted by: Hubert Czech, Reinhard Krause,
Susanne Hochmuth, all at the Deutsches Museum
Freelance photographer: Anton Brandl, Munich

THE AUTHORS
Karl Allwang *ka*
Dr. Margareta Benz-Zauner *mbz*
Silke Berdux *sb*
Dr. Oskar Blumtritt *ob*
Dr. Alto Brachner *ab*
Jobst Broelmann *jb*
Dr. Dirk Bühler *db*
Lutz Engelskirchen *le*
Gerhard Filchner *gf*
Dr. Klaus Freymann *kf*
Dr. Wilhelm Füßl *wf*
Dr. Sabine Gerber *sg*
Christof Gießler *cg*
Dr. Winfrid Glocker *wg*
Dr. Bettina Gundler *bg*
Gerhard Hartl *gh*
Dr. Walter Hauser *wh*
Dr. Friedrich Heilbronner *fh*
Werner Heinzerling *wh*
Robert Heitmeier *rh*
Dr. Helmut Hilz *hh*
Sylvia Hladky *sh*
Dr. Cornelia Kemp *ck*
Dr. Günter Knerr *gk*
Dr. Matthias Knopp *mk*
Peter Kreuzeder *pk*
Dr. Eva Mayring *em*
Dr. Andrea Niehaus *an*
Dr. Annette Noschka-Roos *anr*
Dr. Hartmut Petzold *hp*
Ludwig Schletzbaum *ls*
Max Seeberger *ms*
Hans Straßl *hs*
Prof. Dr. Helmuth Trischler *ht*
Dr. Elisabeth Vaupel *ev*
Dr. Andrea Wegener *aw*

The publication of this volume has been made possible through the generous
support of the Freundes- und Förderkreis Deutsches Museum e.V.

Ingenious Inventions and Masterpieces

Deutsches Museum

of Science and Technology

Edited by
Wolf Peter Fehlhammer

Prestel
Munich · Berlin · London · New York

© Prestel Verlag, Munich · Berlin · London · New York
and Deutsches Musuem, Munich 2003

The Library of Congress Cataloguing-in-Publication data is available.
Die Deutsche Bibliothek holds a record of this publication in the
Deutsche Nationalbibliografie; detailed bibliographical data can be found
under: http://dnb.ddb.de

Prestel Verlag
Königinstrasse 9, 80539 Munich
Tel. +49 (89) 38 17 09-0
Fax +49 (89) 38 17 09-35

4 Bloomsbury Place, London WC1A 2QA
Tel. +44 (020) 7323-5004
Fax +44 (020) 7636-8004

175 Fifth Avenue, Suite 402
New York, NY 10010
Tel. +1 (212) 995-2720
Fax +1 (212) 995-2733

www.prestel.com

Deutsches Museum
Museumsinsel 1
D-80538 München
www.deutsches-museum.de

Deutsches Museum:
Concept and realisation: Rolf Gutmann (Project Management),
Jobst Broelmann, Alto Brachner, Hans-Joachim Becker
Text editing: Birgit Heilbronner, Rolf Gutmann, Denise Menting
Picture acquisition: Margrit Prussat, Christiane Hennet
Design: Sonja Aldejohann and Linda Reiter

Prestel:
Translated from the German by: Paul Aston, Dorset, G.B.
Copyedited by: Danko Szabó, Augsburg
Editorial direction: Christopher Wynne
Production: Ulrike Schmidt
Origination: ReproLine, Munich
Printing and binding: aprinta, Wemding

Printed in Germany on acid-free paper

ISBN 3-7913-2818-2

Contents

Preface

In this centenary volume, the Deutsches Museum presents itself in all its facets—highlighting the variety of its activities and the richness of its collections and displays. The focus has been placed on the pictures which provide a documentary source of the Museum's exhibits in the field of science and technology.

In the hundred years following the founding in 1903 by Oskar von Miller of the 'Deutsches Museum of Masterpieces of Science and Technology', it has seen and suffered construction, destruction and reconstruction . The Museum reflects the vicissitudes of twentieth-century history, from the era of Emperor Wilhelm II to two world wars and National Socialism, from the division and re-unification of Germany to the present day with its quest for information and knowledge. It was a period marked by whirlwind technological progress and globalisation.

"The Deutsches Museum has grown from the notion that the mutual interpenetration of science and technology is of great importance for culture. Its objective is to make a broad public familiar with the exact sciences and the technologies based on them. A better understanding of the state of technology we have reached, which so largely accounts for our present way of life, will grow from a greater awareness of its history and early beginnings, without which later achievements would not have been possible."

These thoughts, uttered in 1925 in a speech by the great physician Max Planck during the opening of the present Museum building, still apply today. The Deutsches Museum aims at being a place of information and education for its many visitors, but at the same time a vibrant place transmitting knowledge, a place of permanent debate and intellectual dialogue across all frontiers. The present volume also serves these objectives.

Though only set up a few years ago, the 'Freundes- und Förderkreis Deutsches Museum e.V.' (Friends of the Deutsches Museum) plays a major role in supporting the Museum in its diverse activities both in practical ways and with ideas. According to its constitution, members are ambassadors of the Museum. We are therefore delighted to be able to make an important cultural contribution, both nationally and internationally, in financing this centenary volume in German and English. Our hope is that reading it will be a visual experience, an exciting preparation to visiting one of the most important technological museums anywhere, and help to swell the number of those worldwide who count themselves among its friends.

Many of you may find memories in the wealth of pictures and images, while for others it might be a first impression. The Deutsches Museum cannot be comprehensively described down to the last detail. You need to see it, experience it—in the literal sense of the word—and appreciate it.

Christiane Kaske

President
Freundes- und Förderkreis
Deutsches Museum e.V.

Foreword

Picture after picture. The twentieth century has been called the 'visual century' and this has been carried on over into the twenty-first. Sociologists, art historians, philosophers and media folk zealously assure us we are 'on the way to' or 'already in' one of those inflationary societies (leisure, IT, knowledge or whatever), in this case an 'image' society, of course. Naturally, there are more complicated ways of saying it. According to Horst Bredekamp, industrialised societies are currently passing through a period involving a 'Copernican change from the dominance of language to the hegemony of the image', which they are not prepared for. Somehow, the Deutsches Museum must have foreseen the imminent overtaxing (or perhaps we should say pictorial antipathy) of its public and therefore hesitated so long to expose it to floods of images. Indeed, the Museum has hitherto exercised a lofty restraint in its publications and attached importance to a splendid corporate design. It has remained true to the word, been doughty with text, in contrast to the colourful and loud offerings of its partners and rivals all over the world—disregarding the 'pictorial turn', the general ousting of speech by image. And it will stick to it! Not of course in its exhibitions, since it knows all about the wholly visual nature of its job, the two and three-dimensional side, and appreciates how much museums and exhibitions are children of this 'show business'.

But that is precisely what it's all about. Here is just where the 'Deutsches Museum of Masterpieces of Science and Technology', to give it its full title, has a huge deficit to make up. This is why, in its centenary year, it is publishing this volume of photos. It is an opulent work that for the first time seeks to do visual justice to the Museum, its displays and its overall importance. Leaf through it and discover Oskar von Miller's masterpiece of all masterpieces, incontestably the largest and most important science and technology museum in the world, Germany's favourite museum, which people simply call 'the Deutsches' with the familiarity of fondness. Look through it and savour it in all its facets—the idyllic island setting so close to the city centre, the architectural beauty of its buildings, the very size of the exhibition areas, the uniqueness of the masterpieces on display, the sheer value and extent of the collections, the extensive range of the library and archives, the treasury of *libri rari*, the scholarly

excellence bound up in the research institute and the Munich Centre for the History of Science and Technology, the Museum's influence in a wider world and its universality. Celebrate with the lucky organisation all the numerous gifts it has received over the years in the form of attractive new sites, which have provided the Museum with the vital space to grow and develop and consolidate the Museum as a seat of scholarship—or rather as a centre of knowledge.

Assuming sufficient 'visual literacy' on the part of the reader and adequate skill on the part of the photographers, perhaps some of the Museum's inner features will come to light, such as the Museum's exhibition philosophy, the clever mixture of enlightening experiment and illustrative object, the fascination and future-orientation of novel forms of communication borrowed from the 'other' culture, or the enthusiasm of the creative staff for their work. I hope, though this is perhaps asking a lot, that the book will reflect the institution's openness and international orientation and the worldwide reputation it enjoys. Despite this, the Museum has nevertheless always retained its special national, cultural character, plus that modicum of extra *gravitas* that distinguishes it from many similar institutions.

After this initial excursus into 'visual science', I should like to continue with a few fine thoughts from Roland Barthes about photography (a very central element here), which I find personally moving." It is often said that painters invented photography. But I say no, it was chemists. Because the meaningful content of the 'that's how it was' only became possible from the day when … the discovery of light-sensitive silver salts enabled light reflected from objects illuminated by varying gradations of light to be captured and recorded … And if the world still had a certain degree of sensibility for myth, we should … no doubt rejoice: the beloved body is rendered immortal by the intermediation of a precious metal—silver. And the idea could be added that, like all metals in alchemy, this metal is alive."

It is now my very agreeable duty and pleasure to mention at this point the Freundes- und Förderkreis Deutsches Museum e.V. (Friends of the Museum) without whose assistance the present product—like a precious metal—and the still more precious scholarly and artistic work of a large number of highly

committed staff, plus the careful, professional final editing and printing by the publisher, could never have come into being. Though still very young and small in number, the body of good, close Friends of the Museum is I'm pleased to say developing rapidly, and insisted on taking responsibility for the entire financing of this major project. We can only express our profound gratitude for the courage and persuasiveness of their executive committee and individual members' enthusiasm for their Deutsches Museum.

To give an overview of technology and science while being both educational and entertaining at the same time was the idea that stirred the engineer Oskar von Miller and led to the establishment of the Deutsches Museum in 1903. By 1906, it had opened in temporary premises—a permanent home in the Museum building on an island in the Isar following only in 1925. The library building and congress hall, where the Forum of Technology has been accommodated since 1992, were completed in the 1930s. The reconstruction work after war damage, and particularly the period from 1960–80, involved a process of constant updating, redesigning and extending, as a result of which the Museum reached its present size by 1984 (with a display area of 50,000 square metres). The collection of originals, models, experiments and demonstrations covers most areas of technology and the principal scientific disciplines from their historic beginnings to the current situation. In the display areas, science and technology are presented in their manifold social contexts— the exploration of the laws of nature in space and time, the use of forms and carriers of energy, communication technologies, technology for producing vital products, the development of means of transport and transport routes and the extraction and processing of natural raw materials, to mention just some of the principal topics.

Educational institutions such as the Munich Centre for the History of Science and Technology and the Kerschensteiner Kolleg facilitate deeper involvement with special subject matter and the study of them in discussions, seminars and courses.

The latest exhibition spaces acquired by the Museum mean some 20,000 square metres extra floor space. These have not only enabled exhibits to be moved out of the main building but have also allowed whole subject areas covered by the Museum to be given a more focused treatment. Schleissheim Airfield, for example, whose historic buildings date from World War I, supplements the aviation and space display of the Deutsches Museum on Museum Island. The Deutsches Museum Bonn is dedicated to research and technology in Germany since 1945, and uses up-to-date media to engage the public's interest. In 2003, the Transport Centre will open on Munich's Theresienhöhe with an exhibition on mobility, and thereafter will include the subjects Urban Transport and Travel, together with the technical developments of rail and road vehicles.

The Museum is increasingly conscious of the need for an entertaining approach to presentations aimed specially at children and younger visitors. In early 2003 the Children's Department will open, which together with the open-air exhibition will form an Eldorado for the 3–12 age group. You can never start too early getting to grips with the complexities of our multifacetted world. This involves approaching science through play and a hands-on experience of research and technology, whereby children can learn to take a critical view of the flood of information and learn to use sensibly the benefits that technical developments undoubtedly offer. New forms of representation awake curiosity in new subject matter—and that applies especially to young people. The Centre for New Technologies is dedicated to topical subjects of research, science, technology and society. In the coming years, a separate forum for special exhibitions and accompanying events will be set up as space becomes available.

The Deutsches Museum thus has no intention of resting on its laurels. In fact, projects are well under way to take it forward into the next hundred years, with all the construction sites that involves. There's barely any time to celebrate!

Wolf Peter Fehlhammer Director General

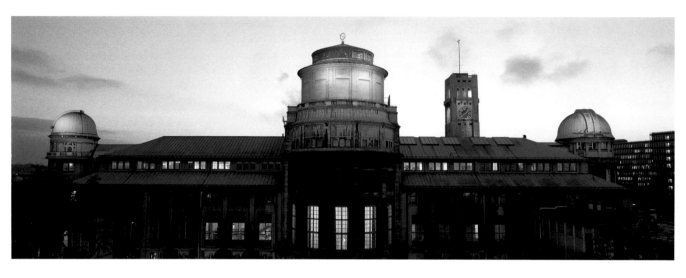
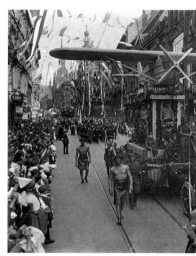

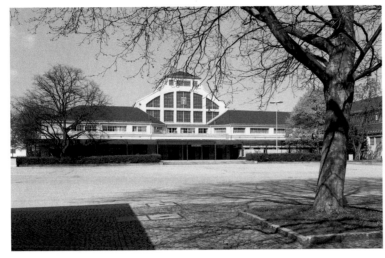

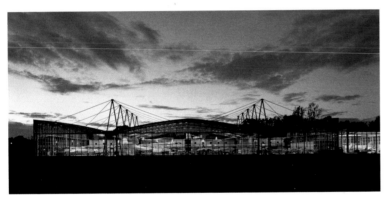

Looking back

Until 1900, what is now Munich's Museum Island in the River Isar was called Coal Island, because coal and charcoal were stored here from medieval times on. Frequent flooding and inadequate stabilisation of the island meant it could not be used for residential purposes—time and again, high water washed away the bridge on the north side. Eventually, a solid stone bridge (the Ludwigsbrücke) was constructed. A barracks was long the only building on the island.

At the turn of the century, the island increasingly attracted attention because of its central position. In 1898, it was used for the second Engine and Manufacturing Machinery exhibition. Then town planners began to take an interest. Engineer Theodor Lechner planned an island railway station, while influential architect Theodor Fischer wanted to construct a small medieval township there.

The proposal to build a national technical museum on the island combined a sensible utilisation with a considerable gain in prestige for the city. This surprise initiative came from Oskar von Miller (1855–1934). Miller was the son of an artisan family that had moved to Munich only one generation earlier. His father Ferdinand was one of the world's leading brass-founders. The lions on the Victory Arch, the figure of Bavaria on the Theresienhöhe and the bronze door on the east side of the Capitol in Washington are all examples of his skills. Oskar von Miller studied civil engineering, but then taught himself electrical engineering. At first, he was technical director of Deutsche Edison (later AEG), but from 1890 headed his own firm of energy consultants. In this guise he pioneered the advance of electrical engineering throughout Europe. His name is associated with the first DC transmission from Miesbach to Munich in 1882, a distance of 35 miles (57 km), and the first rotary current transmission from Lauffen (on the Neckar) to Frankfurt in 1891, a distance of 109 miles (175 km). Miller built numerous municipal power stations all over Europe, and ran some of them himself. Following lengthy negotiations, his design for a

Emperor Wilhelm II laying the foundation stone for the construction of the new Deutsches Museum building. Painting by Georg Waltenberger, 1916

1 Emperor Wilhelm II, 2 Prince Ludwig of Bavaria, 3 Empress Augusta Victoria, 4 Prince Regent Luitpold, 5 Princess Therese of Bavaria, 6 Prince Rupprecht of Bavaria, 7 Virginie Waltenberger, 8 Gretl Scholl, 9 Irma Scholl, 10 Hedwig von Dyck, 11 Lulu von Miller, 12 Marie von Miller, 13 Auguste von Dyck, 14 Elisabeth von Linde, 15 Marianne von Miller, 16 Count Max von Moy, 17 Wilhelm von Borscht, 18 Walther von Dyck, 19 Carl von Linde, 20 Albert Koch, 21 Oskar von Miller, 22 Artur Schönberg, 23 Emil Ehrensberger, 24 Wilhelm Conrad Röntgen, 25 Adolf Slaby,

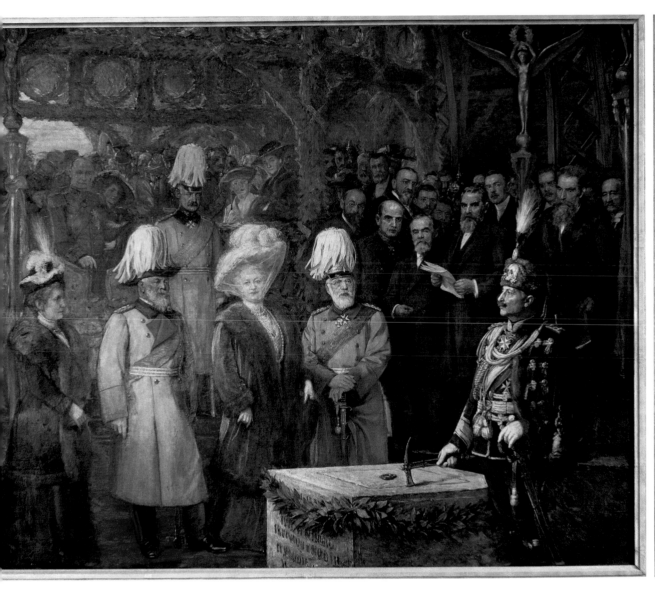

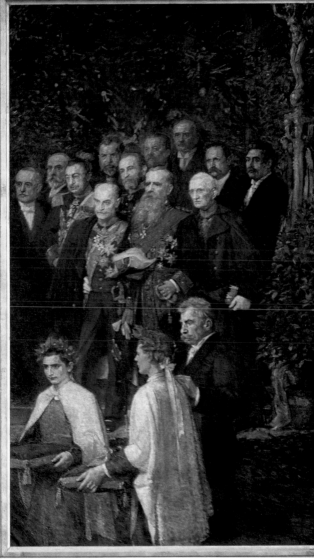

26 Wilhelm von Oechelhaeuser, 27 Walther von Miller, 28 Heini Seidl, 29 Gabriel von Seidl, 30 Count Clemens von Podewils, 31 Count Arthur von Posadowski-Wehner, 32 Count Max von Feilitzsch, 33 Rudolf Diesel, 34 Theodor Peters, 35 Moritz Schröter, 36 Max Krause, 37 Wilhelm von Siemens, 38 Anton von Rieppel, 39 Anton Ritter von Wehner, 40 Wilhelm Freiherr von Pechmann, 41 Wilhelm von Muthmann

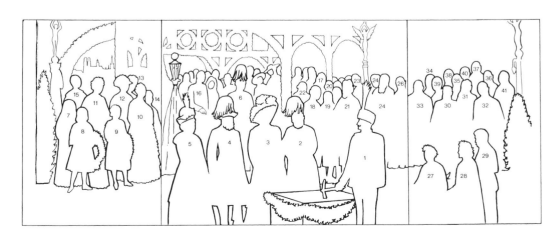

Looking back

power station at Walchensee in the Alps was finally accepted and built, and he then founded Bayernwerk, a company supplying electricity nationwide throughout Bavaria.

His distinguished career brought him offers of numerous offices. He was a delegate at the peace talks in Versailles in 1919, while in 1925 Hugo Junkers secured his services for a while as president of his airline Trans-Europa-Union. In 1930, he was honorary chairman of the second World Power Conference in Berlin. Miller also pioneered industrial archaeology in Germany.

During the annual conference of the Association of German Engineers (VDI), the decision was taken on 28 June 1903 to establish a museum containing 'masterpieces of science and technology,' and this soon acquired the name Deutsches Museum. Miller's worldwide contacts, his notable talents as a fundraiser and his clever organisation of the Museum were major assets in getting the project off the ground. Within a short time, he had won the support not only of the Bavarian government but also large numbers of leading figures in politics, industry and science. Numerous individuals likewise backed the scheme and came forward with significant funds or helped to secure historic or contemporary items for display. Thus by 1910, the Museum had already acquired over 27,000 exhibits.

The Coal Island before the construction of the Museum and the river embankment. Painting by Otto Strützel, 1889

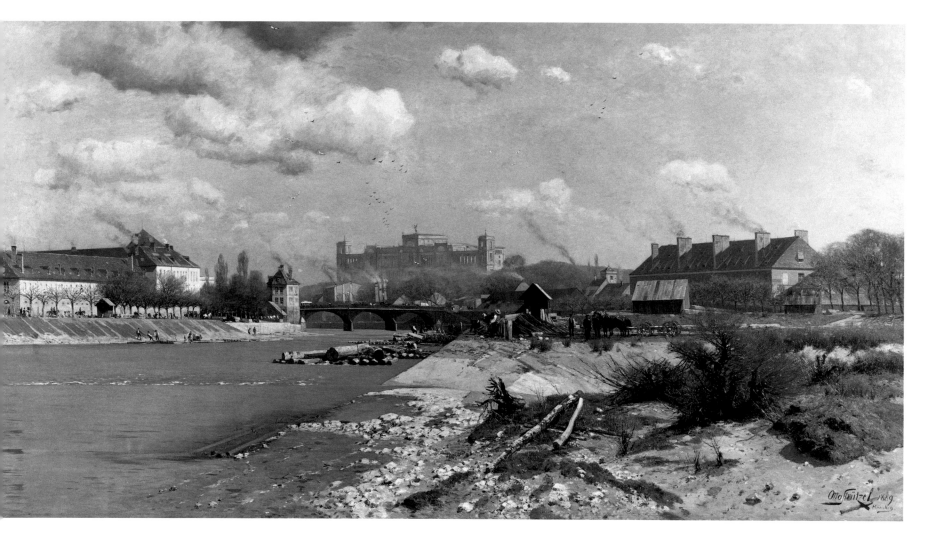

The first provisional collections opened to the public in November 1906 at the Old National Museum in Munich (now the Ethnological Museum) and in 1909 at the former Schwere-Reiter barracks (the site of the present German Patent and Trademark Office). Also in 1906 came the laying of the foundation stone for the permanent museum building on the island in the Isar, in the presence of Emperor Wilhelm II. War and inflation delayed completion until 1925 but, undaunted, the founder organised a lavish procession and typical Miller celebrations to open his cherished Museum. The event is often described as the Weimar Republic's last party. Meanwhile the dark clouds of the Depression, National Socialism and World War II were gathering.

Conceptually, the Deutsches Museum covers a wider field than either the Science Museum in London or the Conservatoire des Arts et Métiers in Paris. The scheme provided not only for displays but also a library and specialist science and technology archives. Right from the first, historical research and a structured lecture programme formed part of it. The museum building was not yet completely fitted out when the impatient Miller began work on his new project for a library with attached Congress Hall. He was present at the opening of the library in 1932, but did not live to see the completion of the Congress Hall. He died in 1934, a year after retiring from the museum board. His retirement was supposed to facilitate Nazi support for the museum, although the Nazis had always expressed scepticism about Miller and his cosmopolitan museum.

The 1,000-year Reich imposed considerable constraints on the Museum. For a time, the Nazis wanted to trump the Deutsches Museum with a gigantic House of German Technology, to be built directly opposite the Museum. The Museum management avoided the all too direct control of the Nazis with some deft footwork and prevented a takeover by the Office of Technology. It is not widely known that among the

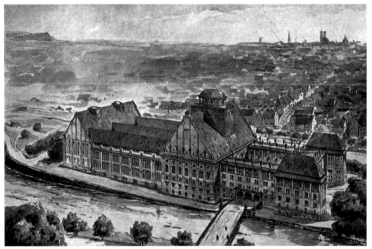

At the turn of the twentieth century there were a number of different proposals for the use of the Coal Island, for example a railway station (*left*). The architecture competition for the Deutsches Museum, which produced a variety of different designs, was won by Gabriel von Seidl.

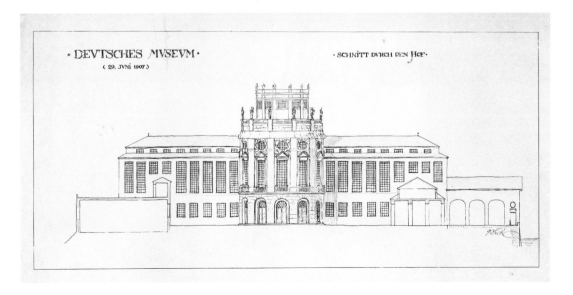

Looking back

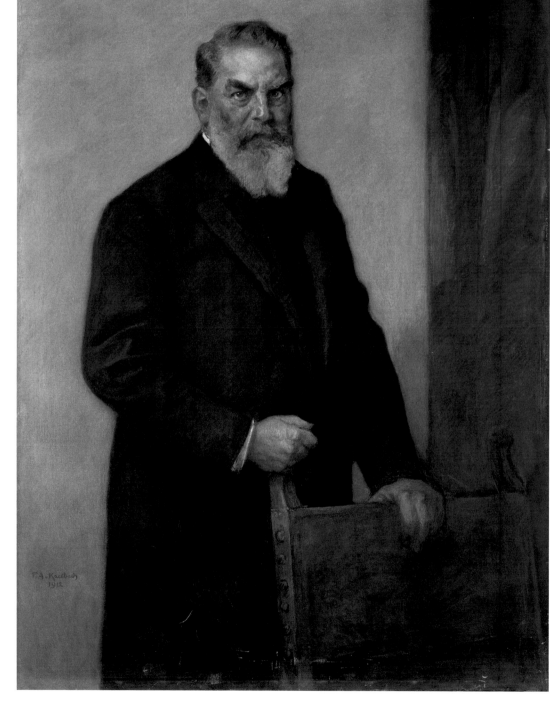

Oskar von Miller. Painting by August von Kaulbach, 1912. Miller was one of the pioneers of electrical engineering in Germany. Following a 20-year debate, he succeeded in turning the hydro-electric power-station project at Walchensee into reality, thus laying the foundation stone for the generation of electricity throughout Bavaria.

museum staff a small anti-regime resistance group was formed. It was found out, and several members died in concentration camps or from their aftermath. The Museum also suffered badly in bombing raids on Munich during World War II. More than 5,000 high-explosive and fire bombs hit the building, and many departments were completely gutted. Around 20,000 display items were destroyed or rendered unusable.

Thanks to rental income from the quickly restored Congress Hall and widespread support from industry, reconstruction followed over the next 25 years. The aim was to restore the Museum completely in the style of the founding fathers. It thus took some time for new areas of technology such as nuclear and space technology, micro-electronics or IT to find space in the Museum. On 23 November 1973, a record was broken with, for the first time, the millionth visitor to the Deutsches Museum within a year.

Since the war, there has been a distinct trend towards greater scientific discipline at the Museum. Collaboration with Munich University from 1963 led to a joint research institute being established. This loose collaboration was institutionalised in 1997 with the founding of the Munich Centre for the History of Science and Technology. Parallel to this, the Deutsches Museum's traditionally outstanding educational role was formalised with the founding of the Kerschensteiner Kolleg in 1976.

The last quarter of the twentieth century was notable for the construction of the aviation hall in 1978–84, adding considerably to the available space. With this addition, virtually all building land on the Island was used up. Since the 1990s, the Museum has therefore decided to establish offshoots elsewhere—firstly the airfield at Oberschleissheim (1992), then the Deutsches Museum Bonn (1995) and finally the opening of the Transport Centre on Munich's Theresienhöhe in the centenary year 2003. *wf*

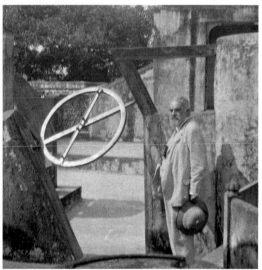

The concept of the Deutsches Museum was championed by a number of prominent figures, including the mathematician Walther von Dyck, the refrigeration engineer Carl von Linde, the chemist Carl Duisberg, the engineer Rudolf Diesel and the physicist Wilhelm Conrad Röntgen.

Oskar von Miller used his trips around the world to acquire objects, to study international schemes and to maintain his contact with other scientists and engineers.

Pioneers in the field of electrical engineering: Oskar von Miller and Thomas Alva Edison, 1912.

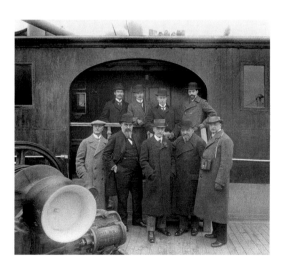

The Library Committee in the USA, 1912, showing museum staff with famous personalities including Diesel, v. Miller, Count v. Podewils, v. Borscht and v. Dyck *(in the front row).*

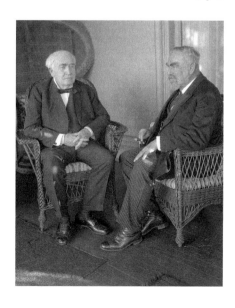

Looking back

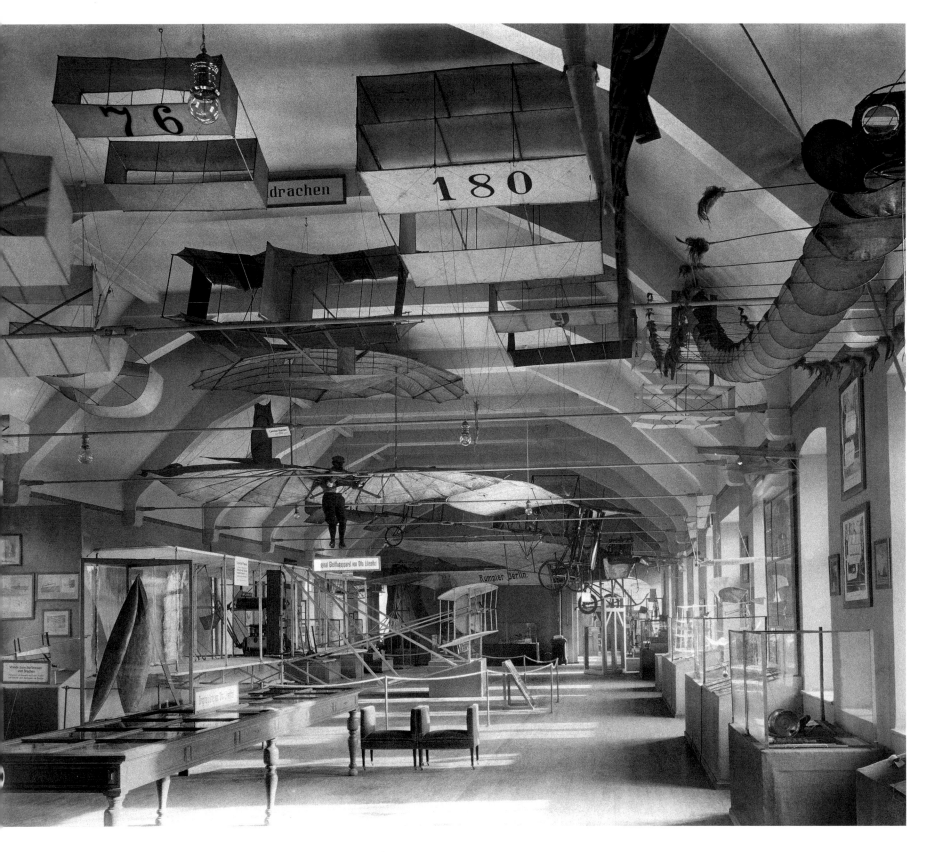

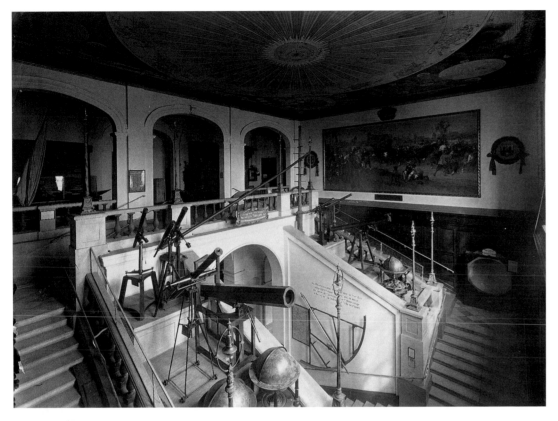

From temporary quarters to a new building: the first collections were opened as early as 1906. Aviation was displayed in the Isar Barracks and the stair well in the Old National Museum (now the Ethnological Museum). The museum building on the Coal Island rests on 1,500 concrete columns. Emperor Wilhelm II also showed an interest in the progress being made.

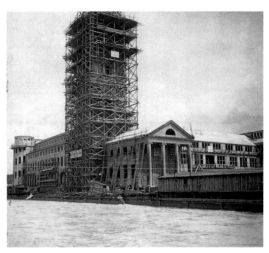

Looking back

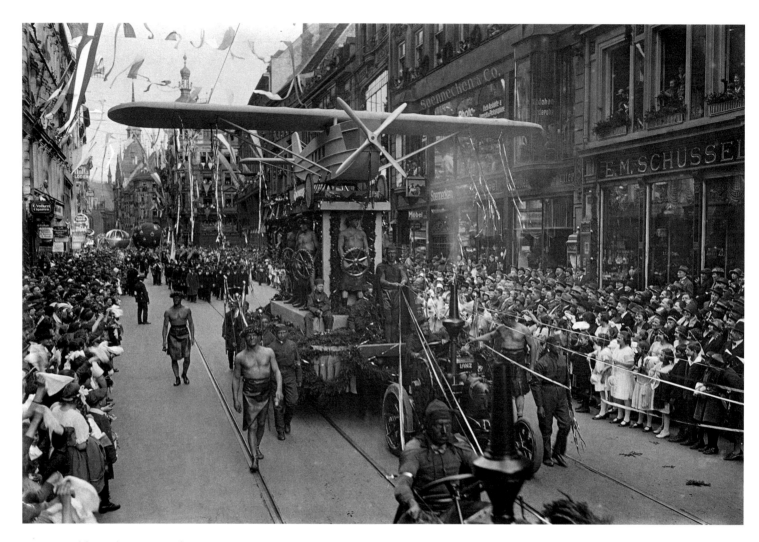

Grand festival procession for the opening of the Deutsches Museum in 1925, showing the mechanical engineering section.

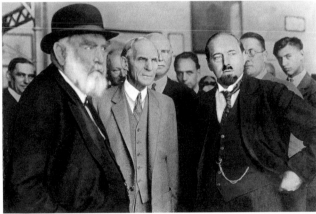

Global recognition: Oskar von Miller with Albert Einstein at the 1930 World Power Conference and in the same year with Henry Ford (*centre*) at the Deutsches Museum.

Looking back

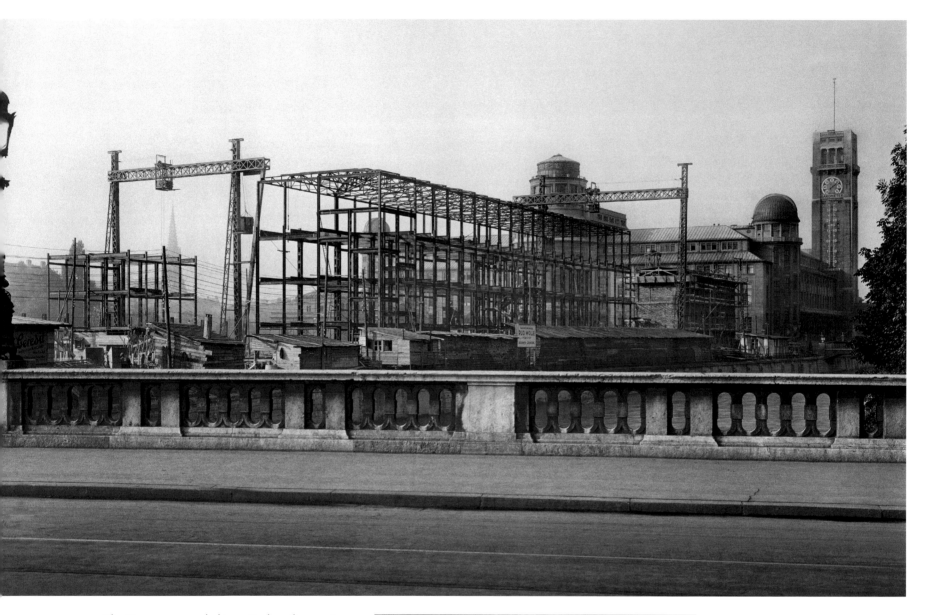

The Museum expanded in 1928 when the construction of the library building and the Congress Hall was commenced. The frescos in the Congress Hall are by Hermann Kaspar.

Einer der Bauvorschläge

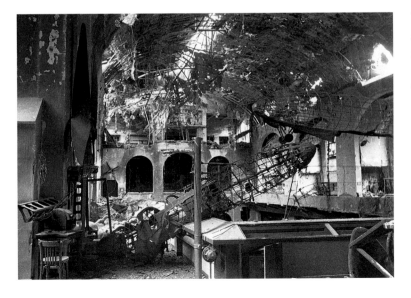

The National Socialists and the Museum's subsequent destruction: during the National Socialist period, the Automobile Hall was built (1937). The Nazis wanted to erect a monumental 'German Technology Building' on the opposite bank of Isar river, as a counterpart to the internationally orientated Deutsches Museum. The project never came to fruition and the Museum itself was bombed heavily in 1944/45 when thousands of objects were destroyed.

Looking back

Reconstruction over a period of several decades followed the destruction during the war. The Congress Hall was used for a variety of purposes, ranging from basketball games and cabarets during the early years to concerts and other events later on.

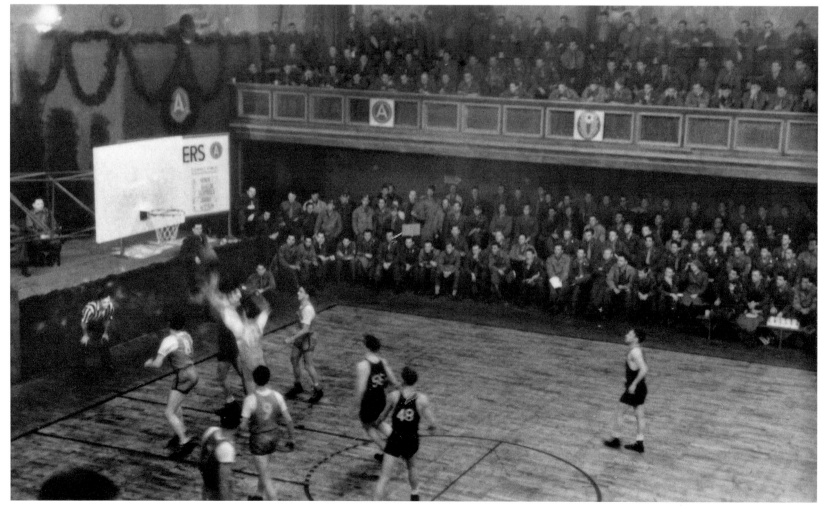

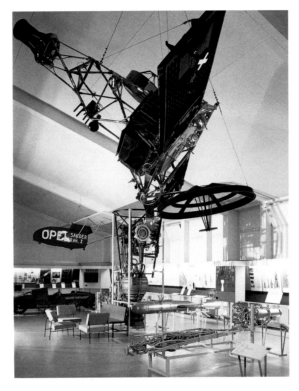

Large temporary exhibitions in the 1950s and '60s such as the 'Atom Exhibition' and 'Man and Space' led to other shows focussing on new topics. The construction of an aviation hall in 1978–84 concluded extensions on the island site.

Memorial plaque in the Deutsches Museum designed by Theodor Georgiri.

Architecture

The Deutsches Museum's most visible contribution to the urban architecture of the inner city and riverside landscape of Munich consists of the Planetarium cupola, the observatory and the tower. However, the Museum is in fact an impressive complex of listed buildings of different dates occupying virtually the entire Museum Island, even extending to the river bed itself. A closer look shows that the buildings are from different periods and styles and serve different functions. Connoisseurs will recognise in it the handwriting of distinguished Munich architects such as Gabriel von Seidl, German Bestelmeyer, Franz Hart and Sep Ruf. Closer acquaintance with the buildings reveals their chequered history, an idea of what their builders started with and were aiming at—and, with each repeat visit, fascinating details never previously noticed.

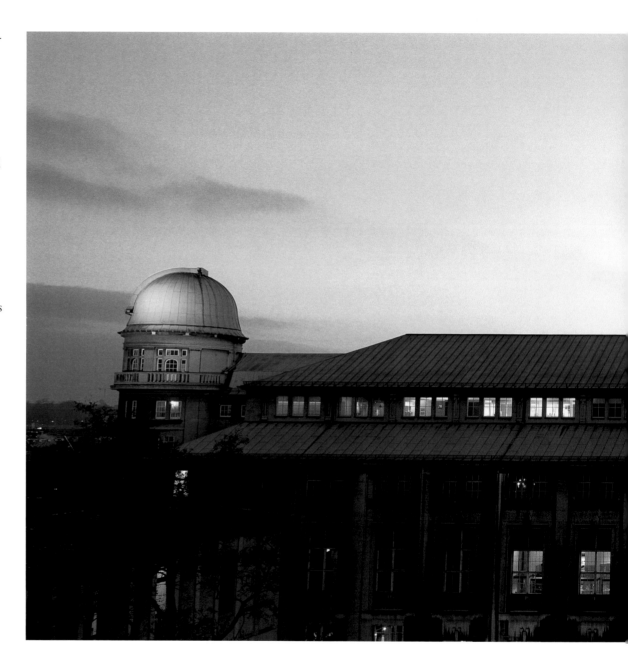

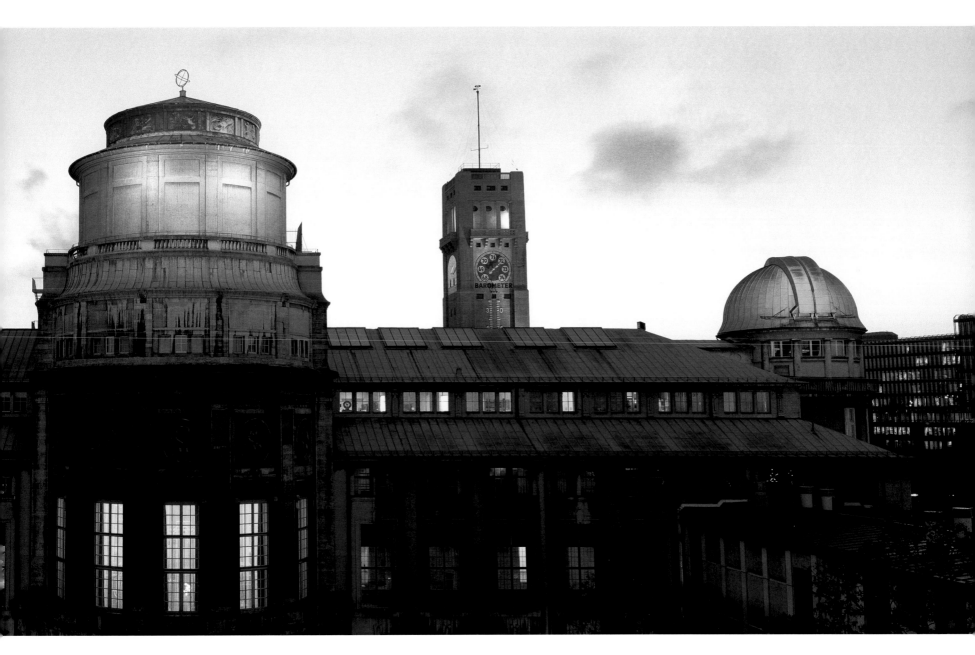

Stuffed to the roof with exhibition rooms
and often used for evening events as well—
the exhibition building seen from the north,
with its patinated cupolas.

Architecture

The most important building of the Deutsches Museum complex is the frequently rebuilt and extended exhibition block. The oldest part of this (begun 1906, opened 1925) was despite its historicising external detail a very progressive building structurally, being built of the very latest material of its day—reinforced concrete. Its imposing façades reflect the lofty architectural aspirations of the founder, though the inner courts, whose exteriors are scarcely visible, are purely functional in style. During the postwar reconstruction and later extensions, the original design was uncompromisingly altered each time in keeping with contemporary styles.

The cupola of the planetarium over the main entrance of the Museum. The façade here is at its most ornate.

Metal and glass roofs on top of the old aviation
hall and engine hall. The rear face of the
planetarium in the background shows traces of
1920s' modernism—erected post 1945.

Architecture

The island created by the River Isar branching into two channels offers the Deutsches Museum a unique location at Munich's historical river crossing point. Being on an island sets the Museum apart from the city, but also incontrovertibly prevents further development, all the land here being now used up. Displays requiring ample space (particularly transport) have therefore been moved to museum outstations at Schleissheim Airfield and the old exhibition halls of the Munich trade fair on the Theresienhöhe.

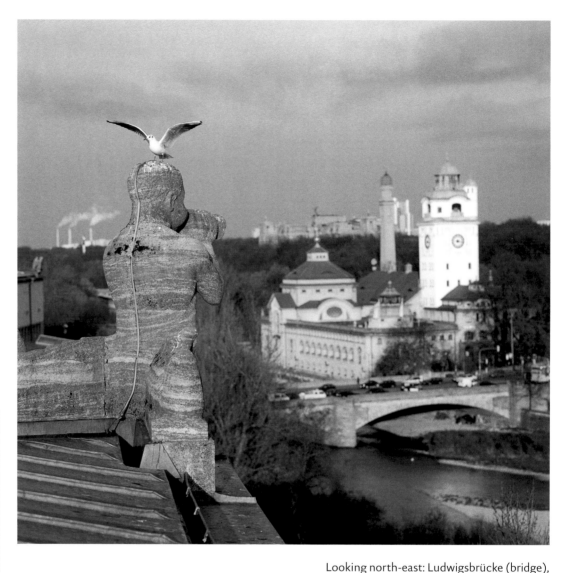

Looking north-east: Ludwigsbrücke (bridge), Müllersches Volksbad (baths), Maximilianeum (seat of the Bavarian state parliament), green areas along the Isar.

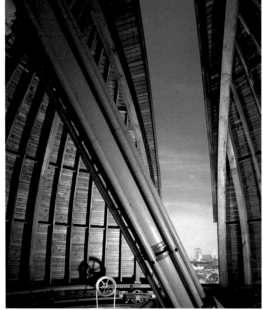

View from the west dome (Planetarium) of the city centre.

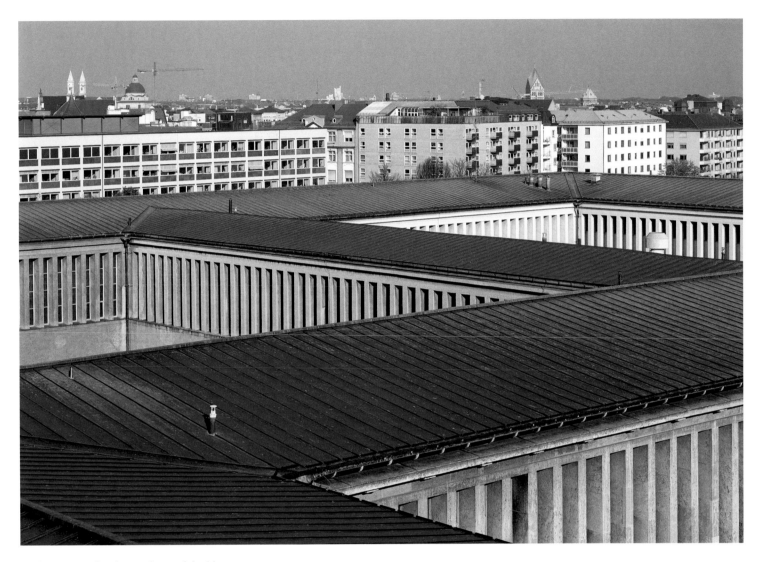

Looking west: the slit windows of the library
beneath copper roofs, with an array of inner city
buildings beyond.

Architecture

The few surviving original halls and staircases of the exhibition and library building radiate a plain quirkiness or solemn grandeur, depending on their importance and the quality of the materials used. That these rooms have survived changing requirements largely undamaged is not necessarily a sign of appreciation—sometime it was just lack of money.

(*below left*) Library entrance hall with rear view of Goethe.

West staircase of the exhibition building.
Later overpainting of the exposed concrete of the supports and balustrade was removed in 2000.

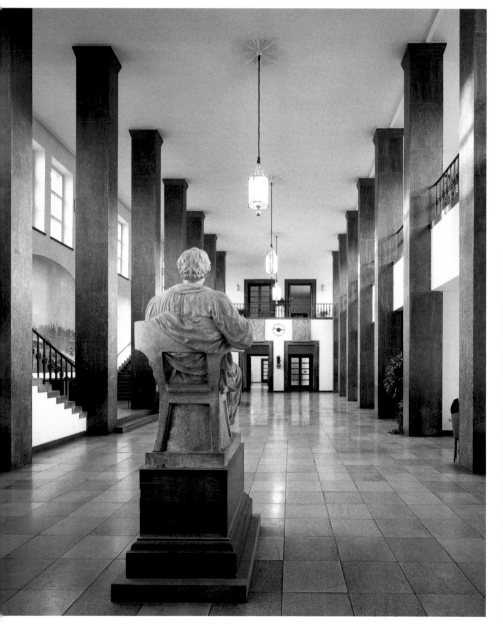

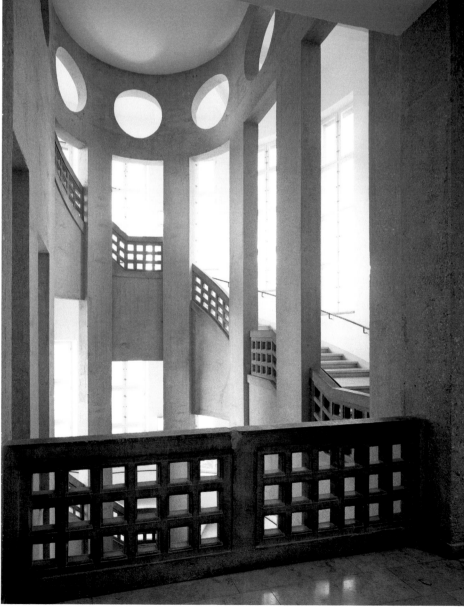

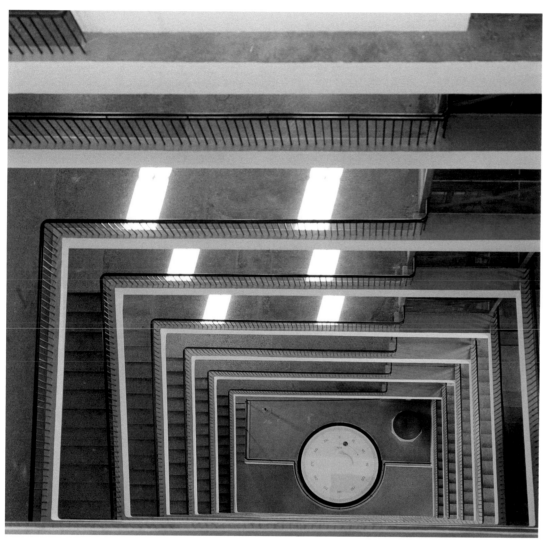

The symbol of the Deutsches Museum is the 213-foot (65m) tower built in 1911. The grandiose interior contains a Foucault pendulum of the original dimensions. Access to the top is via a glass-sided lift or the old endless spiral staircase. The tower, closed for 20 years awaiting repairs, has now been reopened, but the splendid view from the platform at the top is still something of an insider's secret.

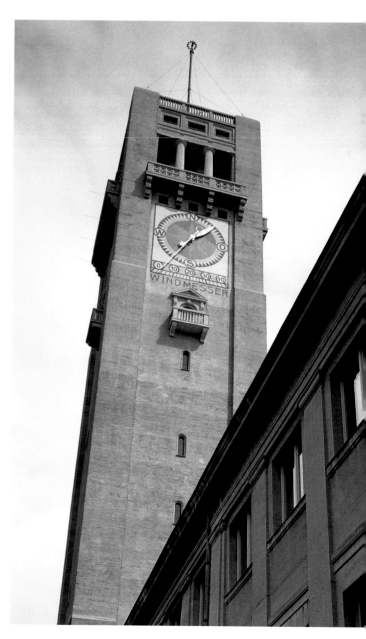

Architecture

During repairs and cleaning of the north façade of the exhibition building, the highly developed shuttering techniques of the fluting and details of the entablature caused surprise given the early date of the ferroconcrete. Typical of the early exposed concrete surfaces is the masonry-like treatment of the entire surface. Only the most prominent parts of the façade were actually built of stone and adorned with reliefs and sculptures.

One of the five façade medallions by Hans Vogl (1955) over the main entrance, photographed during restoration of the façade in 2002.

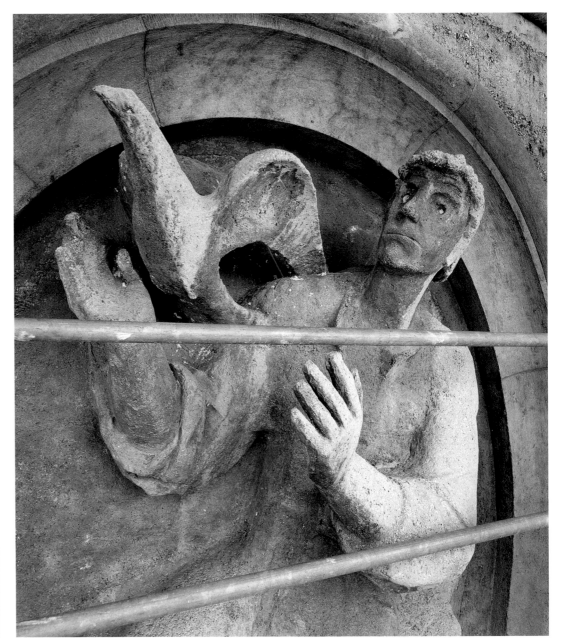

Used every day yet largely unnoticed, the lower ends of the handrails are an excellent example of the notable craftsmanship of the exhibition and library building. The beginning of a handrail is emphasised by an occasionally almost peculiar design and executed in various metals that bear the stamp of precise craftsmanship rather than machined perfection.

Architecture

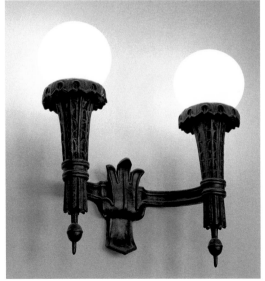

The variety of older lights which can be seen around the Museum and the mood they evoke suit the different uses of the spaces. Many of these lights are original designs made especially for the Deutsches Museum.

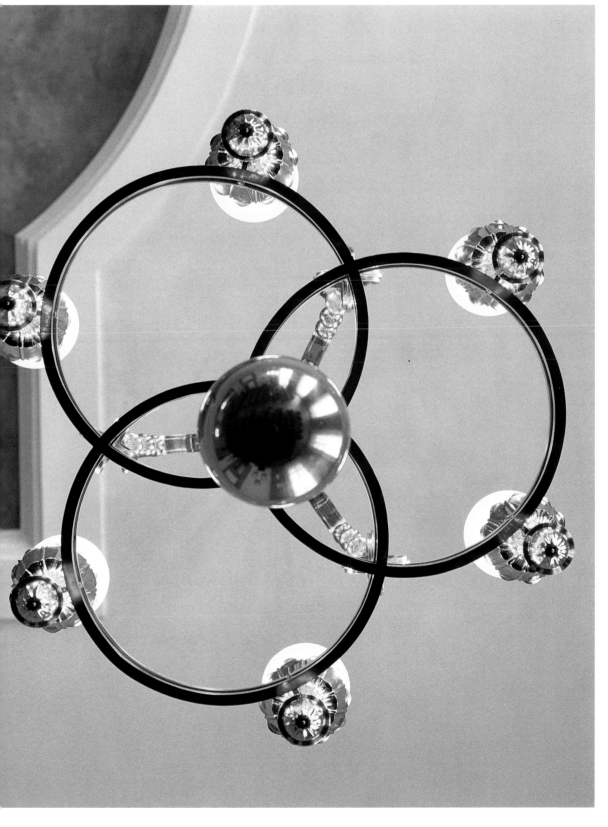

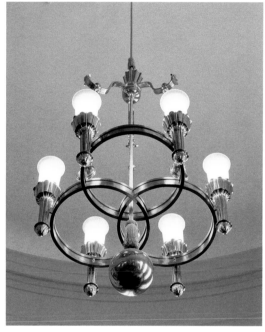

Seen from directly underneath one of the ceiling lights in the Hall of Fame, it is clear who the donor was: the three overlapping circles are the Krupp company logo.

COLLECTING, INFORMING, EXHIBITING

An astrolabe associated with Johannes Kepler, Conrad Röntgen's X-ray tubes, Karl Benz's first car, Manfred Eigen's 'evolution machine' or the first scanning tunelling microscope by Gerd Binnig and Heinrich Rohrer are just a few highlights of the broad spectrum of items in the Deutsches Museum's scientific and technical collections. The latter form the foundations of the Museum's wide-ranging work.

The collections are constantly being updated with important contemporary artefacts and items to fill gaps left open in the past. The treasures in our care are conserved, restored as necessary and prepared for exhibition. This work is carried out in the Museum's workshops.

Exhibitions come about as a symbiosis of collections, scholarship, research and architecture. They are not the Deutsches Museum's only forum for the general public, but they are the most effective one.

Being constantly renewed, and in many fields interactive, the exhibitions convey information from past and present about science and technology. This forum contributes to well-informed debate and illustrates the pre-eminent importance of these areas of knowledge for mankind.

Masterpieces

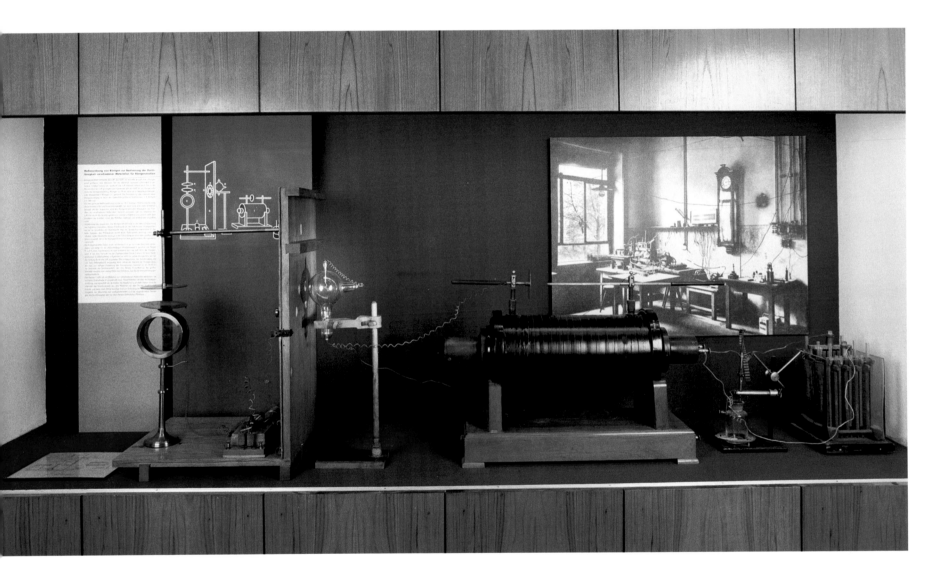

Physics Conrad Wilhelm Röntgen built this
demonstration model specially for the Deutsches
Museum in 1906. Various properties of the X-rays
Röntgen had discovered in 1895 could be demon-
strated on it.

Physics Four-prism spectroscope made by
Carl August von Steinheil for Gustav Kirchhoff and
Robert Bunsen in 1860. In 1859, Kirchhoff and
Bunsen had discovered that every element has a
unique combination of spectrum lines. This was
the beginning of spectrum analysis.

Music The trautonium (1930) on which all noises
for Hitchcock's film *The Birds* were composed. It
consists of several parts: a wireless-type case for the
oscillator, a fingerboard made of resistance wire on
a metal rail, a loudspeaker and a volume control.

Physics Azimuth quadrant made by Georg
Friedrich Brander in 1760. With this specially made
instrument, the Academy of the Electorate of
Bavaria observed the planet Venus passing the sun
on 6 June 1761—a rare event that was analysed by
several observatories in Europe.

Masterpieces · Natural Sciences

Scientific Chemistry Complete blowpipe set. Blowpipes—small, simple appliances—were once indispensable in chemical analysis. They were used in the eighteenth century to distinguish the qualitative and to some extent even the quantitative composition of many minerals, and quite a few new metals were discovered using them.

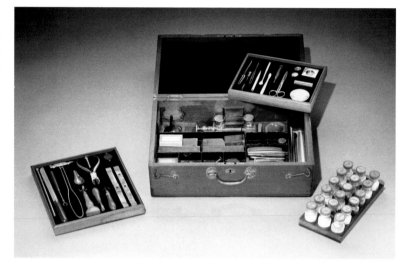

Scientific Chemistry Otto Hahn's experiment table, sometimes called a Hahn Table. Surviving as a reconstruction made from original parts, it was used by Hahn, Lise Meitner and Fritz Strassmann from 1934 to experiment with neutrons decelerated by the paraffin block.

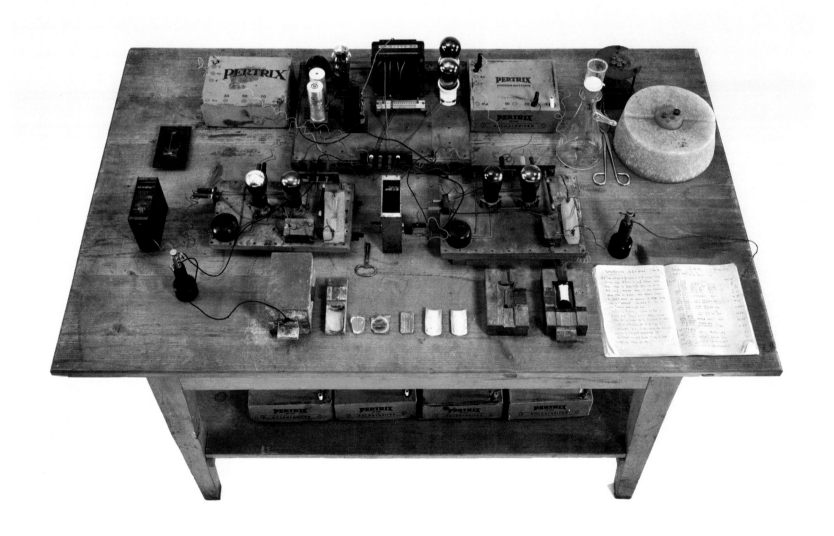

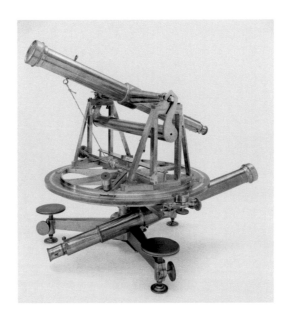

Geodesy Repeater theodolite made by Reichenbach, Utzschneider and Liebherr, *c.* 1806. This was the first convenient high-precision theodolite. Precision was achieved by a new graduated-circle part method developed by Georg von Reichenbach. The angles in the main triangulation in the first national survey of Bavaria were measured with this precision instrument. The quality of the maps produced from it depended on its accuracy.

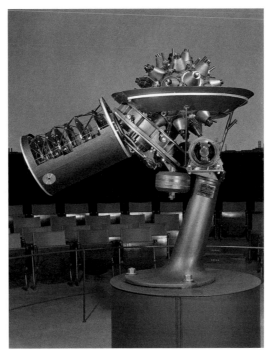

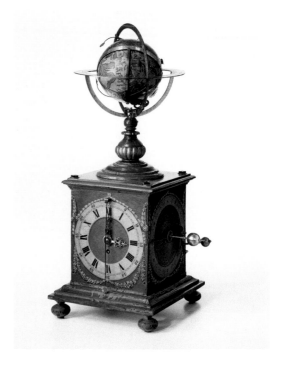

Astronomy Carl Zeiss's projection planetarium model I, built in Jena in 1923. The first planetarium projector anywhere, it was designed and built specially for the Deutsches Museum. It was in service from the opening of the museum building in 1925 to 1960.

Astronomy This clock with four faces and a revolving celestial globe orbited by sun and moon was built for the Prince of Hohenzollern-Hechingen to specification given by the clock and instrument maker Philipp Matthäus Hahn (1739–90). The maker was Hahn's assistant Schaudt.

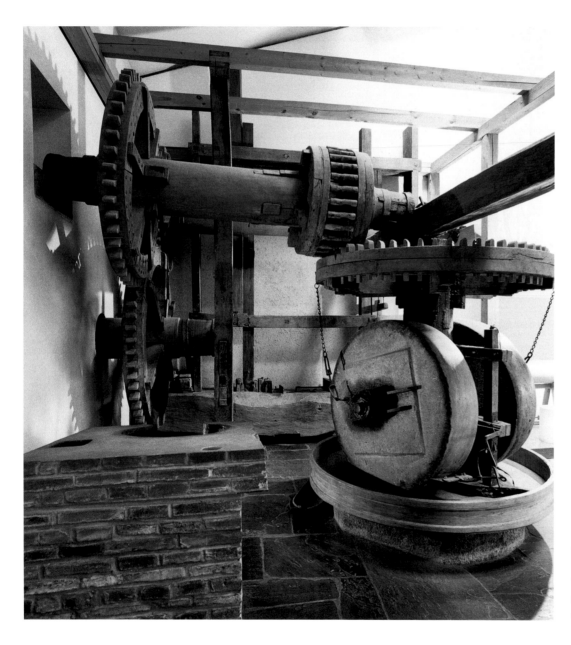

Agriculture Water-driven mill from the Spessart
Hills, *c.* 1750. Operated by a large water-wheel,
the mill was used to process oil-bearing plants such
as rapeseed, poppy seeds, sunflower seeds and
walnuts.

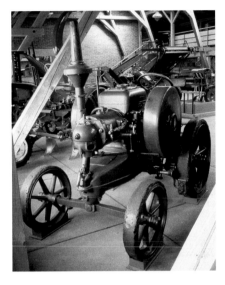

Agriculture Lanz Bulldog traction engine, 1921
The term 'bulldog', originally referring to the
vaguely bulldog-shape design, has now passed
into German as a general term for one-cylinder
traction engines.

Mining Siemens & Halske overhead-electric
mine-loco, made in Berlin in 1883. The locomotive
now exhibited in the Deutsches Museum was
accepted into service in Upper Silesia in
September 1883 with a rating of *c.* 7.5 kW. It was
capable of extracting 50 tons of coal per hour.

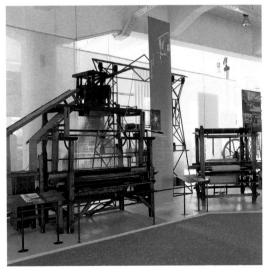

Textiles Jacquard loom. By perfecting existing
designs of mechanical looms, Joseph-Marie
Jacquard succeeded in replacing cam wheel control
with the unending principle of punched card
control.

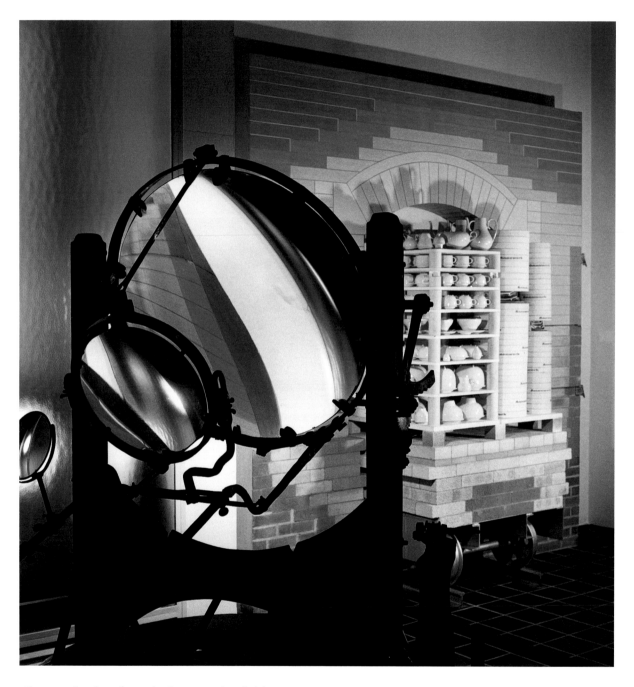

Glass Tschirnhaus lens. This largest and probably finest system of lenses made of full glass was built *c.* 1700 by Ehrenfried Walther von Tschirnhaus (1651–1708) in order to carry out sinter and smelting experiments using sunlight.

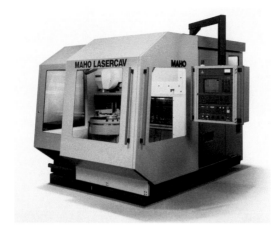

Machine Tools Lasercav, 1990.
In 1989, machine tools manufacturer Maho first succeeded in integrating a high-capacity laser into a five-axle milling machine, such that the laser beam can be directed across any curved surface. This allows very delicate and highly precise structures to be introduced into the hardest materials, even if electrically non-conductive.

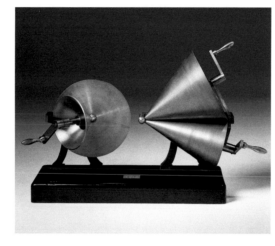

Machine Tools Conical friction wheels, *c.* 1900.
Franz Reuleaux (1829–1905), rector of the Technical University in Berlin, had numerous models made as visual aids for his lectures, to demonstrate complicated movements.

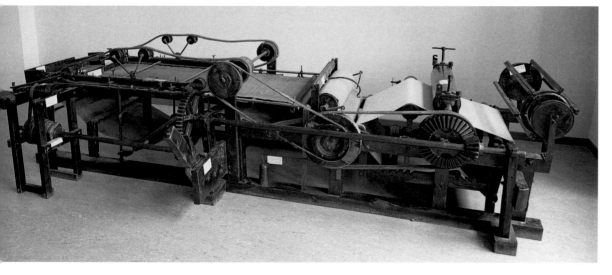

Paper French paper machine, *c.* 1820.
This exhibit is the oldest surviving artefact of early paper-making engineering. An endless strip of paper is produced on the fine-meshed sieve in a continuous process. This concept, patented by the Frenchman Louis-Nicolas Robert in 1799, is the basis of modern paper machines as well.

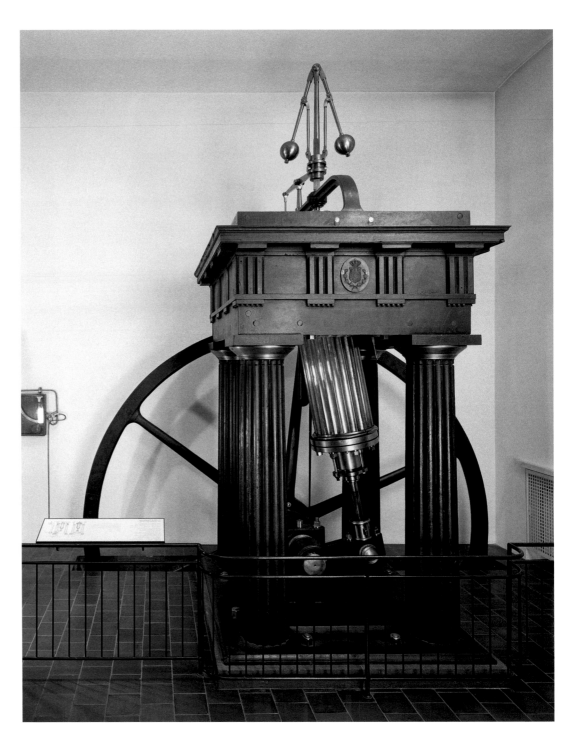

Power Machinery High-pressure reciprocating steam engine designed by Ernst Alban of the Iron Foundry and Mechanical Engineering Institute in Güstrow, 1839. To avoid the bearings overheating, Alban suspended the piston in a large steel frame, which enables the heat to be dispersed more efficiently.

Railways Rhaetian Krokodil Ge 6/6 4n loco-
motive. Work began on the construction of this
Swiss narrow-gauge electric loco in 1921. Because
of the articulated, three-bogie design required for
operation on the tight curves of the Rhaetian
railway network, the loco was nicknamed
the crocodile.

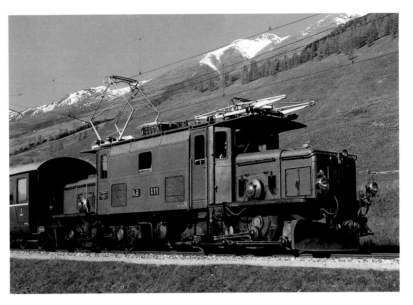

Automobiles and Motorcycles Arguably the
best-looking car that BMW ever turned out—
the BMW 507 sports car.

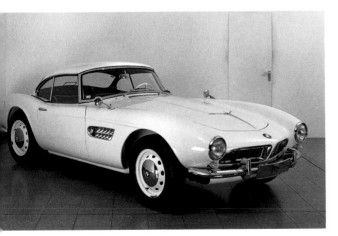

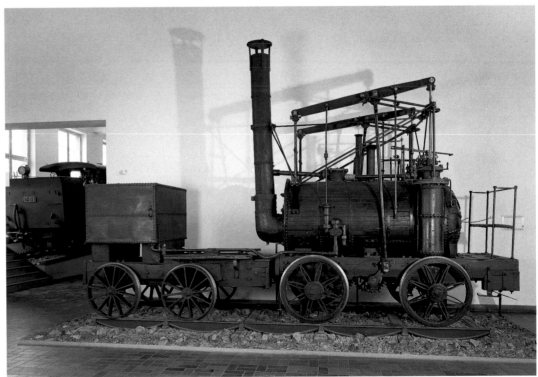

Railways Modern replica of William Hedley's
Puffing Billy steam locomotive, 1814.
The original was used to haul coal trains at
Wylam Colliery, near Newcastle-on-Tyne (England).
It proved operationally so fit for the job that it
remained in service there until 1860.

Masterpieces · Transport

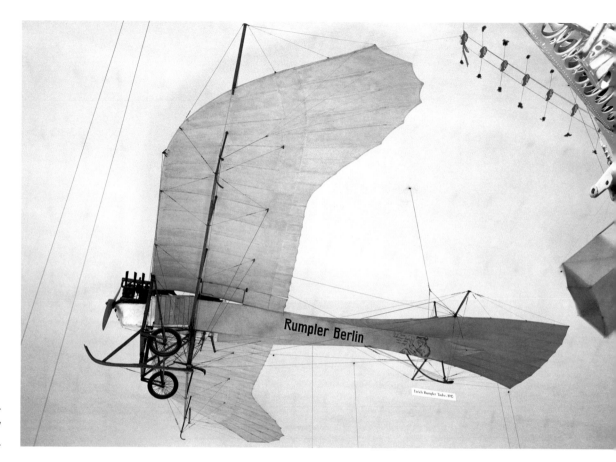

Aeronautics Etrich-Rumpler Taube (Dove), 1910.
With this 'dove' Hellmuth Hirth flew
from Munich to Berlin in 1911.

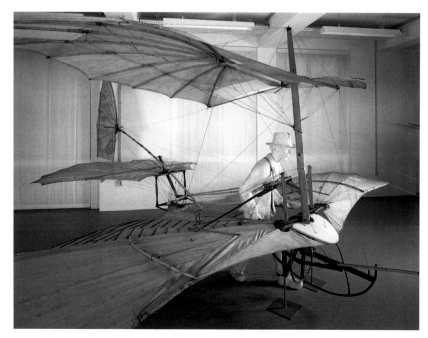

Schleissheim Airfield Wolfmüller gliding machine, 1907.
It is one of a number of gliding machines and flying
machines designed by engineer Alois Wolfmüller
(1864–1948). Many of his flying experiments were done
in this machine.

Marine Navigation Steel ships and submarines need new directional sensors like the gyrocompass. This compass ball is a central component of an improved gyrocompass devised by Hermann Anschütz-Kaempfe in 1925. Albert Einstein also had a hand in the design.

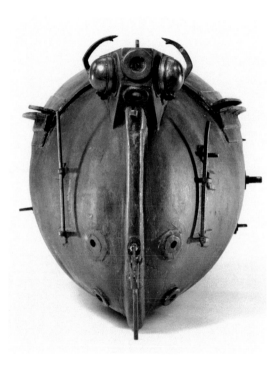

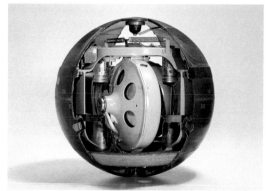

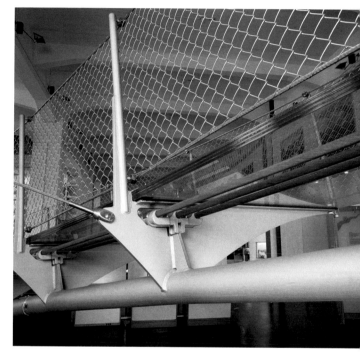

Marine Navigation Working model of a diving vessel built by Wilhelm Bauer in 1852, which he called an 'iron seal'. Bauer's diving vessels still lacked any kind of engine.

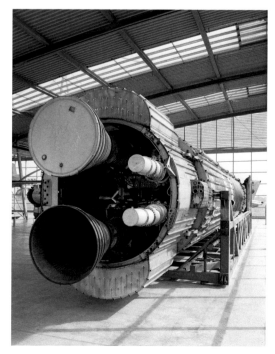

Bridges A high point of the exhibition that at the same time demonstrates the aesthetic and technical possibilities of the suspension technique is this delightful working footbridge with a span of 89' (27m). Made of steel and glass, it was designed by Schlaich, Bergermann & Partners of Stuttgart.

Schleissheim Airfield Europa rocket, 1971. The sole surviving complete example of a Europa rocket bears witness to the first European attempts in the early 1970s to develop an independent three-stage rocket for launching satellites.

The Depository, home of the reserve collections

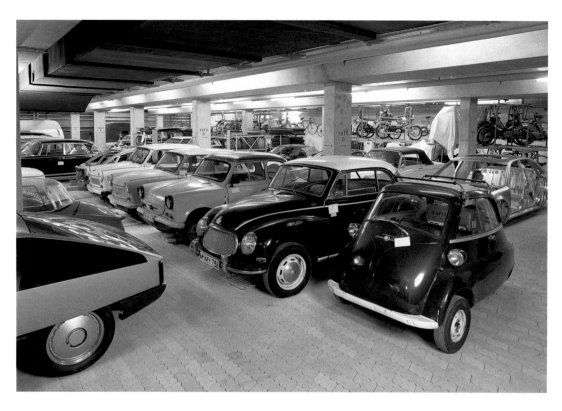

The Depository in the hangars at Oberschleissheim,
with automobiles and motorcycles

Collecting, preserving, exhibiting and researching are the core functions of a museum.

As a century of accession registers bear out, the Deutsches Museum possesses more than 100,000 inventorised items collected for their value in the history of technology or art. Exhibits are collected for 52 specialist subject areas ranging from chemistry and physics through power engineering to land transport, shipping and aviation. The sheer scope of the collection of valuable exhibits relating to technical history is particularly evident in the 1,500 specialist subgroups, such as typewriters, microscopes or sewing machines.

The public displays currently have 18,000 items on show. Some 20,000 items were destroyed during the war. That leaves over 60,000 appliances, machines, instruments, models and demonstration aids preserved in the study collection of the depositories on Museum Island and in outside depots, with a total floor area of more than 20,000 square metres. The differences in size, weight, fragility and historic importance of the exhibits imposes enormous demands in terms of transport and storage.

Access is willingly granted to researchers, specialists and borrowers for scientific work, anniversary exhibitions at donor firms and special exhibitions within the Museum. Information about the total inventory and all changes of location of the 100,000 plus items is kept on a computer program specially developed in-house. Activities such as the computerised initial documentation in the accession room, inventorisation and loan administration, as well as research into old exhibits, are handled by the exhibits administration in support of the Museum's curatorial work. *rh*

The Citröen 2CV AZV 250
delivery van from 1955

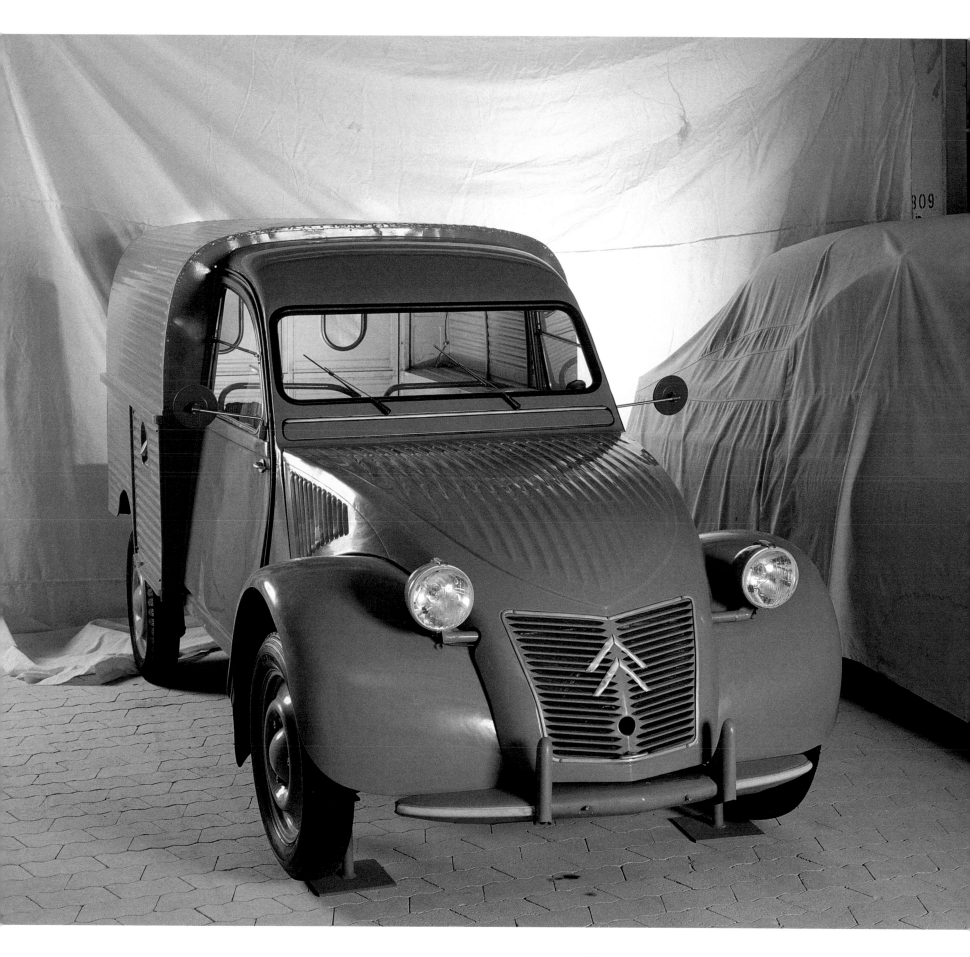

Workshops

Seen superficially, museums are generally considered backward-looking institutions in the way they deal with objects they collect and subject matter they research. Yet this is not even true of typical museum activities such as restoration work, where the very latest methods are used for the preservation of historic items. One of the main areas of the Deutsches Museum's work is restoring technical objects made of a wide range of metals, often in combination with organic materials.

The Museum's broader work has also led to the development of a unique body of knowledge about conveying content by means of interactive experiments or artistically recreating situations from the history of technology. The synergy of classic visualisation techniques with modern media is a continuation of Oskar von Miller's simply operated experiments. *ls*

In artistic professions, creativity is the norm. It is likewise a requirement in the workshops of the Deutsches Museum. Visualising complicated displays requires a strong educational sense, plenty of inspiration and a willingness to explore uncharted or unconventional approaches. Despite much artistic licence in the choice of method, implementation demands that the informational content be rendered with absolute precision.

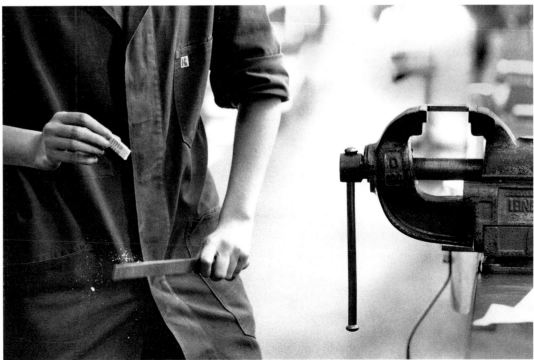

Workshops

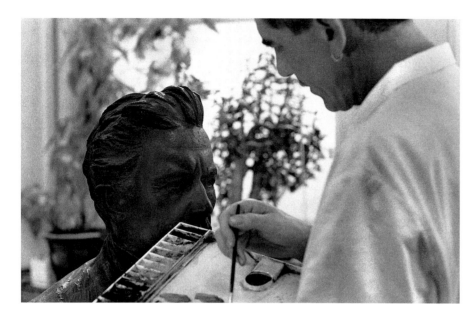

Apart from restoration workshops for scientific instruments and timepieces, vehicles and machines, aircraft or musical instruments, there are separate workshops for the construction of models, sculpture, painting, metalwork, carpentry, electrical work, electronics and media, typesetting, printing and bookbinding.

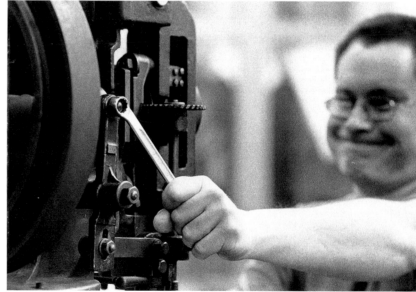

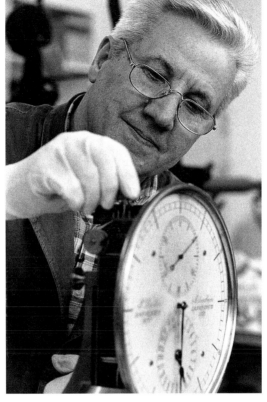

Not only clocks require great precision. Models also demand accuracy to a tenth of a millimetre or—in the case of interactive experiments to be used day in, day out, year after year—even a thousandth of a millimetre. Perfect things are the result of craft skills and maximum concentration.

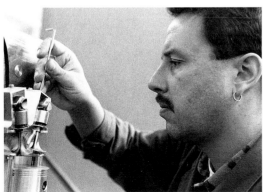

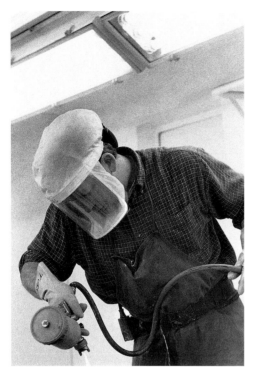

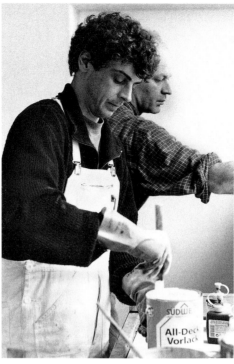

The surface is always visible. Slapdash painting can ruin everything, while meticulousness can enhance the effect of any preparatory work.

Good eyes and tiptop measuring instruments are vital for quality.

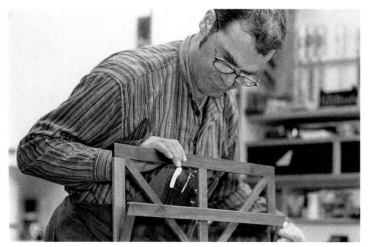

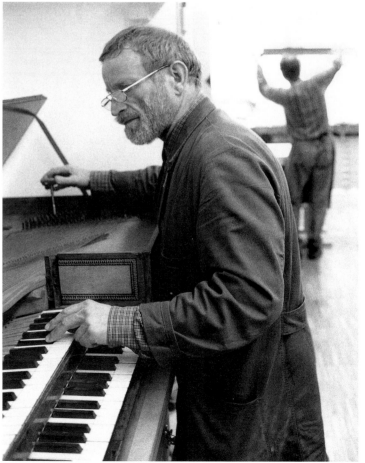

Almost all the items made are one-offs, which is why traditional production methods are appropriate. Even so, modern technology with computer-controlled turning and milling machines has long been used in the workshops.

Every employee is a specialist in his craft. The strength of the workshops is based on good teamwork.

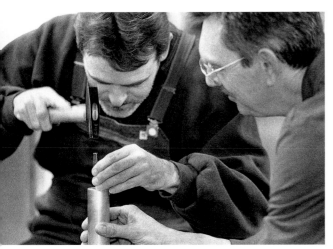

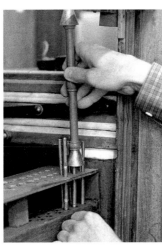

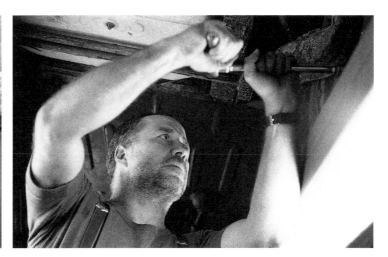

Workshops

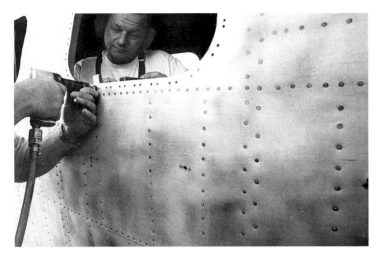

From an historical point of view, aluminium is a modern material, but even so it has specific ageing features that are difficult to restore. With plastics, there is even less experience to draw on, unlike in painting restoration, where knowledge of and experience with old techniques and materials is essential in slowing down the ageing process using modern methods.

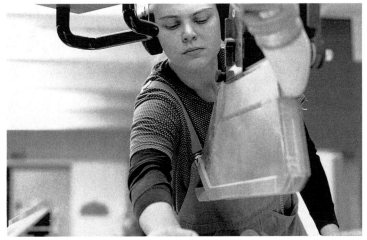

Wood and metal are the classic materials for internal structures and exhibition stands. Modern machines and appliances are a matter of course, but nonetheless the Museum is a listed building and therefore parts of the interior require traditional craft skills in maintaining the countless windows and doors or the famous library chairs.

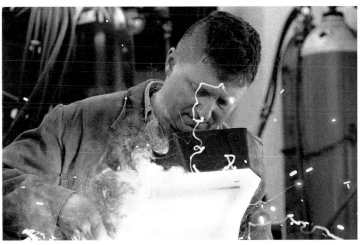

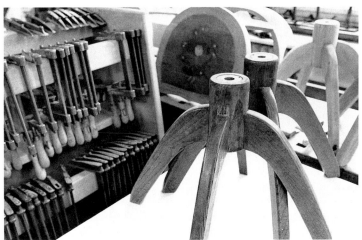

Workshops

Along with metalwork, electrical work and carpentry, maintaining and expanding software has become an important part of the business of keeping the Museum operating smoothly on a daily basis.

One of the main tasks of a museum, along with scholarly research into its collections, is publishing the results of that scholarship. These days, databases and internet techniques are of foremost value, and these are developed jointly with other museums and research institutions. In this way, the workshops of the Deutsches Museum can bridge the gap between the past and the future.

Restoring and rebinding books and periodicals is done by hand with great care in the library's bindery.

Workshops

The construction of the walk-in model of a human cell was one of the greatest challenges the Museum workshops have ever taken on.

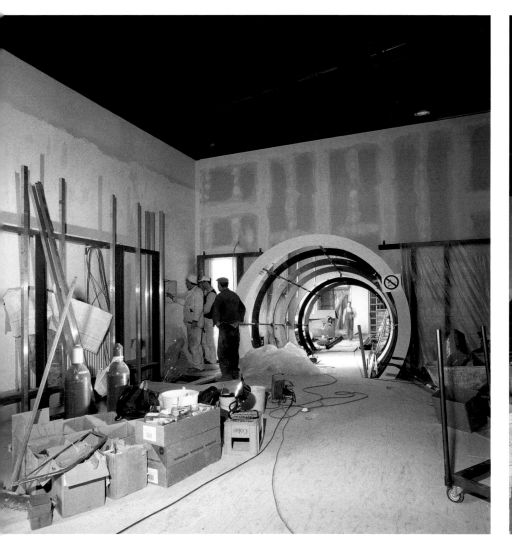

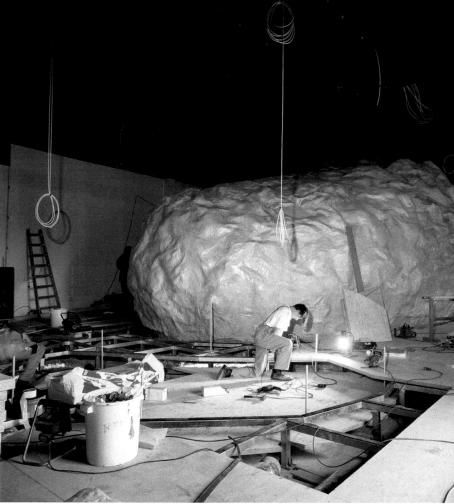

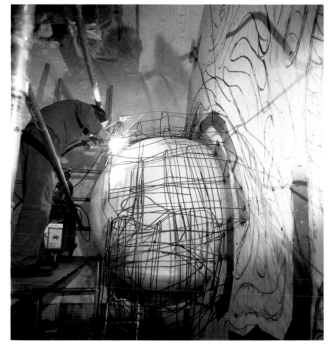

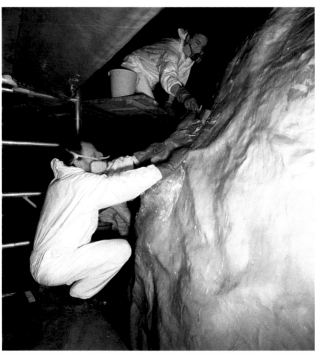

After drawings had been prepared in-house on computer, a frame was built that was then covered with thin wooden boards, fibreglass and plastic. All the organic details were shaped freehand on filigree metal structures.

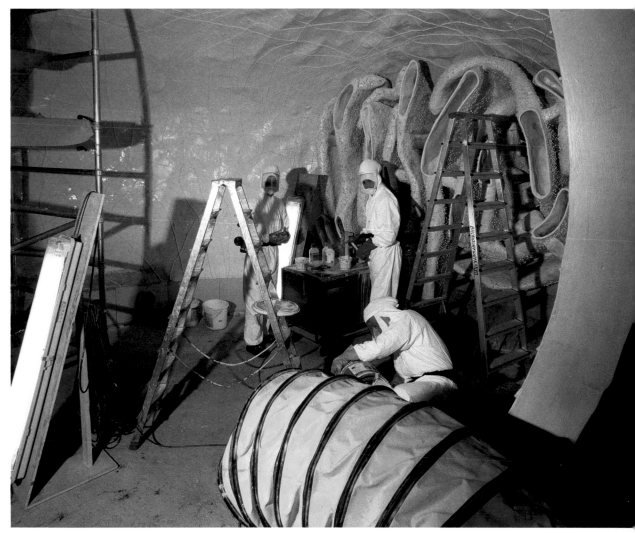

Workshops

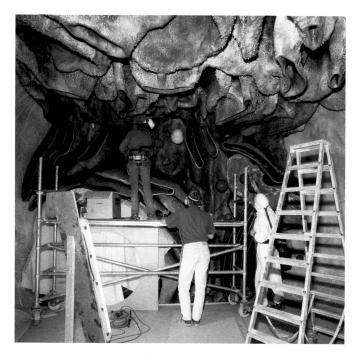

Fumes from plastics are a health hazard and liable to cause explosions, so major security precautions were required. On site, this meant masks with filters, protective clothing and large extraction units.

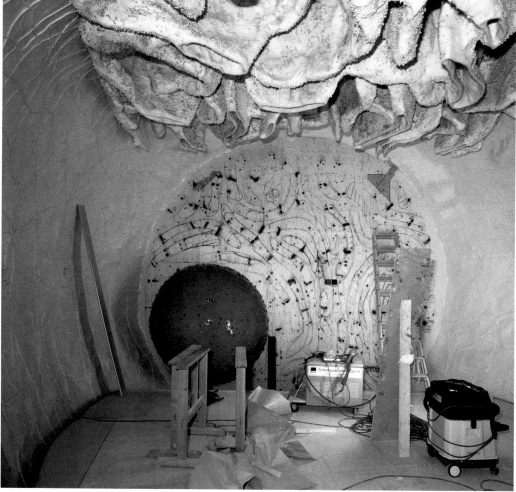

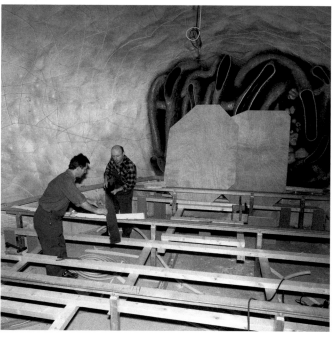

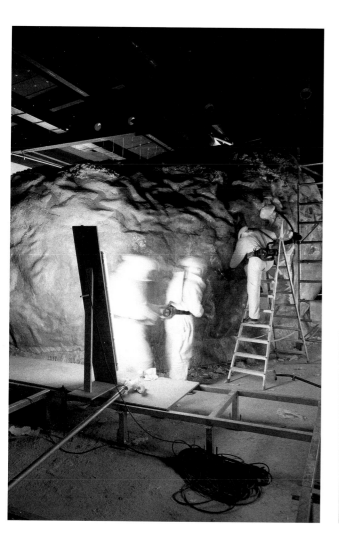

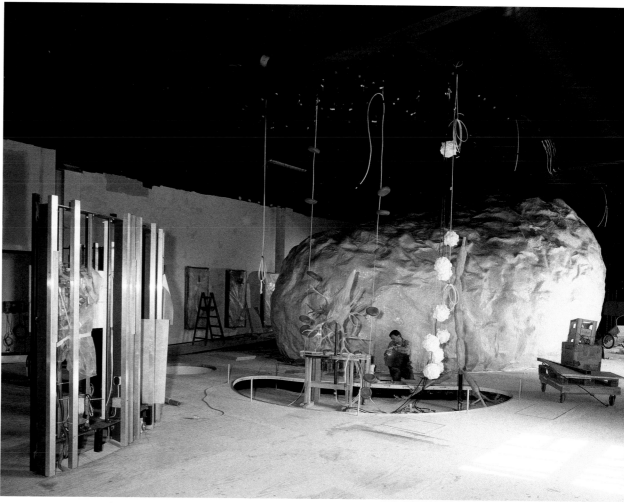

RESEARCH, KNOWLEDGE, EDUCATION

The activities carried out by the Deutsches Museum are manifold. Specialist knowledge and research are the supporting pillars of both its continuously expanding collections and its restoration workshops. Exhibitions and publications are the result of this symbiosis of specialist knowledge, research and the collections. In this manner the Deutsches Museum reaches a broad public and achieves its aim—namely to spread knowledge. This range of services is supplemented by courses. Collection and exhibition areas, the research institute, the library, archives, Kerschensteiner Kolleg and pedagogical museum work are the main focus of the museum. Each of these departments has its own area of operation and its own network of staff and users at home and abroad, and turns out its own products. Even so, despite this level of independence, research, knowledge, restoration, exhibitions and education are closely interrelated scientific aspects of the museum's work.

Research
The Deutsches Museum is one of half a dozen research museums belonging to the Gottfried Wilhelm Leibniz-Gemeinschaft (WGL) academic association funded jointly by the Federal Government and the *Länder* because of their national importance and scholarly work. Forming part of this select circle is both an honour and an obligation. It is, for example, expected that the Deutsches Museum will continuously carry out research work at an international level. But research is not just an obligation for the Deutsches Museum—it is also the foundation of its wide-ranging output and activity. Research is the source of its

authority as a national institution for presenting and analysing scientific and technical change in an historical context.

The research carried out at the Deutsches Museum is not of a white-hot cutting-edge scientific or technical nature. The Museum is more a platform for an open-ended dialogue between scientists and the public. The Museum's own research is devoted to the study of the history of science, technology and industry, their interaction and the cultural and social background. It involves examining the museological basis of what it does in exhibiting, collecting and providing educational facilities and illuminating it in the light of in-house and outside research. The astonishing variety of the collections plus the archives and library are thus explored in a scholarly way and the results made available to the public.

Research at the Deutsches Museum is networked in many ways, both locally and internationally. At an international level, the Deutsches Museum collaborates with such leading museums as the Smithsonian Institution in Washington, the Science Museum in London, the Cité des Sciences in Paris and science centres in Finland, Italy, Japan and Tunesia. At a local level, it is the headquarters of the Munich Centre for the History of Science and Technology, a unique research body linking the three Munich universities and the Deutsches Museum.

With this organic combination of great tradition with new, efficient forms of research and teaching, the Deutsches Museum stands out as a leading forum worldwide for the history of our science and technology-based culture.

ht

Treasures in the Archives

Ohm's Law, the formula for indigo, the design drawings for Lilienthal's glider, the discovery of nuclear fission—so much of what is basic knowledge in school textbooks can be found in original form in the Deutsches Museum archives. The documents carry an aura of uniqueness. They are stacked up on nearly three miles of shelving. Understandably, the archives are a Mecca for scholars and technical historians.

The archives go back to the founding of the Museum in 1903. The founders saw the Deutsches Museum not as just a collection of objects but also as a central repository documenting the history of the sciences and technology. This meant primarily, along with a specialist technical and scientific library, its archives preserve important original documents produced by technologists, engineers, scientists and inventors. The establishment of the archives proceeded amazingly quickly. The first records were manuscripts or documents left by major researchers, plans and drawings by inventors, company brochures and pamphlets (published for special occasions) or historic photographs.

Over their 100-year history, the Museum's archives have brought together an imposing number of original documents, such that they are now recognised internationally as a collection of great value for research. They preserve documents from the legacies of 250 important scientists and engineers, over 20,000 individual manuscripts, around 500,000 photos, 25 closed archives of companies, associations and institutions, 120,000 plans and technical drawings, nearly three-quarters of a mile of shelves with documents on aeronautics and astronautics, over half a mile of documents from over 14,000 companies, 10,000 maps (mostly thematic), 11,000 portraits, a special collection of 3,000 commemorative medals, hundreds of busts, 3,300 films, 500 sound recordings, stocks of important papers of historical value, and so on.

The bare statistics do not indicate how exciting the documents are for scholars and other interested parties. Traditional key areas of interest are the history of chemistry and physics, transport, aviation and space travel and machinery, while recent additions are computing and solar technology. Items collected are drawn from high-calibre sources that are of outstanding importance for the history of various technologies and the interaction of knowledge and technology. In many cases, the archive records are closely connected with objects in the Museum.

The time span covered is from the thirteenth century to the present. Probably uniquely for such archives, virtually all documents were donated to the Museum. The principal reasons for keeping the archives are to make them available to present-day users and to preserve them for the future. Suitable recording methods and the very latest conservation techniques are used for this—a rich heritage also brings considerable responsibilities with it. *wf/em*

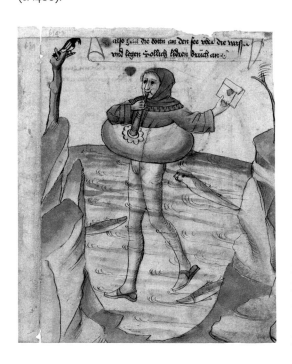

'Important message!' A messenger brings good news—and is not going to be held back by deep water, thanks to his inflatable swimming costume (*c.* 1480).

'Recovering lost treasure' was the motto adopted by Wilhelm Bauer (1822–75), after developing a special lifting device for the sunken steamship 'Ludwig'. He achieved fame as the builder of the first submarine.

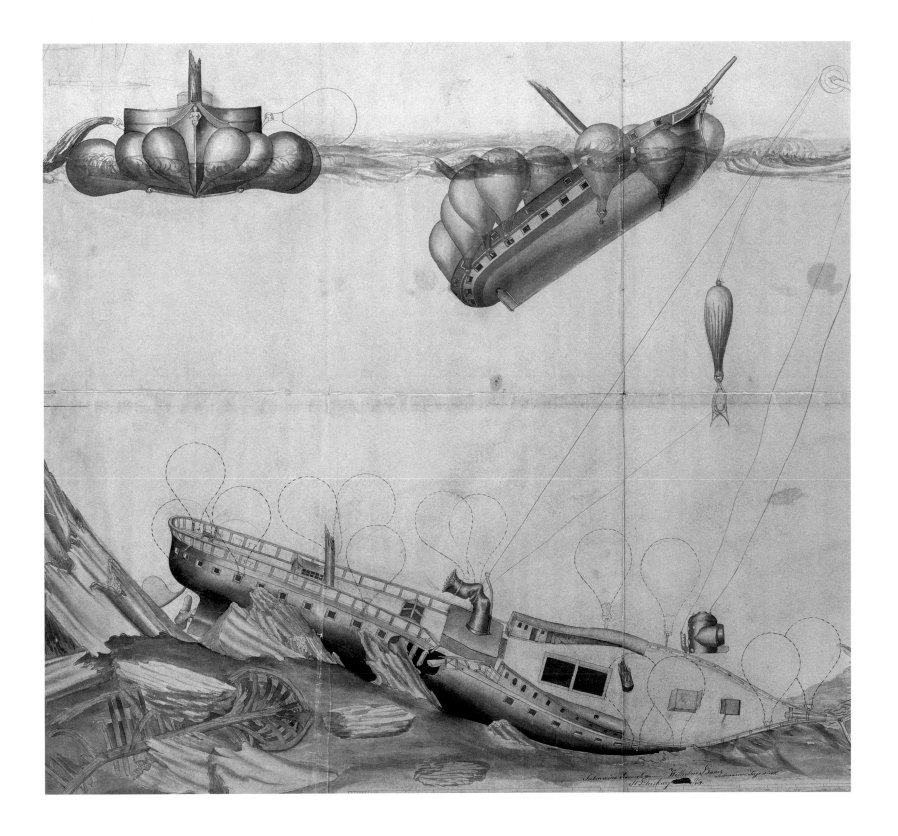

Treasures in the Archives

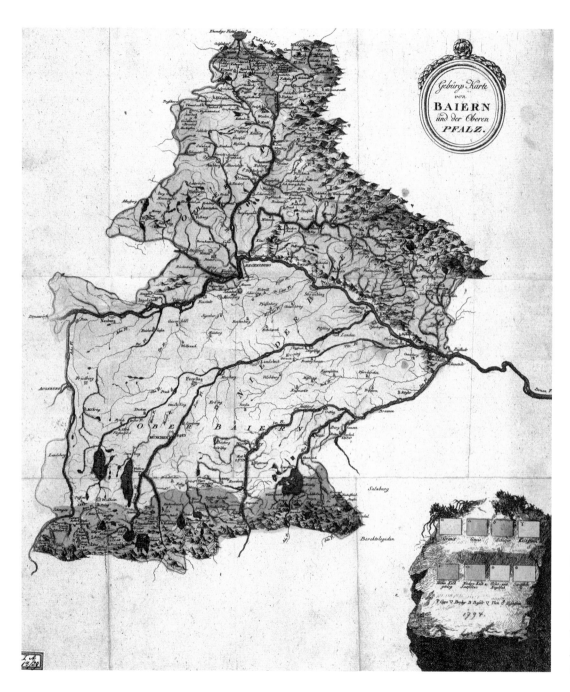

One example of a thematic map is the 'Map of Bavaria and the Upper Palatinate Regions and their Mountain Ranges' of 1792, the oldest geological map of Bavaria. The cartographer Mathias von Flurl (1756–1823) developed a systemised geological representation showing eight different types of rock.

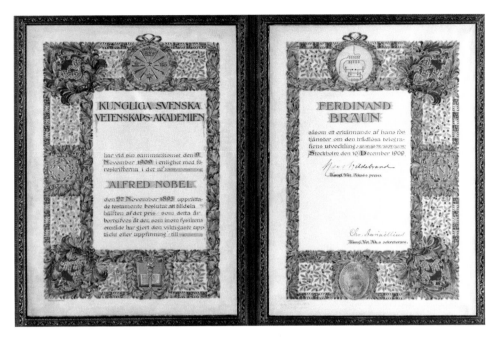

Nobel prize winners:
The archive holds numerous unpublished works and manuscripts, including those of many Nobel prize winners. The Nobel prize certificate and medal presented to the physicist Ferdinand Braun (1850–1918) are among the highlights of the collection.

Writing to Ernst Mach (1838–1916) in June 1913, Albert Einstein (1879–1955) bemoans the 'tireless effort' that his theories on relativity and gravity are costing him.

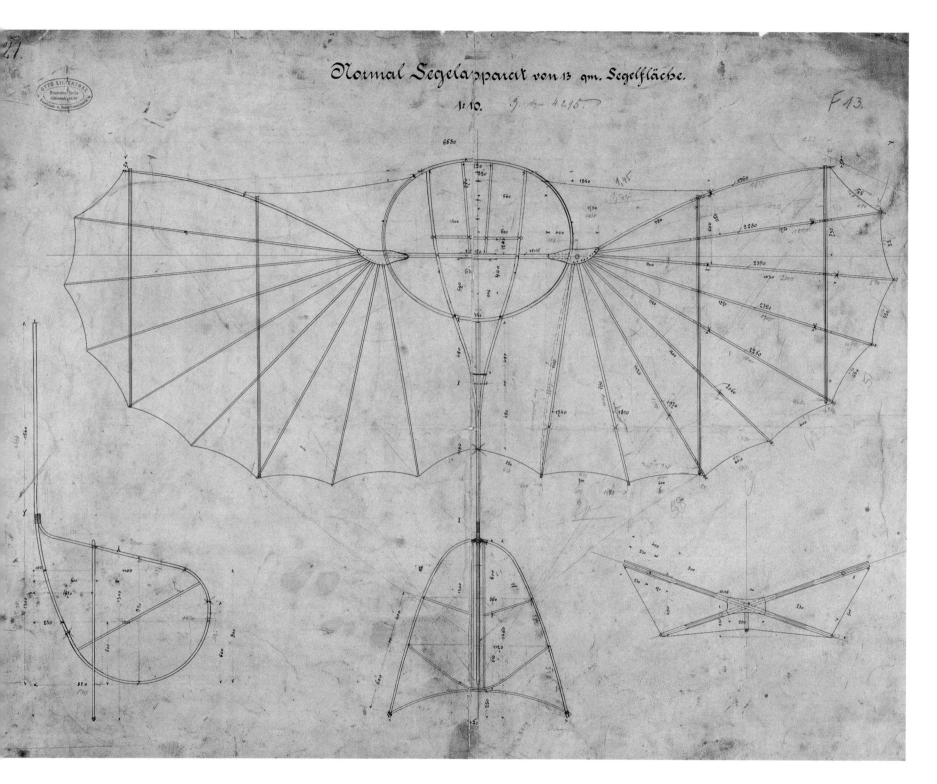

The dream of flying: the ingenious apparatus built
by Otto Lilienthal (1848–96) marked the beginning
of man's taking to the air. He constructed various
devices such as gliders and made more than
2,000 flights himself, reaching a height of up to
850 feet. The standard glider of 1895 is considered
his most important construction.

The beginnings of photography: this picture of the Neuhauser Strasse in Munich taken by Carl August von Steinheil (1801–70) around 1839/40 is one of the oldest photographs in Germany and is one of the most important items in the picture archive.

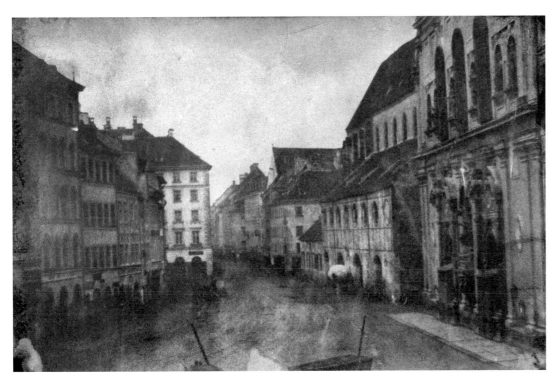

Public Understanding of Science: as the first academic association not to be under the jurisdiction of a university body, the Association of German Natural Scientists and Physicians (GDNÄ, founded in 1822) concerned itself with the presentation of scientific findings in an easily comprehensible manner and with the interchange of information between disciplines. The most important scientists of the day lectured at meetings—here held in Munich in 1899—which took place on a regular basis.

The BASF book of colour samples dated 1928 is just one example of an item in the extensive collection of corporate documents. This one shows the result of more than 100 tests made with analine and alizarin colours on silk. Even today, the quality of the colours, their clarity and accuracy are outstanding.

The Library

The collection in the Deutsches Museum library reflects the whole spectrum of the development of scientific and technical literature since the invention of printing. The classic works of Kepler, Newton or Einstein are represented here, as are very rare works of popular science.

Apart from the 'Libri rari' collection of seventeenth and eighteenth century books–a legend among connoisseurs–the library possesses mainly a high-quality collection of scientific and technical literature of the nineteenth and twentieth centuries. A great proportion of the works here can only be found in the library of the Deutsches Museum. Established with the founding of the Museum in 1903, the library benefited not least from generous donations by private individuals and publishers. In some cases, whole libraries were taken over from institutions and scientists. Over a century, the library developed into a splendid research facility for the history of science and technology, and fortunately escaped damage during World War II. Nowadays, the focus of collecting is mainly literature relating to the history of science and technology along with basic scientific and technical works.

25,000 volumes on science, technology and their histories are available to the general public in the two reading rooms. Opened in 1932, they can accommodate up to 150 visitors. They represent one of the few examples of inter-war library architecture still in existence. Their design was predominantly influenced by similar libraries in the US.

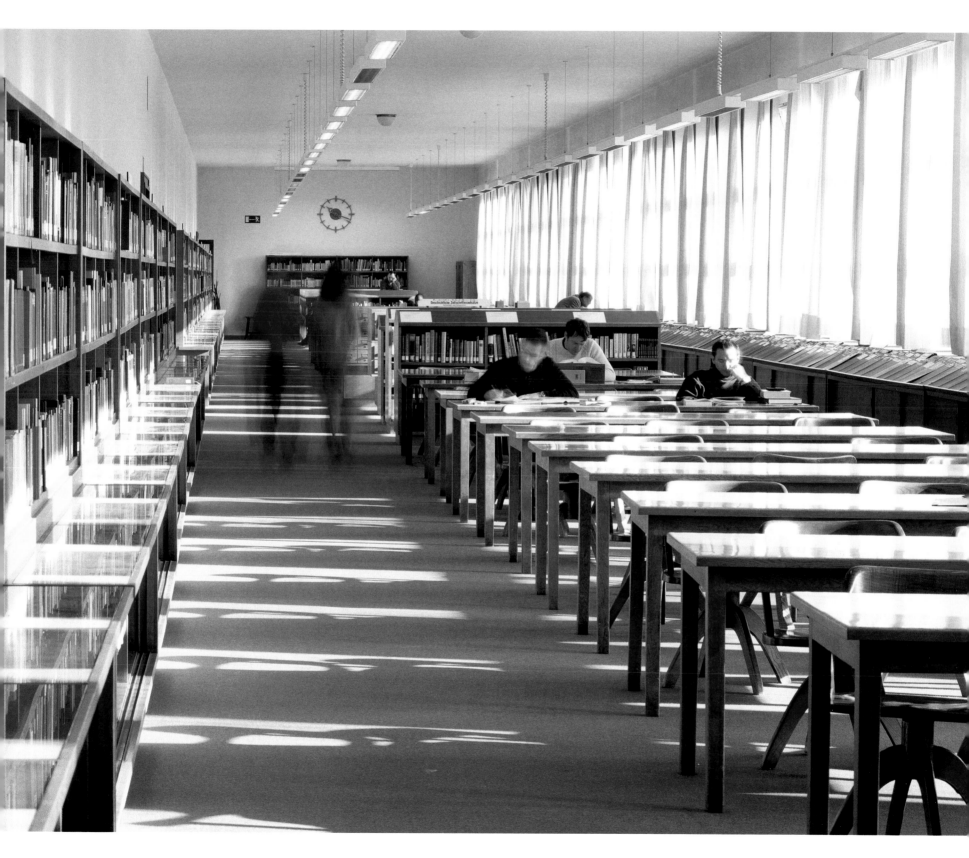

The Library

The library is a gold mine for science and technology historians with its internationally important collection of valuable old volumes.

With a stock of around 900,000 volumes at present, the library is among the largest scientific and technical libraries in the German cultural area and at the same time Germany's largest museum library. At a global level, it is considered the largest specialist library for the history of natural sciences and technology. Along with monographs and around 20,000 periodicals, of which 3,500 are currently subscribed to, the library also has an extensive collection of German and foreign patent documents.

Beside the broad scope of historic works, the library likewise offers scholars a wealth of source material relating not only to the history of science and technology but to cultural and economic history as well. In keeping with Oskar von Miller's original intention, the library also caters to members of the public interested in keeping up to date with current developments in science and technology. In this way, it makes an important contribution to the educational role of the Deutsches Museum. To allow as many people as possible to visit it, the library is open at the weekend, like the Museum itself. Overall, the appeal of the library at the Museum is such that it is a favourite resort for people of all kinds, whether scientists, amateur antiquarians, students or scientific or technically-minded laymen. The surroundings themselves – the two reading rooms, excellent examples of inter-war library architecture–are an ancillary attraction.

Since it was established, the library has worked hard to make its treasures accessible. Catalogues list both books and articles in periodicals. A fair proportion of the catalogues are now online and can be used for research. In the coming years, the aim is to make the rest of the library's stocks available to the public in the same way. *hh*

Few people would expect to find Johann Wilhelm Weinmann's *Phythanthoza Iconagraphia,* published between 1737 and 1745 in the Deutsches Museum. The library holds a representative selection of old botanical works.

Books from the early modern era covering mechanical subjects are among the prize works in the 'Libri rari' collection. This illustration shows Fausto Varanzio's *Machinæ novæ,* published in Venice in 1600.

Trade and industry exhibitions reflect the history of industrial and technological progress. Oskar von Miller provided plenty of inspiration for the design of exhibitions held in the Deutsches Museum.

The Library

The library was originally planned to function as a centralised German library for technology, mathematics and science. As a result, shelving space was generously calculated to accommodate up to one million volumes.

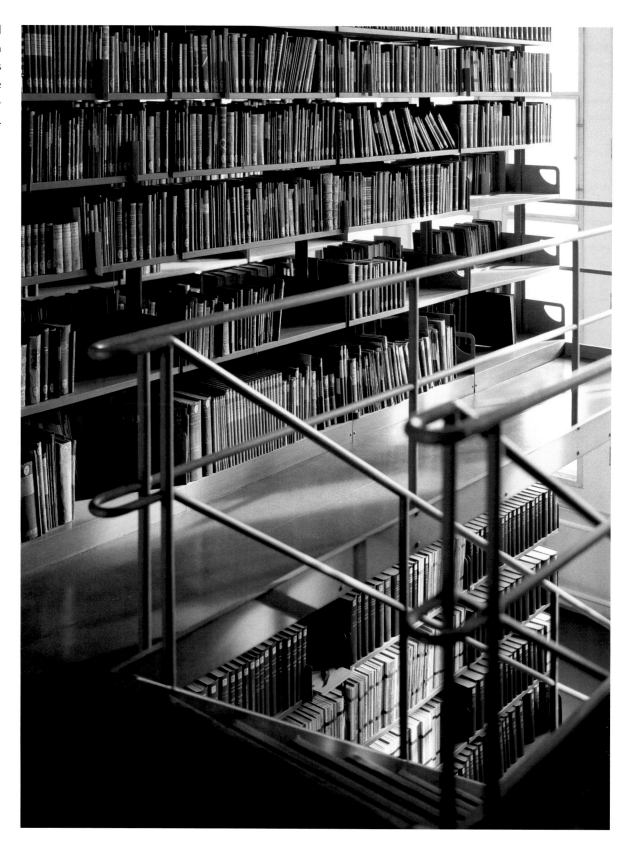

As in many traditional libraries, old card indices can be found next to computer workstations. Step-by-step the old records are being digitalized so that they can also be accessed via Internet.

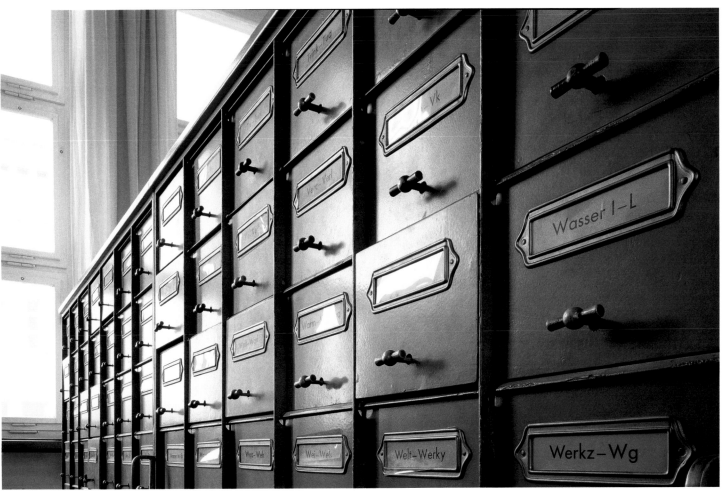

The Museum and its Visitors

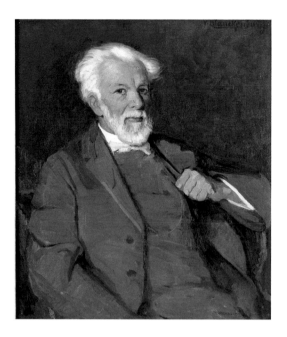

Georg Kerschensteiner, 1854–1932

Right from the first, the Deutsches Museum saw itself as an educational institution, and its didactic approach was heavily influenced by Georg Kerschensteiner. He it was who laid the foundations for an institution that remains attractive to the public and welcomes more than a million visitors a year. An analysis of visitor figures for 1999 and 2000 enables us to look behind the statistics: a good third of the respondents came from Munich and Bavaria, approximately half from Germany, the rest from abroad.

Since it opened on the former Coal Island, the Deutsches Museum has built up its visitor-oriented programmes and added to its classic events such as demonstrations, guided tours, recreations—the mine immediately springs to mind—and interactive exhibits. Nowadays, visitors expect a broad palette of educational facilities employing different methods and providing target-group-oriented activities to help laymen understand the Museum and its exhibits. For example, children can take part in holiday programmes and in Advent come to story-telling occasions centred on the objects on display. Evening events with distinguished specialists are put on for everyone interested in science and technology, and a cultural programme with special theatrical performances and exhibitions establishes a link with art. The range of items targeted at particular groups includes activities for women, senior citizens or leisure-time groups. Besides the obvious provision of programmes and materials for school classes, there has been a systematic selection of study courses available at the Kerschensteiner Kolleg since 1976. The Kolleg has both accommodation and classrooms available to put on courses lasting several days or over the weekend or to organise discussion groups. These are mainly on interdisciplinary topics that serve to extend participants' existing specialist knowledge or set it in a wider context. *anr*

Seminars: the Kerschensteiner Kolleg provides the possibility of studying the museum's exhibitions in depth. The seminar programme is adapted to meet individual requirements, with participants living and studying in the museum complex.

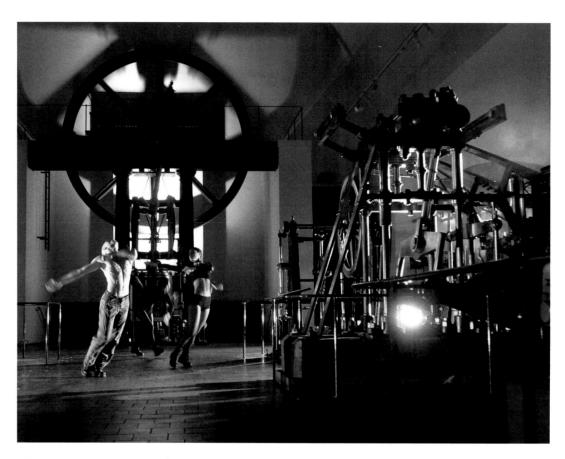

Events: theatre performances at the Deutsches Museum, fairy-tales for children, dance shows or cabaret form a link between art and poetry on the one hand and science and technology on the other. Theme related events are adapted to certain target groups and supplement the classical tours on offer.

Experiments: models, texts, pictures—the 'classical' educational tools still stop visitors to the Deutsches Museum in their tracks and provide an easily comprehensible introduction to scientific and technical principles. With the added benefits of new media, they form the perfect basis for animation, games and supplementay information.

Demonstrations: as in the past, demonstrations remain one of the most popular attractions at the Deutsches Museum. They cover a unique range of subjects from the fields of craftsmanship, industry and science, from the visible to the invisible—as for example with the electron microscope—to experiments in the visitor laboratory.

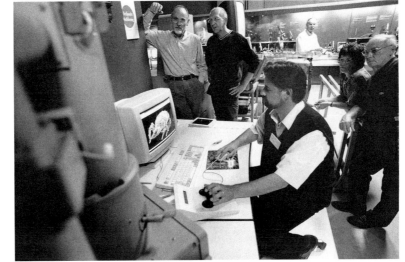

NATURAL SCIENCES

While the philosophers of Ancient Greece and Rome strove to understand Nature better by logical means, since the Renaissance period practical experimentation has been favoured, in which a selected facet in the natural world is subjected to precise examination. The gradual interaction of results reached through experimentation and mathematics was ultimately channelled into the 'natural sciences'—astronomy, physics, chemistry, biology, etc.

Increasingly precise methods were created to delve deeper into areas in the natural world that are not immediately accessible. The results gleaned are used to make our lives more comfortable. Natural science and its methodology laid the foundation stone for the industrial nations and as such rendered a greater population density around the world possible for the first time.

However, the natural sciences also effect man's view of the world. In the Middle Ages, man considered himself the pinnacle of creation and the centre of the universe. Since the Enlightenment in the eighteenth century at the latest, attempts to define the world through religion and metaphysical treaties have been in decline.

Natural scientists have given us a better understanding of the structure and history of the universe and the world of elemental particles. Although many things still guard their secrets and increasingly elude our comprehension, ever more precise scientific means pose new questions in turn.

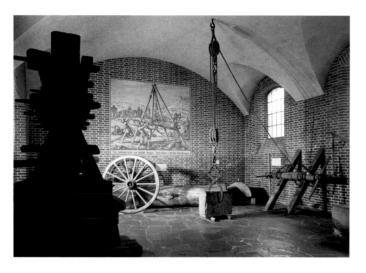
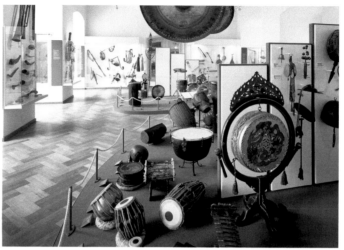

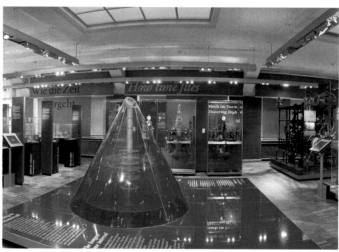

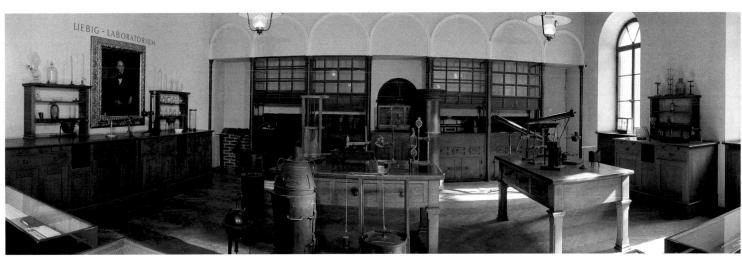

Physics

"Give me a (firm) spot to stand on and I shall move the earth."

Archimedes (*c.* 287–212 BC)

This scarcely modest claim by the great mathematician and physicist Archimedes of Syracuse (*c.* 287–212 BC) appears in his treatise on levers. Archimedes was the first to provide logical proofs of the physics of levers, which is one reason why he is numbered among the founders of theoretical mechanics.

Archimedes was thoroughly aware of the practical importance of his work, as the above quotation indicates. What he could not suspect was how important his claim would be figuratively for modern physics. If you replace the 'firm spot' and the lever in his statement by modern physics, it applies to the latter as a whole. Physics is the scientific basis of virtually all scientific subjects. Physics showed the way to numerous technical applications that have changed our world in no small degree and released mankind from the trammels of direct natural forces.

Discoveries in physics contributed substantially to the nineteenth century Industrial Revolution and the mechanisation of western culture in the twentieth and twenty-first centuries.

With the assistance of physics, 'natural philosophers' looked beyond the confines of everyday experiences directly accessible to our senses. They were on the hunt both for the 'ultimate building bricks' of matter and the structure and origins of the universe. The former was the realm of particle physics, the latter that of astrophysics. Surprisingly, despite advancing into such totally different dimensions, the two aspects of physics came together. Without the discoveries of particle physics, neither the origins of the universe nor its structure would have been comprehensible in detail.

These days, physics is no longer reliant on the achievements of individual researchers, as it was in earlier days. It is usually teams of researchers working at major institutions who make the discoveries. With these discoveries increasingly exploited in practical applications, physics has transformed our lives. The achievements of physics have, for example, made unparalleled densities of settlement possible, but also

Knights' Hall: for a long time, levers, screws, block and tackle pulleys and crooked floors had a considerable influence on strenuous manual work. In Antiquity this led to the advances in the theory of equilibrium, statics. Original pieces from the 18th, 19th and 20th centuries.

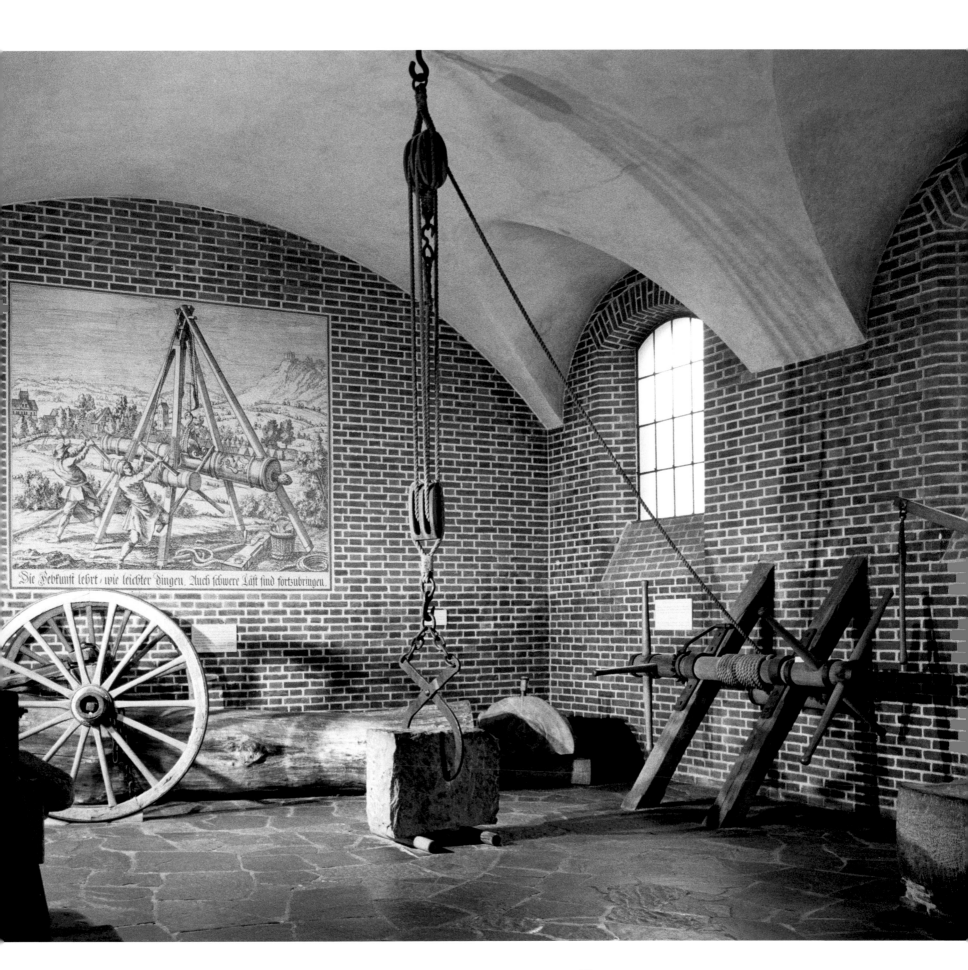

Physics

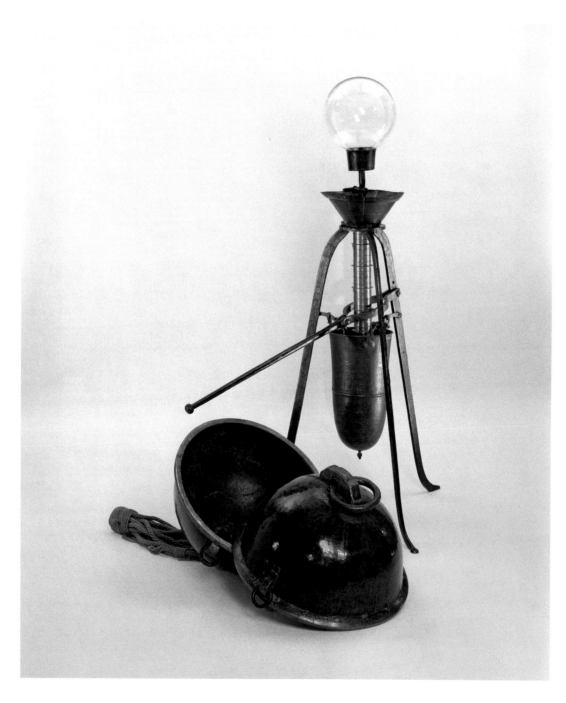

Otto von Guericke's first vacuum pump and hemispheres from c. 1663. During the 30 Years' War in the mid-17th century, the mayor of Magdeburg Otto von Guericke was the first person to prove that, contrary to popular belief, Nature was not 'afraid of the vacuum'.

conjured up the spectre of mankind's rapid self-destruction.

Physics has thus moved steadily into the floodlight of public attention. The far-reaching results of physics research and ambivalence of many discoveries have not only preoccupied physicists and politicians but prompted writers to take up their pens. One of the best-known examples is the play *The Physicists* by Friedrich Dürrenmatt, written in 1962.

Right from the first, the Deutsches Museum devoted a large amount of floor space to aspects of physics. Of the 36 subjects the Museum was originally divided into, eleven related to physics, astronomy, mathematics and geodesy, not to overlook music, which in accordance with the canons of antiquity still was grouped with physics.

Because of its sheer scope, the display could not be implemented all at once. It grew steadily from 1905 onwards as numerous valuable historical original items were added and demonstration models were set up. The latter acquired a special importance when it is borne in mind how little 'polytechnical' teaching there was in the schools of the time. For many years, the displays were provisionally accommodated partly in the old building of the Bavarian National Museum, partly in the barracks on Museum Island.

After the Museum building was completed in 1925, physics acquired a permanent home on Museum Island. The last display section completed before World War II was the consequence of a special exhibition on television.

Continued on p. 104

The law of gravity is demonstrated using the device shown below, made in 1795 by Johann Anton Wisenpainter.

Reconstruction of Leonardo da Vinci's Perpetuum Mobile (19th century).

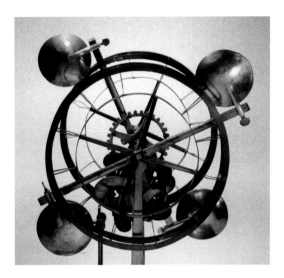

A number of such tables for electrical experiments were constructed by the Parisian engineer Hippolyte Pixii for André Maria Ampère. One of these was acquired by the Bayerische Akademie der Wissenschaften.

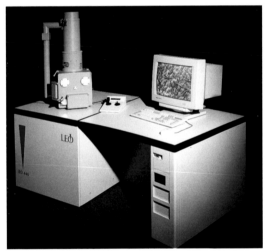

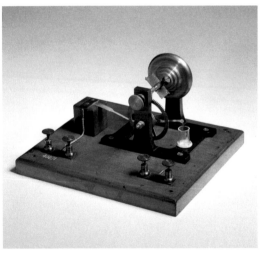

The demonstrations shown on the scanning electron microscope 440 i from LEO are a special attraction in the Optics section. Images, magnified by as much as 100,000 times, have an exceptional clarity. Some of the possible uses of this research tool are displayed using selected objects from the fields of biology, mineralogy, geopalæontology, biotechnology and microtechnology.

Rotating mirror for the transmission of electromagnetic waves produced artificially by Heinrich Hertz in 1886/88.

Physics

Two of Antoni van Leeuwenhoek's original micro-scopes. A member of the illustrious Royal Society in London despite being self-taught, he made several sensational discoveries in the 17th century. Leeuwenhoek of Delft was, for example, the first to analyse the sperm of humans and other living creatures. He confronted his contemporaries with the fact that the pure mechanism of human reproduction was no different from that of the flea.

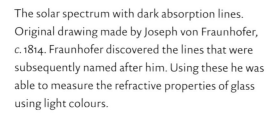

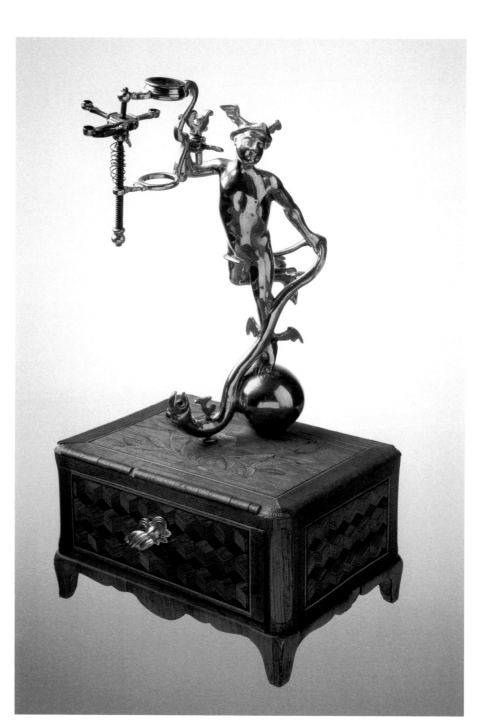

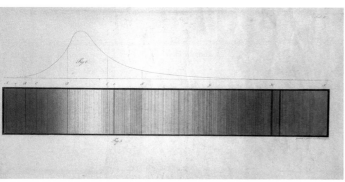

The solar spectrum with dark absorption lines. Original drawing made by Joseph von Fraunhofer, *c.* 1814. Fraunhofer discovered the lines that were subsequently named after him. Using these he was able to measure the refractive properties of glass using light colours.

This instrument being held aloft by Mercury shows that microscopes were also considered status symbols in the 18th century. The artistic design overrides the object's function.

Hermann von Helmholtz was the first to be able to look into the interior of a living person's eye using his invention from 1850, the opthalmoscope, which became the optician's most important tool.

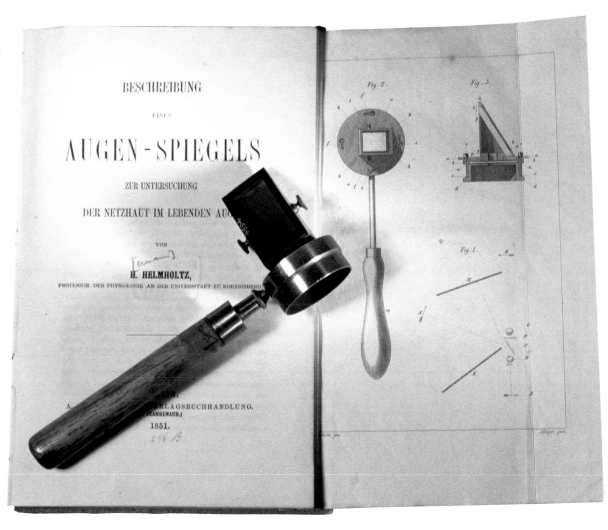

Reconstruction of the first scanning tunnelling microscope, for which Gerd Binnig and Ernst Rohrer received the Nobel prize for physics in 1986. This microscope and the scanning power microscope developed according to the same principle, have now become essential tools in the field of nano-technology, even allowing single atoms to be manipulated.

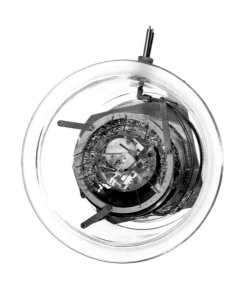

This photo taken with a scanning microscope in 1999, shows an ant fitted with a microtechnical orbital motor from the Institute for Microtechnology in Mainz.

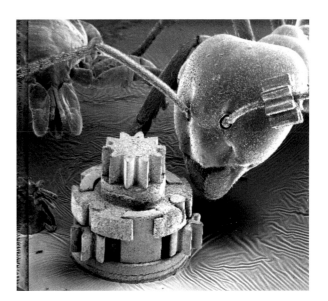

Physics

Using this equipment, Max von Laue, Walther Friedrich and Paul Knipping discovered the diffraction of X-rays on crystals in 1912. For the first time, it was proven that crystals comprise an structured arrangement of minute modules and that X-rays are short electromagnetic rays. The analysis of X-ray structures was born.

After the damage sustained during World War II, some physics rooms were reopened to the public as early as 1948. Again, work steadily continued on expanding and revising the Physics section. The most recent additions are Optics (1989) and the revised Nuclear Physics section (2001). As the real-life applications of physics expanded, so the relevant parts of the display were developed into separate sections. These included Telecommunications, Astronomy and Astrophysics, along with Music.

Today, the physics display includes 450 demonstration models plus numerous original items such as Otto von Guericke's first vacuum pump and Magdeburg hemispheres, Heinrich Hertz's first transmitter and receiver, Wilhelm C. Röntgen's tubes, original items by M. von Laue and L. Meitner, and the first scanning tunnelling microscope by Gerd Binnig and Heinrich Rohrer. These names indicate that the treasures of the physics collection also include a considerable number of original appliances by Nobel prizewinners.

The physics exhibition offers the visitor an overview of the whole spectrum of the subject, beginning with mechanics and ending with nuclear physics. The appeal of the display lies in its combination of important original appliances and replicas along with 450 demonstration models. The latter are increasingly produced with the latest technology, in order to keep maintenance costs as low as possible. Computer simulations of important natural laws have also been created, and the display is linked to research institutes.

In this way, the display shows important stages in the development of various fields of physics, and also invites visitors to experiment themselves. Special demonstrations are a popular addition, such as in the field of very low temperatures or microscopy. The first illustrates the phenomenon of superconductivity, the latter accesses the field of nano-technology.

Historic recreations are also an attractive feature. Galileo Galilei (1564–1642), for example, the founder of modern physics, is honoured by a recreation of his workroom. Occasional theatrical performances in this room offer audiences an insight into this important period in the origins of modern physics. *ab*

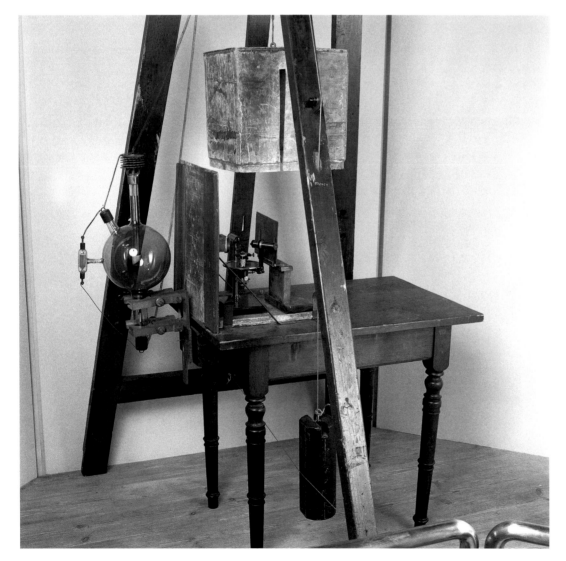

A view of the display in the elementary particle section. The opened superconducting zyklotron 'Tritron', weighing 8 tons, has been suspended from the ceiling. Up until 1996 it was being developed in the acceleration laboratory used by both universities in Munich. Now it gives us an idea as to the complexities of acceleration plants.

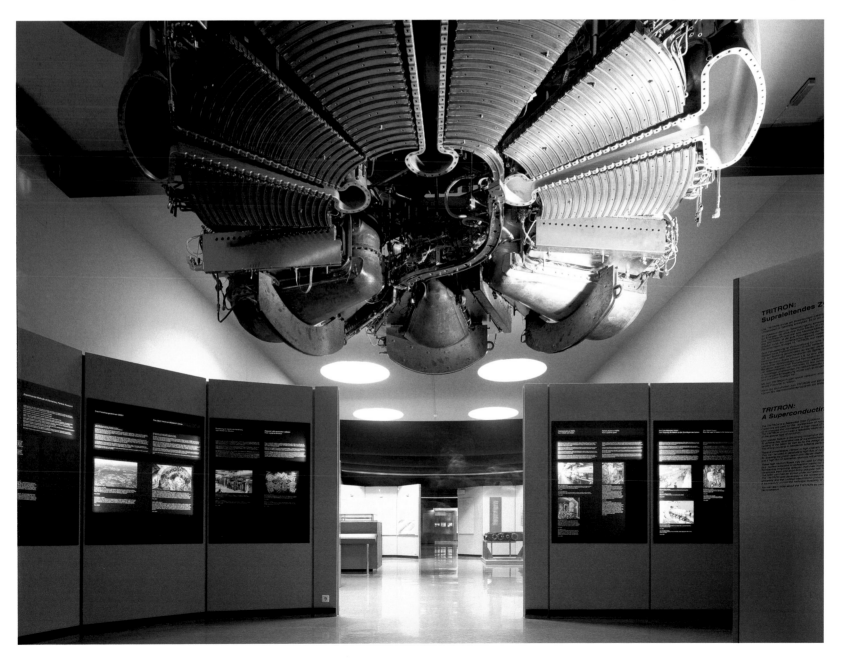

Musical Instruments

"Everything was spread out that rings and sings, honks, roars, rattles and drones … The magic appeal that uncle's trading premises, this paradise of silent but hundred-toned variety of agreeable sounds, exercised on us boys will be obvious."

Thomas Mann, *Doctor Faustus*

The display ranges from a replica of a Bronze Age Nordic *lur* to electronic instruments of the present day.

A collection of musical instruments was already envisaged in the first scheme for the Museum in 1903. Under the heading 'technical acoustics', it showed the practical application of acoustic laws in the construction of instruments and technical development from the earliest times to today.

In the Museum building on Museum Island, Emanuel Seidl designed a room for the instruments in the Historicism style, which, in modified form, still houses the core of the display. In 1994, self-playing and electronic musical instruments plus experiments in musical acoustics were hived off into separate rooms and six other rooms were added to the display.

The display focuses on the development of musical instruments from their early forms to the present. Instruments are presented systematically according to the method of sound generation, and this chronologically within each section.

The Music Room before the war

The string, brass and percussion instrument display following revamping in 1998

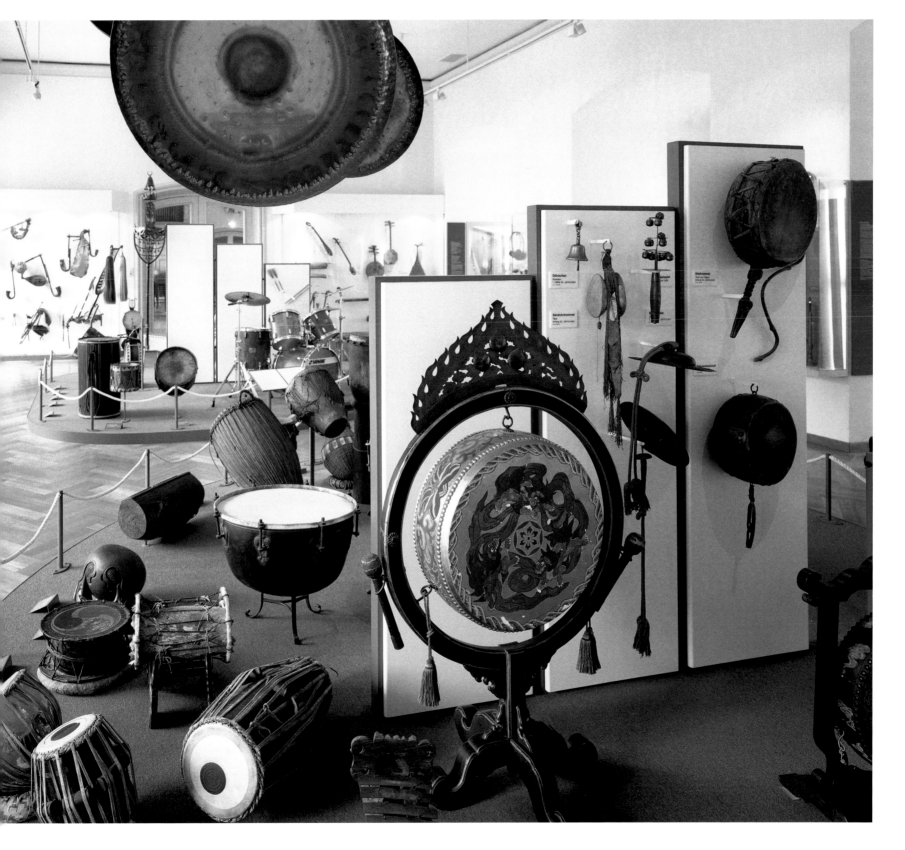

Musical Instruments

Today, the collection contains around 1,800 instruments and several thousand pre-programmed pieces for self-playing instruments.

These include a harpsichord by Franciscus Patavinus (Venice, 1561), the organ from the pilgrimage church of Maria Thalkirchen (1630) and a tenor trombone by Hanns Doll (Nuremberg, 1638), plus exotica such as a belloneon belonging to the Kaufmann family of Dresden and a twittering machine (Paris, mid/late nineteenth century), the Siemens studio for electronic music (1958–60), and a Baroque-style organ by Jürgen Ahrend (Leer 1995).

Models of piano mechanisms, valve systems and self-playing musical instruments and 'transparent' instruments with removable parts or sections illustrate functional and technical processes. Fingering tables and teaching books document playing methods and use. In addition, acoustic laws can be discovered hands-on.

There are daily guided tours explaining instruments and in some cases with demonstrations. In the winter months, distinguished players put on organ concerts and matinées at which individual instruments, particular themes or rare repertory are presented. *sb*

Tenor trombone by Hanns Doll, Nuremberg, 1638

Detail of a harpsichord by Franciscus Patavinus
(Venice, 1561)

Detail of the organ from the
pilgrimage church of Maria Thalkirchen (1630)

Detail of the 'twittering machine' by Bontems
(Paris, mid/late 19th century)

The Siemens studio for electronic music,
Siemens AG, Munich (1958–60)

Musical Instruments

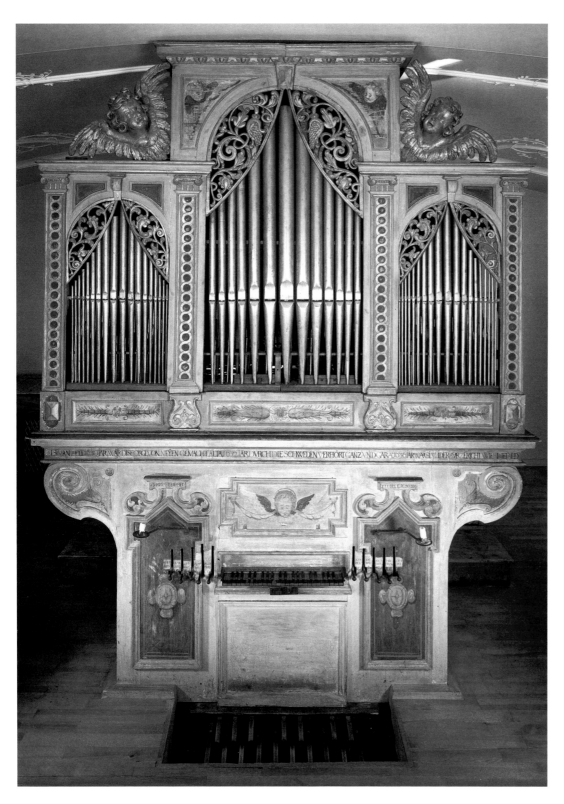

The organ from the pilgrimage church
of Maria Thalkirchen (1630)

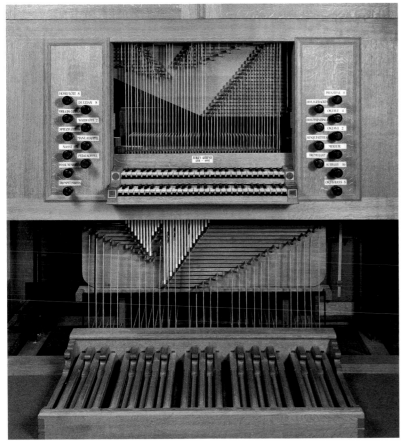

The casing of the organ built in 1995 by Jürgen Ahrend based on a Baroque design can be removed to reveal the workings behind.

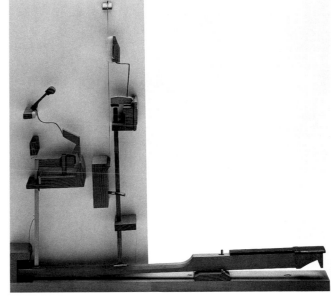

The mechanics of a clavichord, cembalo and pianoforte are shown using models, such as this one of an upright piano built in 1750/70.

Instructions show the finger positions and how to play instruments. The 'Instructions on how to become acquainted with and how to play a bass clarinet' by J.H.G. Streitwolf, published in 1833 in Göttingen, contains a number of the author's handwritten corrections.

Astronomy

"The unanimity with which galactic systems are making off almost looks as if they had a pronounced antipathy to us. We do not understand why they avoid us as if our island were a plague spot in the universe."

Sir Arthur Eddington, c. 1920

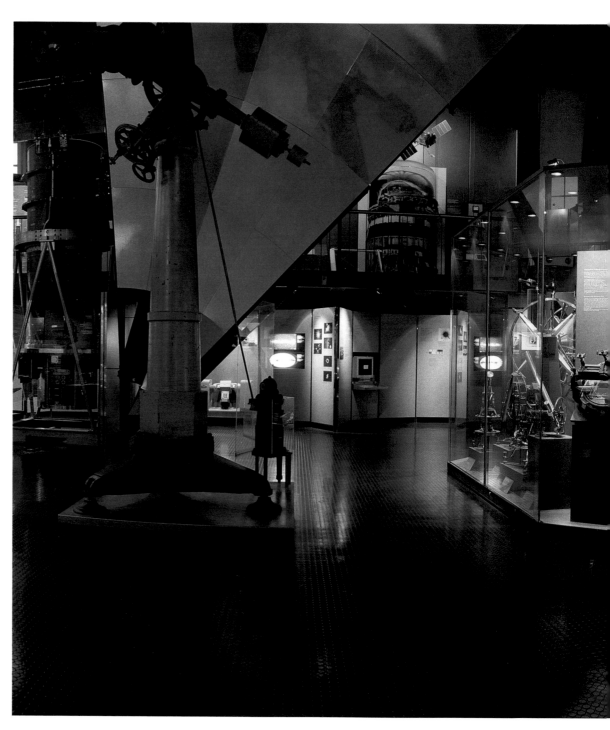

General view of the astronomy display, 2002. *(left)* The Repsold heliometer from 1889, in front of a reflector segment from a submillimetre telescope from the 1980s; *(centre)* display case with historical astronomy instruments; *(right)* model of the Tycho Brahe observatory, late 16th century.

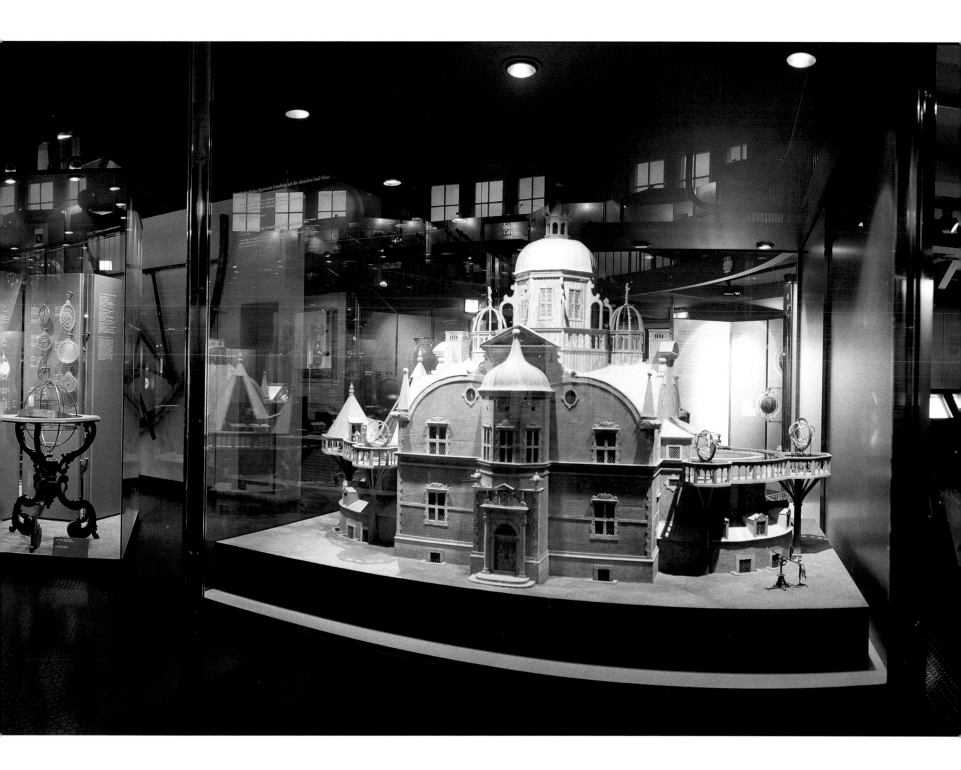

Astronomy

English mathematician and astrophysicist Sir Arthur Eddington was writing here about the 'flight of galaxies' discovered in the 1920s. Spectral measurements had shown that all galaxies were moving away from us. Our present understanding is that this is because the universe is expanding, as a result of which all galaxies are moving away from each other, not just from us. But if the universe is expanding, the question arises as to the beginning (was it a Big Bang?) and end (will it go on expanding for ever?). The further an object is removed from us—in the case of remote objects, we can no longer see individual stars but only galaxies or quasars as the cores of galaxies—the faster it is moving away from us and the older the light reaching us from this object. Looking into the depths of the universe is also looking back at the past, into the cosmic nursery. Astrophysics is the physics of large dimensions, maximum energies and extreme conditions of matter. It is largely inaccessible to us by direct sensory perception.

However, astronomy is also observation of nature. It deals with phenomena of the daytime and night sky, the rising and setting of the stars, seasonal changes in our night sky, the closest neighbours of our own star, the sun, the moon, the planets and their moons, comets, the countless other stars in our galaxy and the Milky Way. These phenomena and objects are partly accessible to the eye and can be experienced, even though our awareness of the night sky as part of our natural environment has largely been lost as a result of the manifold influences of civilisation.

Astronomy began with human exploration of the night sky and the attempt to describe and understand what was seen. Stars were attributed to the divine realm, and fateful meanings were ascribed to heavenly happenings.

Intensive observation and measurements enabled things to be described more accurately and also allowed astronomical predictions to be made. Differing interpretations of the cosmos arose in different cultures.

At the beginning of the modern era, the Copernican revolution removed the Earth (and thus mankind also) from the centre of the cosmos. Mankind now revolved with subsidiary location Earth along with other planets around a new central star, the sun.

In the mid-nineteenth century, astronomy dramatically expanded. What had hitherto been the key task—defining the position of the stars as accurately as possible—was extended to investigating the quality of their light. Its intensity and spectral characteristics enabled conclusions to be drawn as to the physical characteristics of the stars, for example, their temperature, material composition, remoteness and even how they were moving.

These days, astronomical observational and measurement methods are dependent on high technology and specialisation. Radiation at all wavelength bands of the electromagnetic spectrum—radio signals, submillimeter radiation, infrared radiation, visible light, ultra-violet radiation, X-rays, gamma radiation and even particle radiation—serve as sources of information to explore the cosmos.

The astronomical installations at the Deutsches Museum are organised so as to convey

Engineer's model of the first German X-ray telescope, ROSAT. Using the largest Wolter X-ray telescope in the world at that time, important discoveries were made in deep all-sky X-ray surveys.

The sun's protuberance from 2 August, 2000. Height c. 145,000 km (approx. 11.5 times the Earth's diameter), taken using an H-alpha filter on a 300/5000 mm Zeiss refractor, Deutsches Museum observatory.

The pearl-necklace effect, taken shortly before second eclipse contact. Light rays from the sun are just shining through valleys on the moon. The light dots around the dark moon disk take on the appearance of pearls on a necklace.

(*top right*) Photomontage showing the course of the total solar eclipse on 11 August, 1999 between 11:16 and 14.01 (MEST) in the sky above Munich. Starting on the left, individual shots have been positioned so as to reconstruct the actual course of the moon. In the first half of the sheet the moon moves (from the right—west) slowly in front of the sun. Shortly before reaching its highest point at midday, the sun was completely concealed by the moon from 12:37:12 to 12:39:20 (MEST). In the second half of the sheet, the sun gradually reappears and the moon moves further to the left (east).

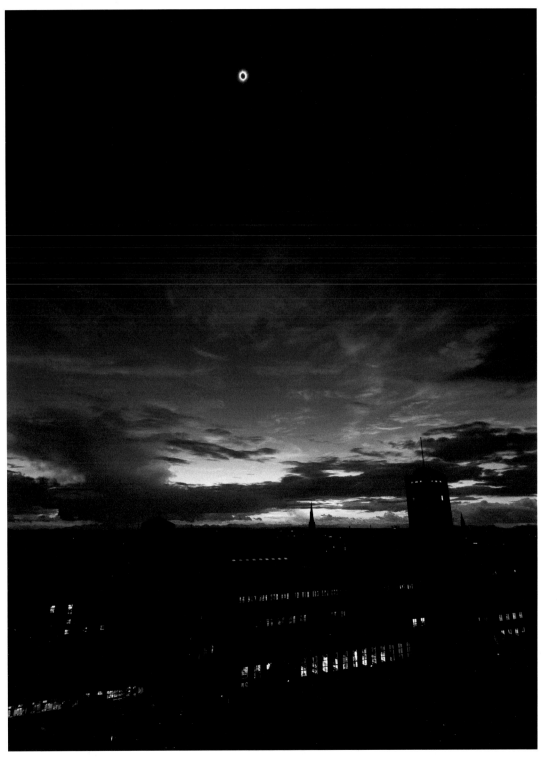

The core shadow above Munich: view to the south from the roof of the German patent office. In the foreground the Deutsches Museum can be seen with the lights on; in the background the Alps can be seen in the sun, still outside the core shadow area; at the top, the total eclipse of the sun in an almost pitch-black sky.

Astronomy

This drawing made around 1919 by H. Stierhof shows the design of the world's first projection planetarium, built a few years later at the Deutsches Museum.

knowledge in three steps, following Oskar von Miller's original scheme: the exhibition display provides information about the history of the subject, basic astronomical knowledge, astronomical observation and measuring techniques and the results of astronomical research. The planetarium allows the visitor to study an artificial night sky, where the arrangement of the stars, how they rise and set, and the course of the planets, sun and moon are simulated in a realistic way.

The creation of the astronomy department at the Deutsches Museum went hand in hand with the development of the world's first projection planetarium, a completely novel display medium which Oskar von Miller commissioned from Carl Zeiss of Jena in 1925 for the opening of the Museum.

Finally, the observatory provides an opportunity to experience astronomical objects by looking at the stars and consolidating impressions gained from the exhibition and planetarium.

gh

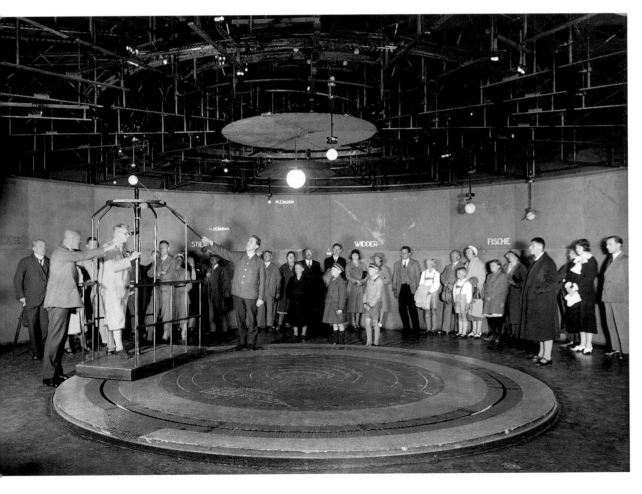

The Carl Zeiss Copernican planetarium, Jena

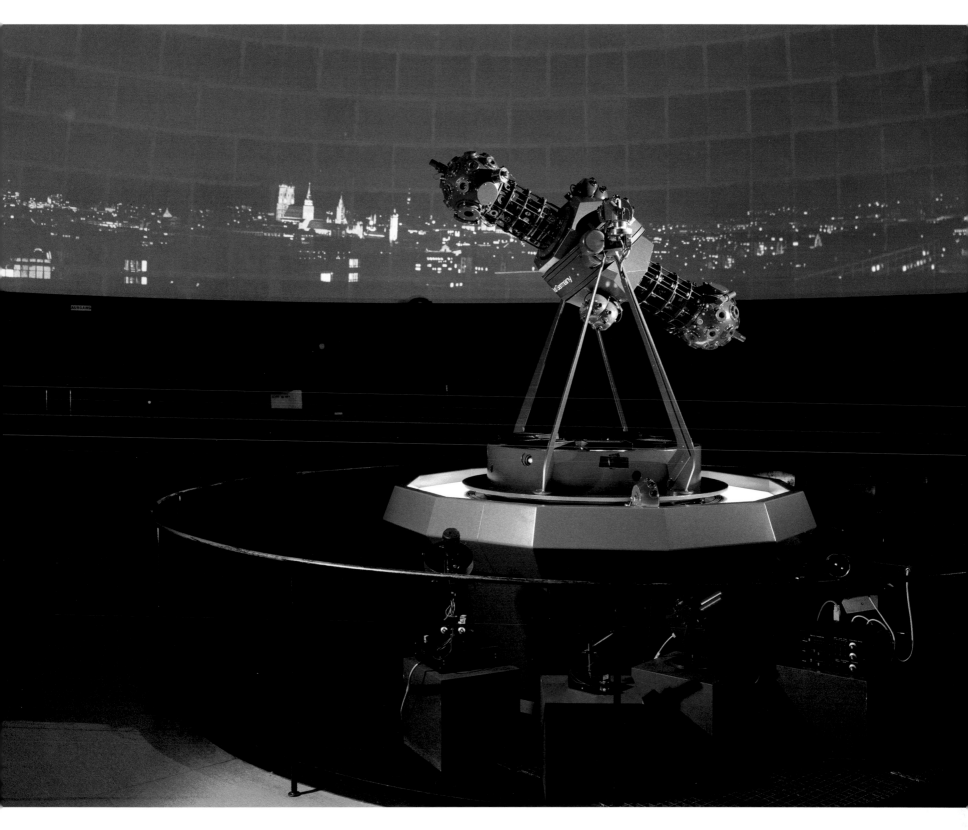

Zeiss Planetarium, model 1015, with computer-
driven projector. This generated a realistic night sky
by projecting onto a 15 metre dome.

Geodesy

"There is a measure in all things."

Horace (65–8 BC)

Geodesy remains relatively unknown to the general public, but the results of its activities are both necessary and well-known. The production of land registers, the construction industry, civil engineering and navigation, for example, all depend on accurate maps. Every map we have is the product of a scientific discipline with a tradition dating back over 5,000 years. Determining the shape and size of our Earth, measuring its surface and depicting it in maps are the classic tasks of geodesy.

Opened in 1993, the geodesy display at the Deutsches Museum contains around 200 exhibits, over 100 wall-panels with texts and diagrams, plus a number of demonstration models and screens to illustrate the development of geodesy from the beginnings to the present day.

With every measurement, it is necessary to establish the relevant location of points on the Earth's surface. To do this, distances, angles and differences in height are measured with suitable measuring instruments, or else gravitational acceleration is established with gravity measurement instruments.

Photogrammetry is measuring parts of the Earth's surface by photographing them from two different points. The pictures show the spatial shape of the terrain. In geodetic space surveying, space satellites are used to determine the spatial position of points on the Earth's surface that are widely separated.

A fundamental task of measurement techniques is to create fixed points on the Earth's surface that can be employed in many fields. Science needs such fixed points for example to determine the shape and size of the Earth, civil administrations need them to map the surface of the world topographically, to survey and register land holdings and for land administration measures. The construction industry needs fixed points for planning, marking out and monitoring technical objects (surveying). Measurement techniques have opened up new areas of use, such as in industrial production and ergonometry.

There have been 'world maps' since Antiquity. It is a function of cartography to show the curved surface of the Earth on a flat map surface (map projection) or on a globe. Differences in height can be shown in relief or contours. To produce map originals, cartographers have used different methods historically–drawing by hand, woodcuts and engraving, lithography, engraving on glass, film or electronic means (digital maps).

The end of the display includes a practical demonstration on how to use maps, compasses and GPs. The hiker or seafarer can discover how to orientate himself and find his way through unchartered territory. *ms*

View of the surveying section taken in 1951.

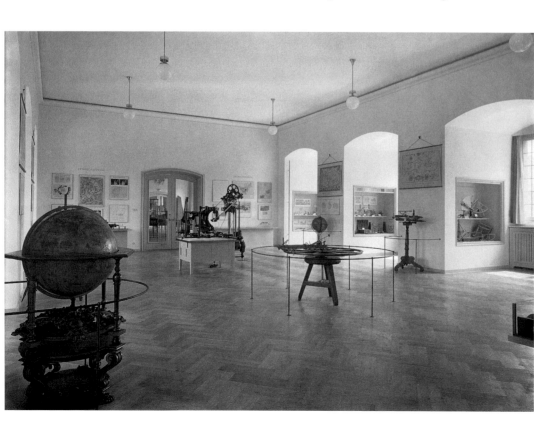

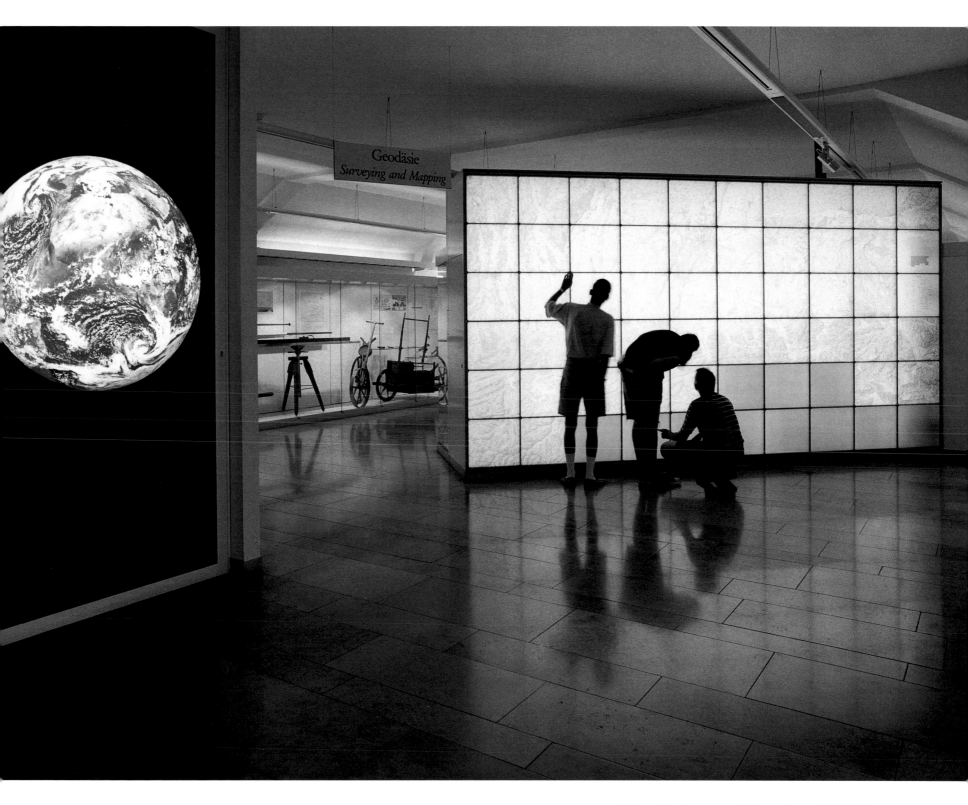

View of the first room of the geodesy exhibit. This includes a view of the Earth taken from space and a 2.5 x 5 m topographical map of Bavaria. The oldest map of Bavaria was drawn by Philipp Apian in 1568.

Chronometry

"As far as physicists are concerned, what matters is not how you define time but how you measure it."

Richard Feynman, 1963

The blueish-red, shiny, capped cone is a model representing the history of the expanding universe since the 'Big Bang'. The orbitting logarithmic time scale dates both the smallest fractions of a second following the 'Big Bang' as well as the time since then, right up to the present day.

Chronometry

Timepiece from South Germany, *c.* 1620. Despite the surprising simple spring-driven mechanical movement of the figures, the associations conjurred up in the viewer's mind are much more complex. The repetition of the movements follows the same sequence.

For Nobel prizewinner Richard Feynman, measuring time was what mattered. He was interested in measuring times of greatly differing duration. Such measurement is not just routine work, even though it is done every day in probably every physics and science laboratory in the world by people who are sticklers for precision.

The fame of distinguished experimental scientists not infrequently rests on a sophisticated and accurate measurement of time. Measuring time was always a major element of scientific work and will no doubt remain so.

The importance of the precise measurement of time in scientific laboratories is in stark contrast to a quick glance at a watch or at a church tower in our everyday lives which are governed by time. The clock industry today makes more timepieces than ever before in history, using the very latest manufacturing technology. The highly precise time of atomic clocks is transmitted via radio waves and cable, not just round the globe but also into space.

Looking at the variety of clocks and other time-measuring instruments in the Museum is altogether a different matter. Here, passing time ceases to matter. It is of course very interesting to learn the abstract and often highly sophisticated principles by which invisible time is measured in each case, but the essence of the pleasure is in enjoying the technical craftsmanship and artistic quality of the exhibits. *hp*

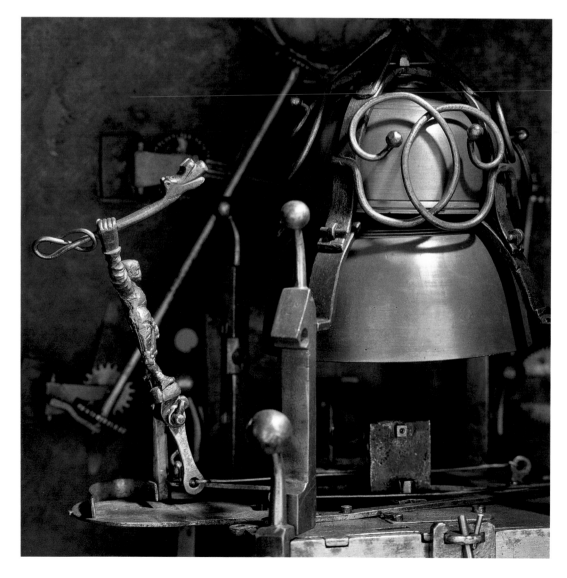

Apart from the time-related information shown on the dial of the clock, each quarter is struck in a different way. The mechanism includes a rider with a lance and a cudgeon-swinging fighter who hit the two bells.

The front of this astronomic clock from 1592 has five faces and a rotating globe. The striking mechanism was not meant to be seen.

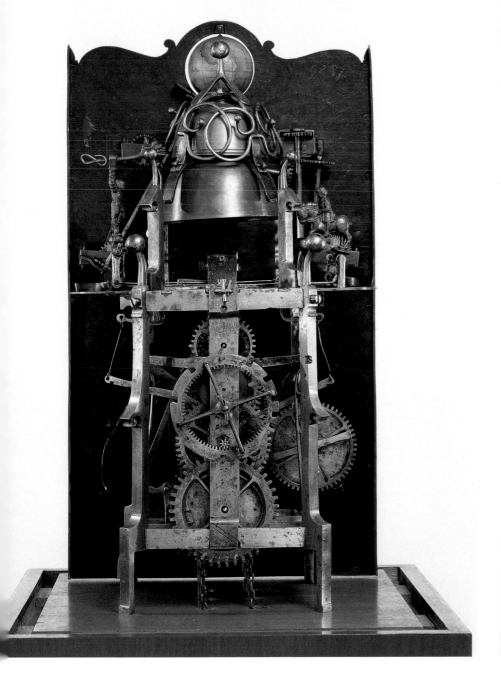

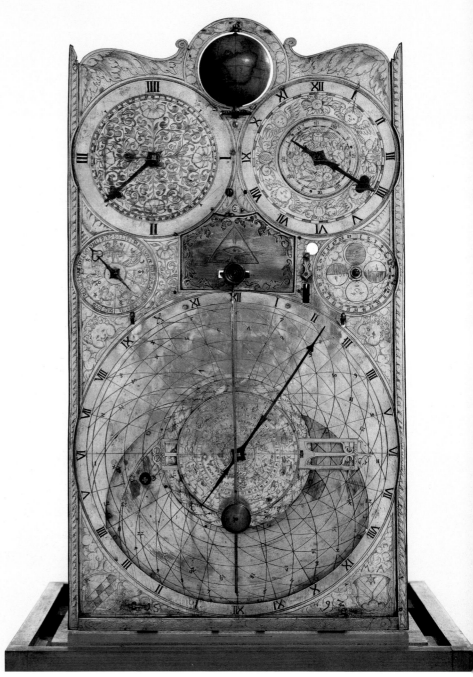

Pharmacology

"We have to learn how to forge bullets which, like the magic bullets in 'The Marksman', only kill pathogens."

Paul Ehrlich (1854–1915),
Pioneer in the field of chemotherapy

Adam and Eve (after Lucas Cranach the Elder) showing the hormonal processes within the human body.

Since the beginnings of mankind, our ancestors tried to find remedies for illnesses or relief for pain. The origins of pharmacology can be traced back to medicinal plants, whereby the alchemist Paracelsus (1493–1541) placed chemistry in the service of medicine. Modern-day scientific chemistry was used in developing medicines by Paul Ehrlich (1854–1915); today medicines are often initially developed for a specific purpose on paper.

Over many decades, following the opening of the new museum building in 1925 on what was then Coal Island, the subject of pharmacology was represented just by the eighteenth-century pharmacy from the monastery of St. Emmeram. Plans to have something on modern pharmaceutical research beside the historical aspects of pharmacology in the Deutsches Museum went back a long way, but it was the Chemistry for Life project by ECSITE (the European museums association) combined with a general intention to redesign the whole section on chemistry at the Museum that prompted action. The eight principal chemistry-related themes of the Chemistry for Life project were to be the seeds of the redesign of the chemistry department. The first— 'You are Chemistry'—became the motto of the pharmacology display.

Thus, central to the display which opened in May 2000 are the biochemical processes of the human body, how they work in healthy and sick organisms and of course the opportunities for influencing these reactions by using chemical substances, that is, drugs. Both spatially and in terms of content, the heart of the display is a walk-in human cell 350,000 times life-size. Other thematic displays, ranging from diseases of the heart, circulation and respiratory tracts through infectious diseases and cancer to painkillers and contraceptives, are arranged around this. This selection is rounded off by Medicinal Plants and Phytopharmacology (with a living herb garden as the central feature) and a display showing the long haul of getting a drug from the research stage to the pharmacy counter. The historical

'You are Chemistry', an unfamiliar, mysterious world awaits the visitor at the end of the tunnel.

Pharmacology

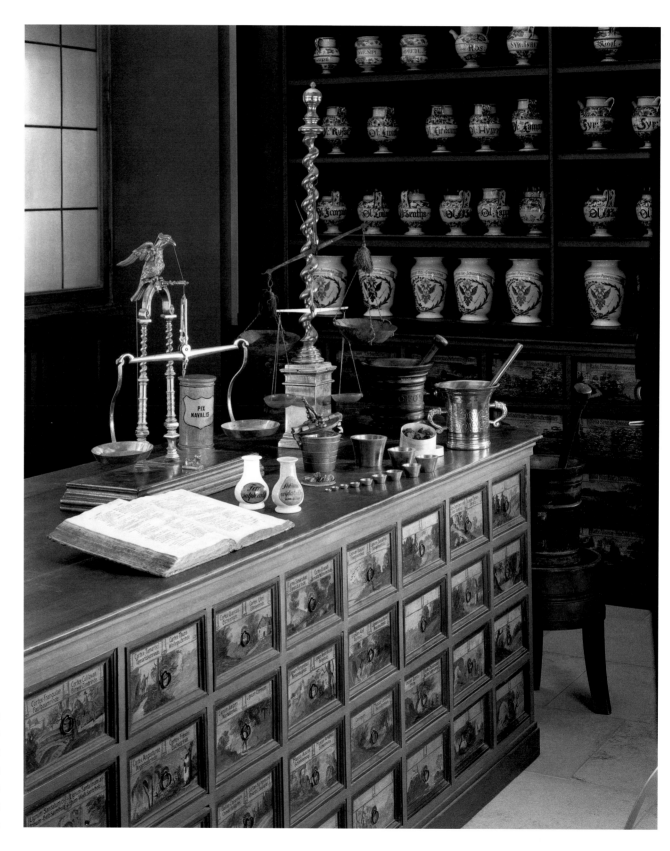

The apothecary's desk in the historical chemist's shop originally in St. Emmeram's monastery: precious vessels and equipment recreate the atmosphere at the end of the eighteenth century.

monastic pharmacy kept its place in the new display. A multi-media system now offers a virtual tour as an alternative to an official guided tour, with much detailed information on pharmacies and their history, apothecaries' vessels and the remedies used in the eighteenth century.

Unlike many other displays at the Deutsches Museum, this one is not based on either history or historical objects but on processes that take place at a molecular level and are therefore normally invisible. With a few exceptions, the display cannot therefore fall back on classic exhibits. Instead, a wide use of media systems and clever designs are relied on. The display area is intentionally kept dark, allowing targeted use of colour and light to create an atmosphere of mystery as the visitor travels into this unknown microworld. Videos, audio stations, games and a total of seven multi-media systems not only make complicated pharmaceutical and chemical subject matter comprehensible to a lay public but also highlight a number of social and cultural aspects.

The pharmacology display is the first time that life sciences have taken over a whole subject area of the Museum. Other activities in a field which has become profoundly important both for research and our everyday lives will follow, particularly within the framework of the Centre for New Technologies. *aw*

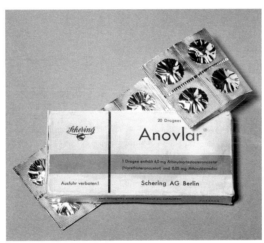

Even though they are not in the limelight, historical objects play an important role in the pharmacology display.

(left) Petrus Andreas Matthiolus' book of herbs from 1554

(above) Salvarsan, Paul Ehrlich's concoction 'No. 606', the first chemotherapeutic substance to prevent infection, *c.* 1910

(centre left) Anovlar, the first 'Anti-baby pill' in Germany, 1963

(left) Pocket spittoon with lid, known as a 'Blue Henry', *c.* 1890

Pharmacology

The non-realistic 'cell forest' installation, showing the variety and multifacetted shapes of cells within the human body. A 'walk-in' cell can be seen in the background.

Design and multi-media play an important role in the pharmacological display. Light installations, original historical and modern objects, spectacular, large format images and demonstrations are just some of the exhibits waiting to be explored.

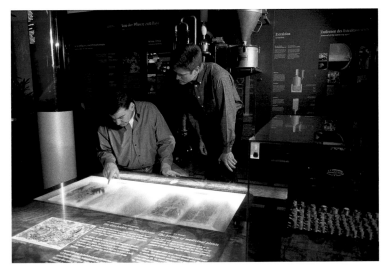

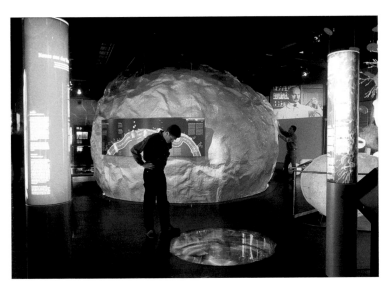

Scientific Chemistry

"Without a knowledge of chemistry, the statesman must remain a stranger to real life in the state and its organic development and perfection. Without it, his gaze will not be sharpened nor his spirit awakened to what is truly useful or harmful to the country and human society."

Justus von Liebig, *Chemical Letters*

Inspired by the great success of a reconstruction of the Liebig laboratory at the World Fair in St Louis in 1904, a replica of Liebig's celebrated teaching laboratory in Giessen (1843) was exhibited in the very first chemistry display at the Deutsches Museum. This reconstruction is still the core exhibit of a section of the display dealing with the history of chemistry.

Scientific Chemistry

When the first chemistry section was opened in the Deutsches Museum in 1906, Germany's chemicals industry was incontestably the world leader. Dyes and drugs made in Germany were highly rated and in demand world wide. The reputation of graduates educated at German universities was second to none. In view of the great economic importance of chemicals, the leading representatives of the German chemicals industry—most notably Carl Duisberg, managing director of the powerful Bayer Werke company in Leverkusen—and a number of distinguished chemistry academics took it upon themselves to champion the creation of a large chemistry section at the Museum. Three well-known chemistry professors, two of them later Nobel prizewinners, drew up a scheme for the planned display. They were Hans Bunte, Wilhelm Ostwald and Walther Nernst.

Of these, the contribution of physicist and chemist Wilhelm Ostwald was particularly important. He was very interested in the history of chemistry, and with his remarkable efforts to popularise knowledge of chemistry had made himself a resounding name not only among fellow experts.

In their efforts to get a general chemical background across to a broad public, the three academics looked to two sources for inspiration: the famous world fairs of the nineteenth century, which had always included chemicals sections (most memorably the Paris exhibition of 1900); and their own teaching experience at the university. The world fair model ensured due regard for flair of presentation, while the university dimension stood for solid educational value and putting across an indispensable body of basic knowledge. Around a third of the display area was devoted to the history of chemistry, a second third to explaining contemporary developments, the last third to facilities enabling visitors to carry out experiments themselves.

Little has changed in principle in the basic concept during the hundred-year history of the chemistry section. A few items have been moved to other departments, or removed altogether. For example, the cultural history of perfumes and cosmetics, which formed part of the first display, is no longer dealt with in the Museum. The 'technical' chemistry display has also been taken out. Conversely, the subjects of glass and pharmaceuticals, once in the chemistry section, have been hived off as separate Museum sections.

Today, the German chemicals industry, which in the early days of the Museum provided tremendous help in setting up an attractive and interesting display, has faltered in its support of the chemicals section. *ev*

Of these, the contribution of physicist and chemist Wilhelm Oswald was particularly important. He was very interested in the history of chemistry, and with his remarkable efforts to popularise knowledge of chemistry had made himself a reputation not only among academics.

View of present display in the chemistry section. On the left are the digestors, protected behind glass from direct handling by the public, with experiments that can be carried out at the push of a button. In the middle is a portrait of the German chemist and Nobel prize-winner Hermann Staudinger, the founder of macro-molecular or high-polymer (synthetics) chemistry. On the right is Staudinger's experiment desk with original instruments.

Scientific Chemistry

One of the most popular push-button experiments deals with luminol's chemiluminescence that glows in the dark as if by magic. Luminescence reactions play an important role in biology, being responsible for the appearance of numerous deep sea creatures and glowworms.

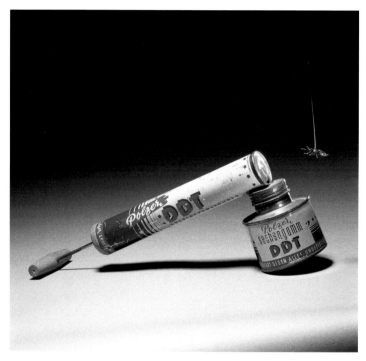

DDT spray
Objects such as this – a 1960s household spray containing the environmentally harmful insecticide DDT – are not masterpieces of chemistry, but are nonetheless eloquent of their day and age. They document the downside of the chemical industry in using environmentally damaging materials in the 1960s and 1970s. This contributed to the emergence of environmental movements and to a general increase in environmental awareness.

View into the chemistry depository: the Museum has been to great lengths to bring together all kinds of different chemicals. These demonstrate the range of industrially produced substances available on the market.

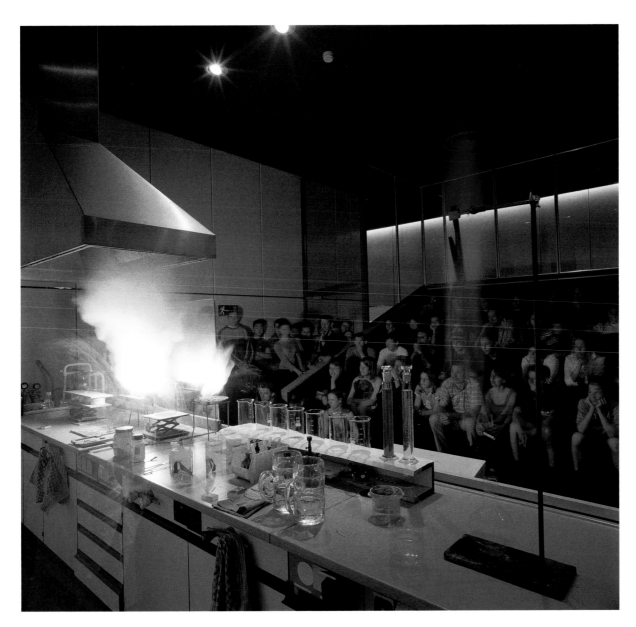

Live experiments are far more satisfactory than any push-button demonstration. A major feature of the present chemistry department is therefore a 100-seat lecture theatre. A 45-minute lecture is put on here every day, during which spectacular chemistry experiments are staged. The idea is to make chemistry entertaining for the audience.

The Evironment

"*Spectant victores ruinam naturæ*"
(*Certain of victory, they watch the destruction of nature*)

Pliny the Elder, 23–79 AD

Environmental problems are as old as humanity. Since humans walked this Earth, they have interfered with nature, whether in the form of the new extraction procedures in mining referred to by Pliny, the massive consumption of wood to make charcoal or salt which turned Lüneburg's oak and birchwoods into Lüneburg Heath, or anthropogenic carbon dioxide emissions that contribute to global warming.

Opened in 1992, this permanent exhibition was the Deutsches Museum's first attempt at a display about the environment. It was seen as contributing to the controversial and often very emotional discussion about the environment by offering a broad public scientific facts and a balanced viewpoint. The focus of this topic-oriented display is not so much objects as information conveyed in text, image and diagrams. A wide range of topics is covered. Population growth is addressed, as is ozone smog or the use of regenerative energies. The display outlines the basic causes of environmental problems and shows possible ways of eliminating them and, above all, avoiding environmental damage.

Environmental subjects are short-lived—the statistical background is constantly changing, like the statutory framework at home and internationally, and changes in scientific, technical and socio-political views are constantly altering the importance and evaluation of environmental problems. For this reason, the display was revised and updated after only five years and reopened in 1998 in new rooms. *sg*

Speicherung in der Atmosphäre 12,5 ± 1,8 Gt CO₂/Jahr
accumulation in the atmosphere
CO₂-Anstieg: 0,4 %/Jahr
increase of CO₂: 0.4 %/year

Photosynthese:
220 Gt CO₂/Jahr
photosynthesis

Speicherung durch
Landlebewesen:
7,0 ± 5,9 Gt CO₂/Jahr
*accumulation by
terrestrial organisms*

Atmung, Zersetzung durch
Microorganismen:
220 Gt CO₂/Jahr
*respiration, degradation
by microorganisms*

Rodung der Wälder
5,9 ± 3,7 Gt CO₂/Jahr
felling of forests

Verbrennung fossiler
Brennstoffe
220 Gt CO₂/Jahr
burning of fossil fuels

Austausch zwischen
Atmosphäre und Meer
330 Gt CO₂/Jahr
*exchange between
atmosphere and oceans*

Speicherung
im Ozean
7,3 ± 3,0
Gt CO₂/Jahr
*accumulation
in the oceans*

Population growth, the consumption of energy and raw materials and the generation of waste are the main causes of ecological damage.

Current environmental problems—air pollution, ozone smog, the destruction of the ozone layer in the stratosphere and global warming—take place mainly in the atmosphere.

MATERIALS AND PRODUCTION

The use of tools and materials ensured mankind's survival right from the earliest times. To obtain them, man had to dig into the depths of the Earth's crust and in more recent times the depths of the ocean as well.

Coal and ore, metals, pottery and glass, oil and natural gas—understanding the secrets of nature was inevitably followed by their exploitation, in order to ensure human survival. For the greater part of the history of human development, the use people made of them was limited to air, water and food. From the Stone Age on, man also sought to access hidden substances—extracting iron ore and coal by mining. Since then, he has successfully worked to change the characteristics of naturally occurring substances for his own ends. Smelting metals goes back at least 6,000 years, making pottery more than 10,000 years. Glass was first made 3,000 years ago, while blown glass only dates from around 200 BC. Finally, oil and natural gas have been used industrially since the nineteenth century, once the technology in other fields was sufficiently advanced to make such inventions as the internal combustion engine possible.

Manufacturing is thus always applied science. As raw materials found in nature are only minimally suited to satisfy man's needs directly, they have to be processed in different ways. This principle applies as much to corn, which has to be ground before it can be used in the baking of bread, as to iron ore, which has to undergo a whole series of processes before it can finally be turned into a gutter or a ship.

Development has been a protracted story. Rudimentary tools to make hunting and fishing easier were in use over 500,000 years ago. Revolutionary advances were the use of fire around 100,000 years ago and tilling the soil about 10,000 years ago. The changeover from purely manual labour to automation is shown in two types of production—textiles and agricultural technology being the production industries with the longest traditions. The machine department shows the history of machine tools and advances in metalworking.

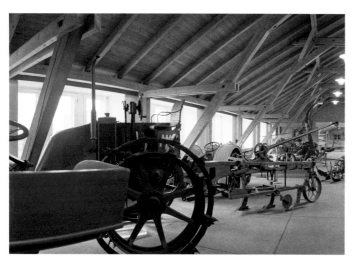

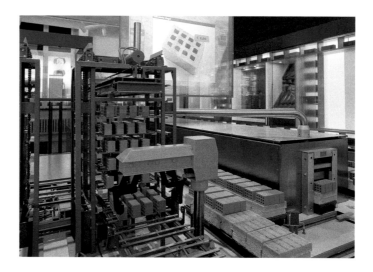

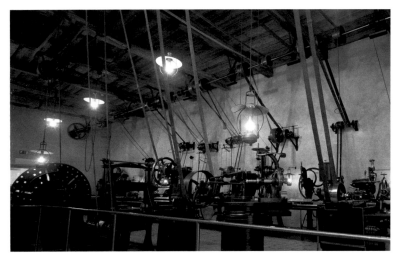

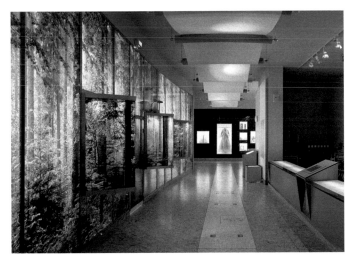

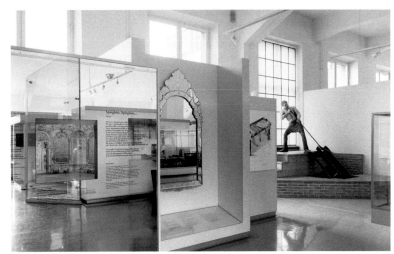

Agriculture and Food Technology

"With a few exceptions, there is a degree of homogeneity in the way the main implements now used in agriculture developed. A new idea crops up almost simultaneously in several places, and looks for a shape and a design. Experiments, public enthusiasm, false starts and real successes follow over a number of years, until gradually one shape after another disappears as the right instrument evolves and with minor variations rules the land."

Max von Eyth, 1893

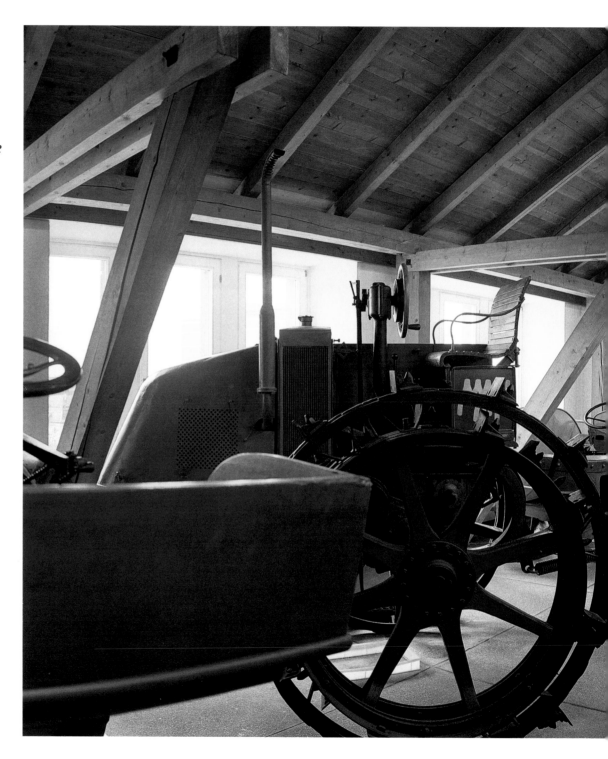

View of the agriculture technology display:
(left) motorised plough from MAN, 1919;
(right) machinery transporters from Fendt, 1961;
(in the background) a Columbus von Claas combine harvester, 1961.

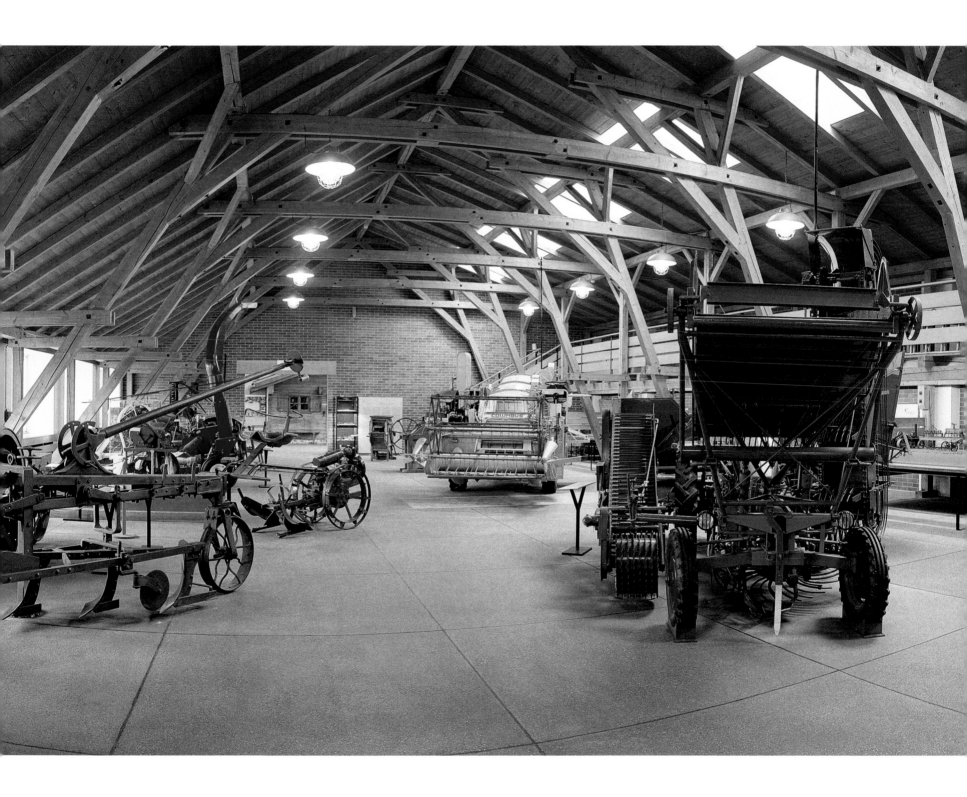

Agriculture and Food Technology

Agriculture comprises arable and livestock farming for the purpose of generating food and raw materials. Food technology includes ancillary activities associated with agriculture such as dairy product-based food production, grain-milling, brewing, distilling and sugar production.

According to recent archaeological finds in the Nile valley, the first steps towards agriculture—systematic arable farming—were made in the Old Stone Age (16,000 BC), when man (the hunter/gatherer) turned to arable farming, that is, moved from an appropriative to a regenerative way of life. Livestock farming on the other hand, as still practised by nomadic peoples, is much older.

The changeover to mechanised farming and automation has thrown up a wholly new branch of technology, principally eliminating the use of manual labour and livestock for heavy work in farming, forestry and horticulture. Not only does this help those who work the land—by increasing food production it also provides sustenance for the whole community.

Globally, half of the world's families are still dependent on agriculture for a living. In 2000, the global population was more than six billion, of whom two billion went hungry. Agriculture still has a long way to go.

The pre-war display on agriculture was destroyed during World War II, and a replacement was not completed until a reduced 1,230-square-metre display finally opened on 7 May 1962. By then, there were additional aspects of the subject to cover, and as the new display focused on the technical side, it was called 'Landtechnik' (agricultural technology). In 1992, a distinction was made between 'Agrartechnik' (to do with arable farming) and food technology, to cover ancillary activities.

The first hall is devoted to farming, in a display area made up as a barn, subdivided into indoor and outdoor activities. The latter narrates mainly the 6,000-year development of arable farming from dibblers to tractor operation.

The neighbouring rooms deal with food production, with displays on the dairy industry, grain-milling, brewing, distilling and sugar production incorporating significant original items and models. *fh*

The 'Schlagalm' shepherd's hut from Valepp, 1830. The hut was owned by the mountain farmers from the Scherer in Gmund area near Lake Tegern; the furnishing and equipment for making cheese and butter come from the 'Stiftungen der Milchgenossenschaft Auffach, Wildschönau', Tirol.

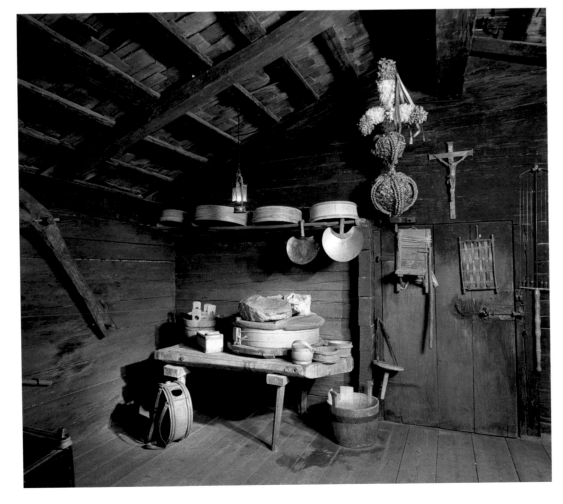

The old 'Spaten' brewery, 1812. This model shows the 'Spaethbräu' premises in the Neuhausergasse, Munich which was acquired and revamped by Gabriel Sedlmayer.

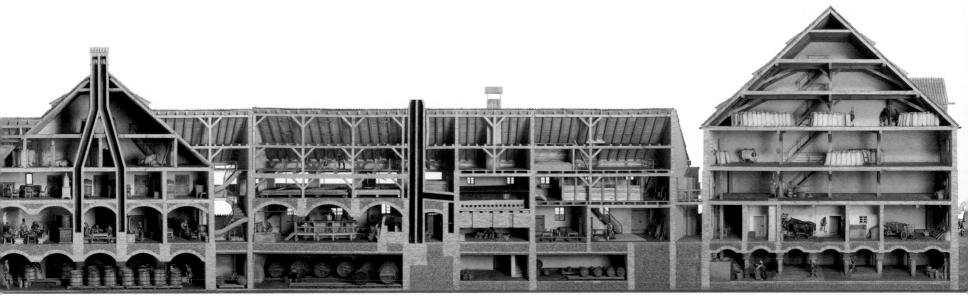

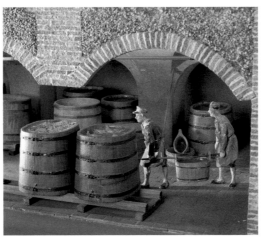

The different stages in the brewing process. The close-ups of the model show the steep, fermentation, cooler (addition of yeast), drying kiln and transport processes (*from top left to bottom right*).

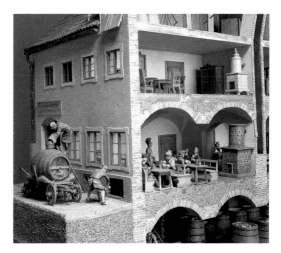

Textiles

"He found fencing extraordinarily difficult, in fact totally impossible, because over his black Sunday best—his only suit—he wore a broad, dark grey cycling cape lined with black silk, as it lent the wearer a noble and romantic air … Posing had become a need, without him having any malevolent or deceitful intent thereby. In fact, he was content to be left in peace to get on with his work. But he would rather have gone hungry than parted with his cycling cape and Polish fur cap."

Gottfried Keller, *Kleider Machen Leute* (Clothes Maketh Man, 1883)

The exhibition ranges from Stone-Age textiles to state-of-the-art computer-programmed machines.

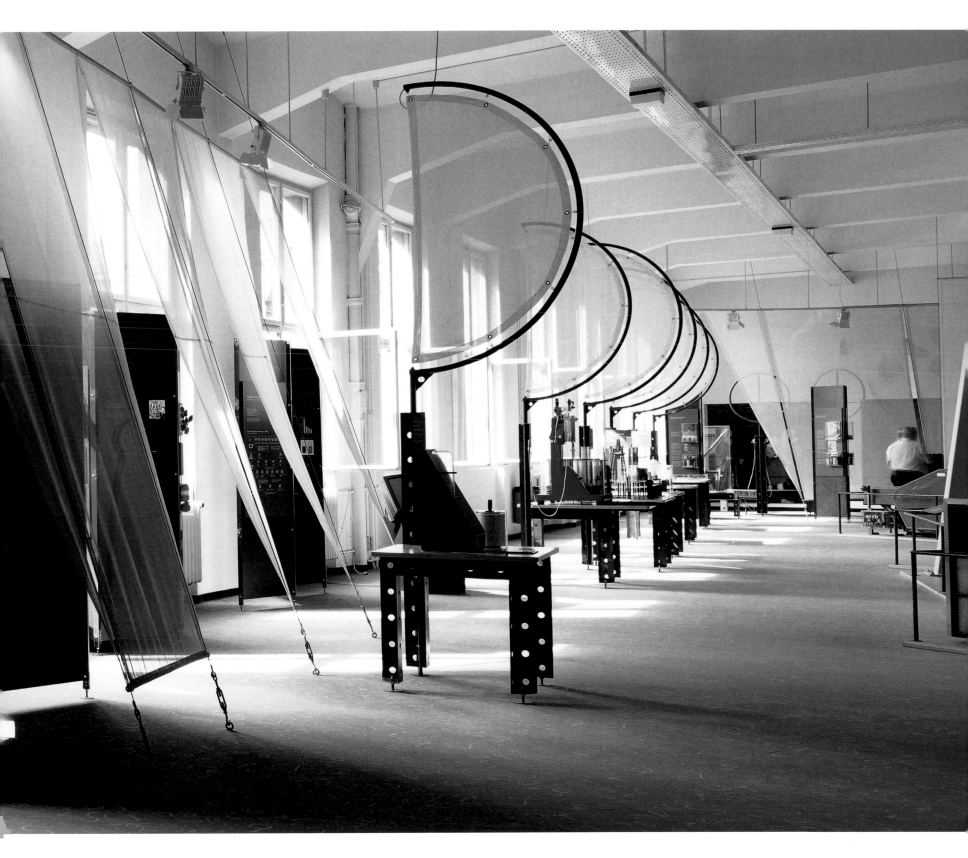

Textiles

Clothing not only provides protection from climate and weather but from the earliest times has also been an ornament and a mark of social order. Working clothing, for example, is adapted to the requirements of particular jobs, so that wearers are immediately recognisable for what they do. The eighteenth and nineteenth centuries saw the change from manual labour to industrial production as mechanisation progressed and the division of labour became the norm. With the historical recreations of cloth-making, the textiles department of the Deutsches Museum covers the whole gamut from Stone Age cloth-making, through the mills of the eighteenth century to the 'textile revolution', taking in both the first manufactories and the latest computer-controlled machines. Five recreations show the most important advances along the way.

Spinning and weaving are the oldest and best-known cloth-making techniques, and they still account for 40% of production, not including the clothing industry. Together with hand knitting, machine-knits and finished (dyed or processed) cloths, these two techniques cover 95% of the global demand for textiles.

How is denim made? Visitors investigate the manufacture of an everyday product.

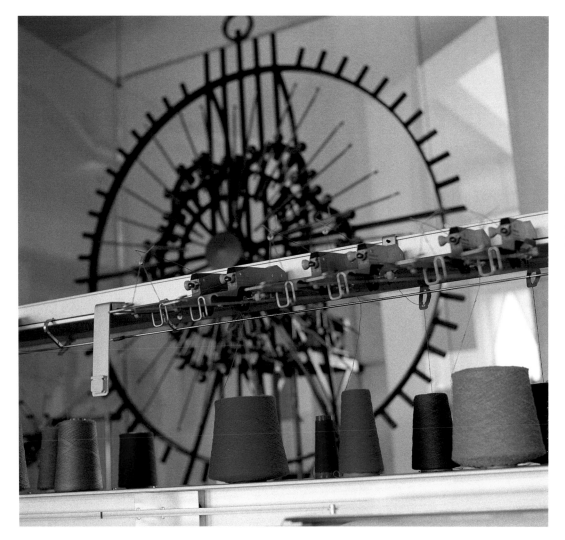

The Selectanit computer-controlled flat knitting machine of 1993 knits not only all shapes of a pullover but also neck edgings, button holes etc.

Weaving and knitting are not the only ways of producing fabrics. Bonded fabrics are made with individual fibres evenly arranged to make a loose layer called a fleece. This layer is then strengthened by various processes to make a finished fabric that can be used for a wide range of products.

Altamira Cave

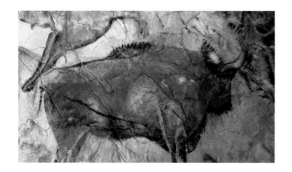

One of the upright bisons, looking amazingly realistic thanks to the way polychrome shades of ochre red and black were used. The dignified and mighty appearance of the creature impresses even 21ˢᵗ-century onlookers.

The Deutsches Museum's recreation of the celebrated paintings in the Altamira cave in Spain was begun in the 1950s and opened in 1962. The original pictures are some 15,000 years old, and were painted during the first phase of the Stone Age. They are among the finest and most impressive relics of early human history.

But that is not the only reason why Altamira occupies a special place in Stone-Age painting. It is also notable in that its cave paintings were the first to be recognised as such. When they were discovered in 1879, their great antiquity was disputed by many. People found it hard to believe that early man was capable of such achievements. It took over two decades, until 1902, for the genuineness of the paintings to be generally accepted. Even today, they are simply amazing.

The reproduction on show at the Deutsches Museum is the first recreation to faithfully follow the design and materials of any Stone-Age cave paintings anywhere. Its making involved a very complex process, as the original painted surfaces could not be touched. In this respect, it counts as a major pioneering achievement by the Museum, the process later being taken up by other museums. Since the 1970s, the most famous caves in Spain and France have had to be closed in order to protect their paintings from the dangers of excessive exposure to a growing public. The availability of copies is thus the best solution to cater to public interest while preserving the millennia-old paintings.

In 1995, the Altamira cave display at the Deutsches Museum was revamped. The new presentation makes the differences between copies and originals clearer while generating as much cave-like atmosphere as possible. As you pass through the entrance chamber, which protects the space from daylight, cold air and the sound of dripping water are a reminder of the cool, damp cave ambience that enabled the ancient paintings to survive to the present day. As your eyes adjust to the darkness and the paintings become clearer in the normally air-conditioned but greatly darkened Altamira room, the vitality of the animal images leaps out at you. *mbz*

The photogrammetric measurement of the cave ceiling paintings was the first step in a complex process of reproducing the paintings without touching them.

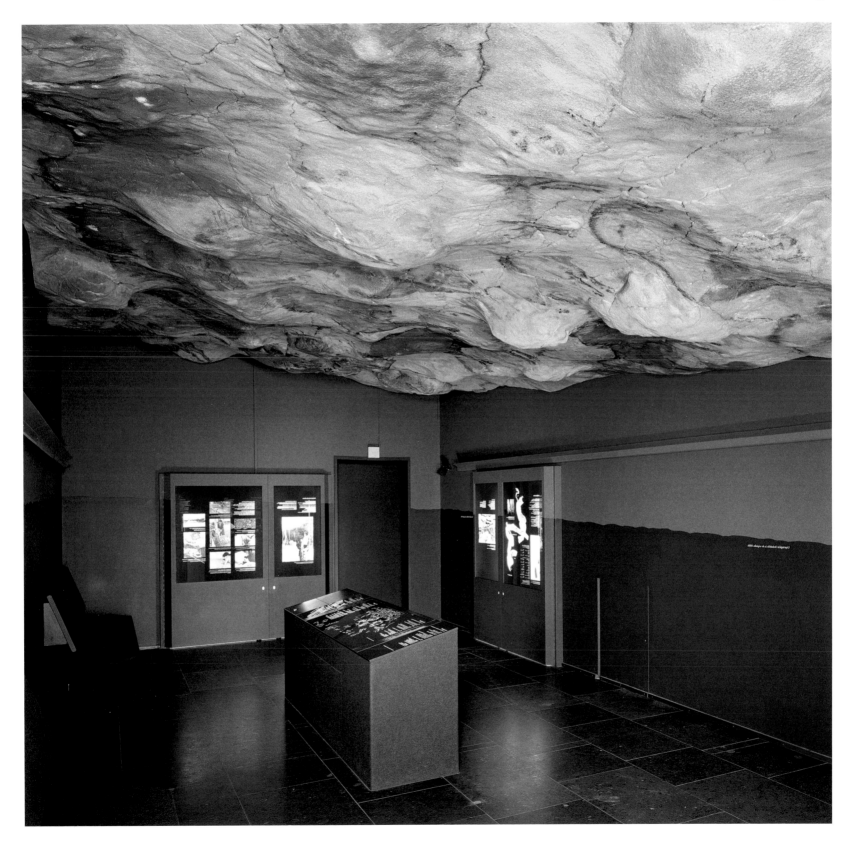

The Museum's Altamira Room, with its reproduction of the richest section of the original cave ceiling paintings.

Mining

"Down below there's a confused rustling and humming, and you keep bumping into beams and ropes that move ... Now and then you reach hewn-out passages called galleries where you see the ore growing and where the solitary miner sits all day arduously chipping pieces of ore from the wall with his hammer. Between ourselves, the level I got to seemed already quite deep enough. A constant roaring and whistling, eerie noises of machines moving, ... smokily rising vapours and the pit light flickering ever more palely in the solitary night. It was really overpowering."

Heinrich Heine, *A Journey in the Harz Mountains,* 1924

Mining is arduous work. Out of sight during daylight, miners inhabit a mysterious underground world that has excited interest for centuries. To an outsider like nineteenth-century poet and journalist Heinrich Heine, who had a chance to visit this subterranean world, there was much that appeared disconcerting, incomprehensible, almost eerie. The search for and extraction of raw materials was and is dangerous, but also calls for intrepidity, stamina and inventiveness on the part of mining operators, whether in a technical or scientific, business or even social context. It took generations of expertise to arrive at today's modern, highly mechanised mining industry, adjusting to constantly changing economic requirements in the various mining regions of the world. The mining display in the Museum focuses on three aspects:

1. Mining, with shaft-building and extraction techniques;
2. A display with full-scale reconstructions of mines for extracting ore, salt or coal;
3. A display of mining machinery with the associated dressing techniques.

This triple division from the opening year of 1925 has survived to this day, with some changes. During World War II, the mining display fortunately escaped with only minor damage, and reopened to the public on 7 May 1949. However, in 1953, a display featuring a bituminous coal mine in Upper Bavaria suffered considerable damage as a result of fire.

Continued on page 156.

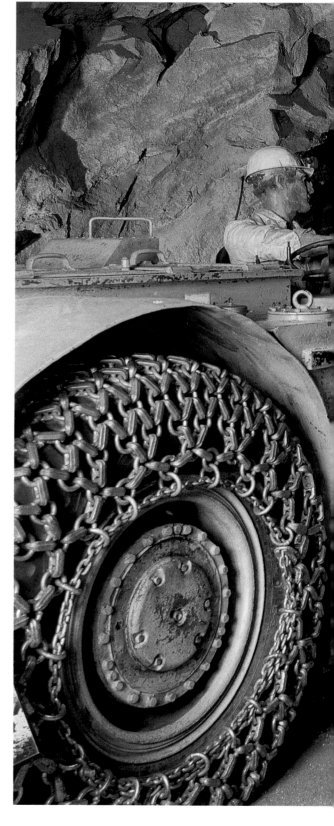

Diesel-powered loading shovel of 1972, which remained in service at Haverlahwiese ore mine until 1982.

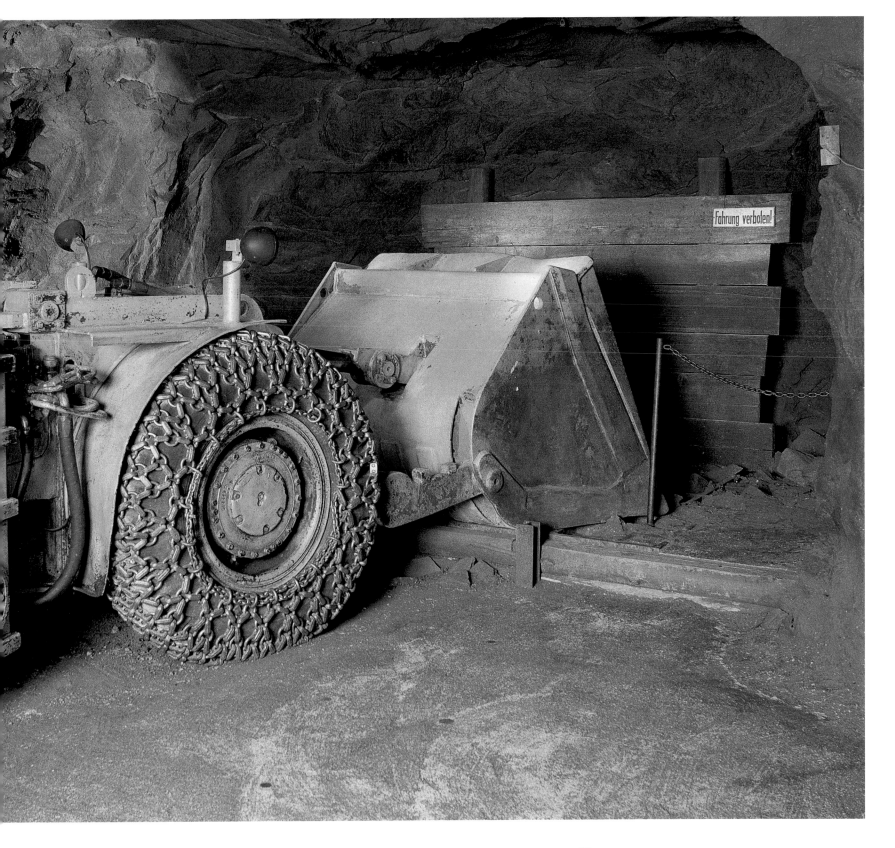

Mining

The reverse of a silver medaillon issued by Duke Ernst-August (1679–98). In the middle it shows a mine, on the right a dressing plant and on the left an ironworks. The cornucopias on the trunk of the two firs pour forth the fruits of their labours—minerals and coins. The scene illustrates the wealth created by mining in the Harz Mountains.

A sixteenth-century miner working with hammer and iron in a narrow gallery.

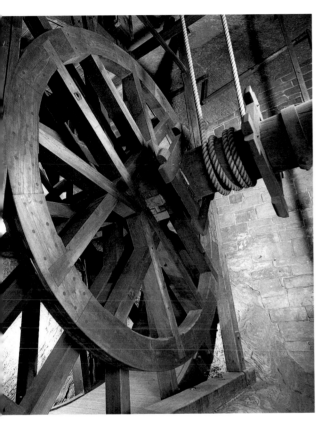

View of the mouth of a shaft. Here a miner is emptying a mining barrel into a waiting wagon. The tableau was created using original parts from the Rammelsberg ore mine near Goslar.

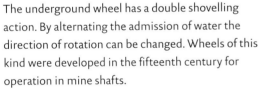

The underground wheel has a double shovelling action. By alternating the admission of water the direction of rotation can be changed. Wheels of this kind were developed in the fifteenth century for operation in mine shafts.

Until the nineteenth century, the prayer room at the entrance to the mine was where miners waited before and after shifts.

Mining

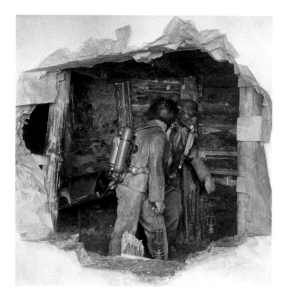

Rescue team in action in a model of an old mine.

When reconstruction got under way, the coal-mining section was greatly expanded to cover contemporary mining techniques. The new display opened on 7 May 1955. Thirty-two years later came a new, modern coal mine and, the following year, modern iron ore mining.

Right from the first, the principal aim of the mining department was to give visitors a memorable view of mining, and this concept held good throughout later rebuilding and expansion work. Planners, craftsmen and artists worked under the guidance of mining experts to create a genuine mining ambience. Galleries, shafts, seams and veins—partly fitted out with real ore and coal—were created in faithful detail. The display shows modern operational and historic machinery, impressive models and milestones in technical development in mining. *kf*

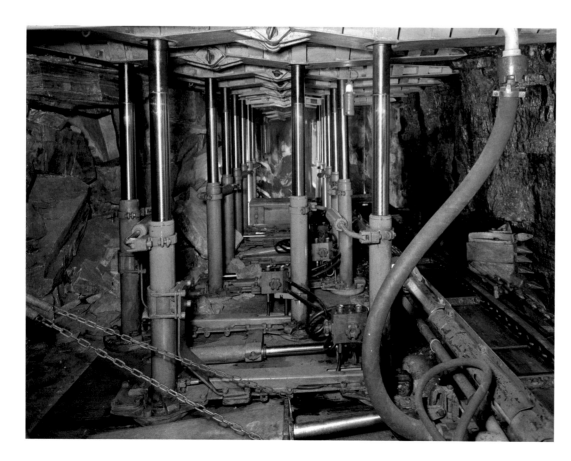

Coal mining from the 1950s, with a coalface cutter ripping at the exposed coal. A double chain-conveyor transports it to a conveyor belt.

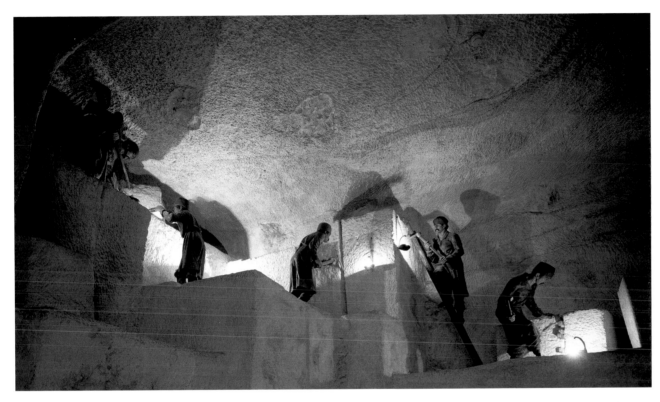

Reconstruction of rock salt being extracted in the famous Wieliczka salt mine in Poland.

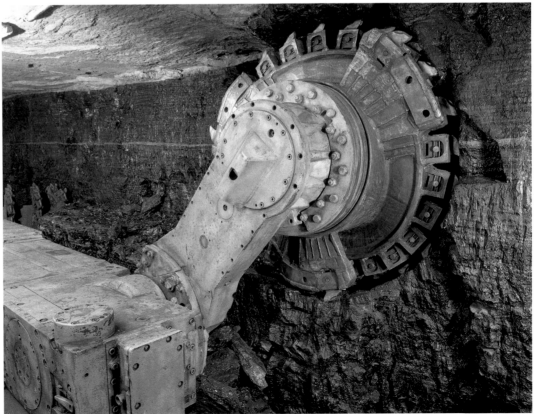

A roller cutting compressor in a modern colliery. It cuts the coal out of the exposed seam. Beneath it is a chain belt carrying the coal extracted to a loading point.

Mining

Pit bottom of a shaft, modelled on the 720m
(2,350') deep Klenze pit in Hausham Colliery, Upper
Bavaria. An electrically powered loading installation
pushes the loaded wagons into the conveyor cage.

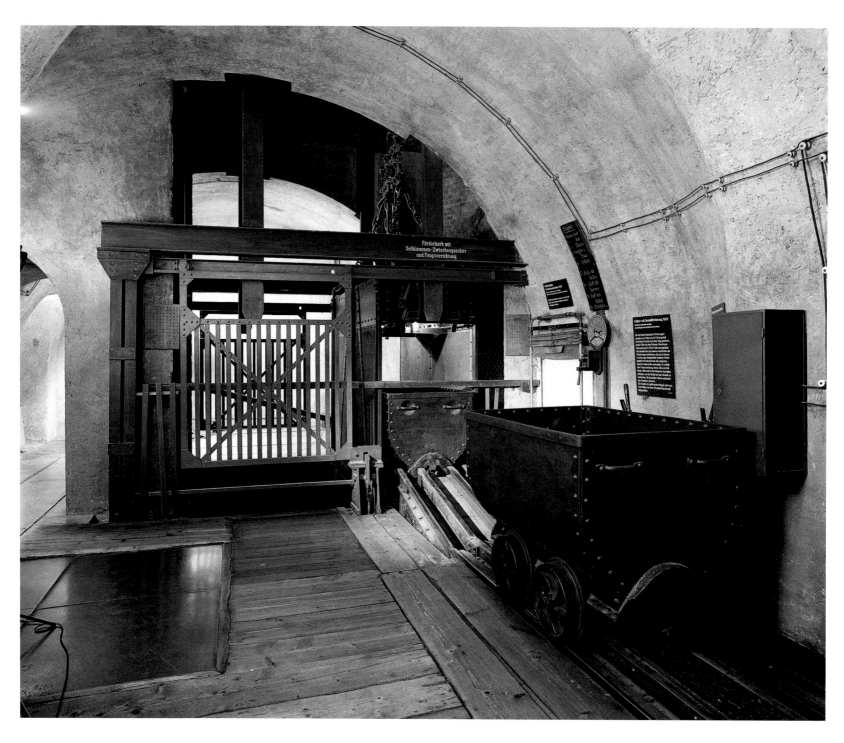

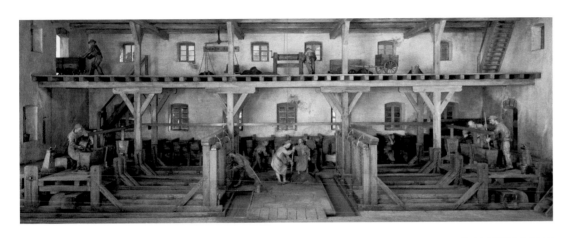

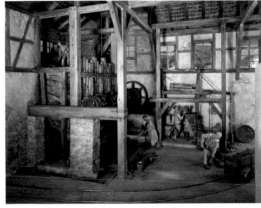

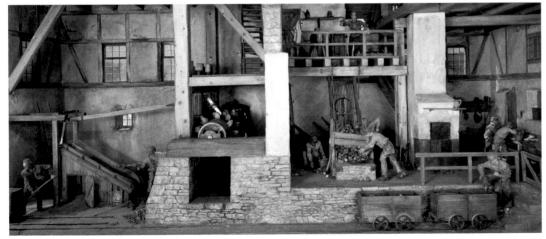

Model of a dressing plant, made in the workshop of Freiberg model-maker Richard Braun. The model-making workshop produced the demonstration model for the mining academy in Freiberg.

Metals

"Eras were always named after metals. In Antiquity, people spoke of a golden age, a silver age and an iron age. In the modern age, we distinguish between the Stone Age, the Bronze Age and the Iron Age."

Karl Aloys Schenzinger, *Metals,* 1939

Tapping a blast furnace in Siegerland (model).

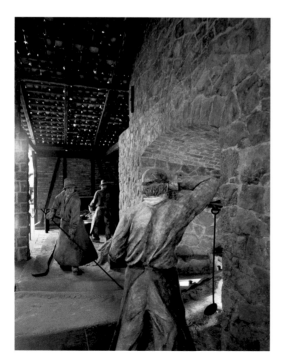

Man has been using metals for about 10,000 years. At first, it involved only naturally pure metals found lying around on earth's surface. The pieces of metal drew attention to themselves by their weight, their shininess and their malleability. By 6,000 years ago at the latest, metals were being made from their compounds, ores. Since then, metals have become an important factor of human life, and are now indispensable in many walks of life due to their special characteristics as materials.

The metals display, which began life in 1925 as 'the iron and steel industry', was completely re-organised and updated in 1995. It now presents a view of the technology of metallurgy from the earliest times to the present day. Initially this means singling out highlights of the history of metals from the early days via the Renaissance to industrialisation.

Iron and steel still form a focal point of the display, which is chronologically arranged. The beginning of the history of iron and steel-making and processing is represented by the Siegerland blast furnace with its charcoal hearth and scythe forge.

Technical changes during industrialisation lead to modern methods of extraction and processing.

Non-ferrous metals are treated separately. There are displays about the extraction of copper, lead, zinc and aluminium and refractory metals such as tungsten, tantalum or niobium. Metallurgical processes such as blast furnaces, puddling furnaces, converters and electrolysis are explained in detail. Extracting refractory metals requires special techniques, as these cannot be produced in traditional smelting furnaces. The objects displayed and demonstration models show both extraction and further processing by conversion.

Powder metallurgy and its technology for manufacturing complex-shaped construction components from metal powders are illustrated by means of a powder press and a model of a sintering furnace.

Finally, the subject of finishing and coating links the iron and steel and non-ferrous sections again with a section showing a zinc-coating belt system.

The final part of the Metals section of the exhibition, following the subheadings Extraction, Reshaping and Casting, is foundry technology with a demonstration foundry. *kf*

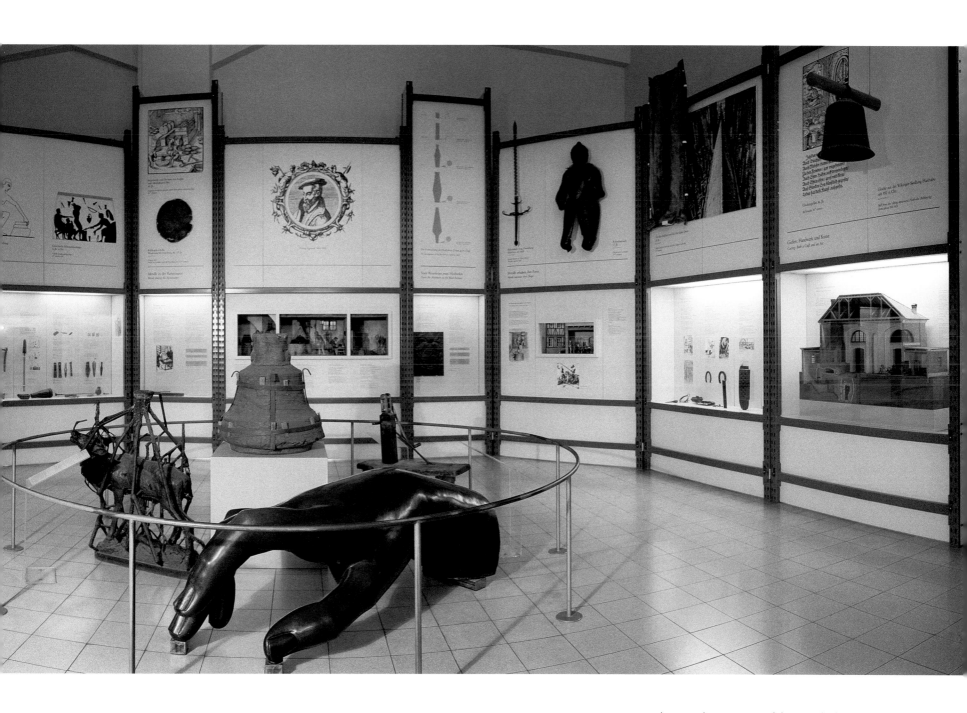

The introductory area of the metals display
provides a panorama of the development of
extractive metallurgy and its subsequent
processing from the beginnings to around 1800.

Metals

The original of a small continuous-casting machine illustrates modern steel processing. Liquid steel is turned into an interim product ready for further processing, for example, by rolling.

The rolling mill area.

In the area leading to the foundry department, the metals department has a display explaining various conversion processes. Front left are models illustrating the processing of metals by forging and pressing.

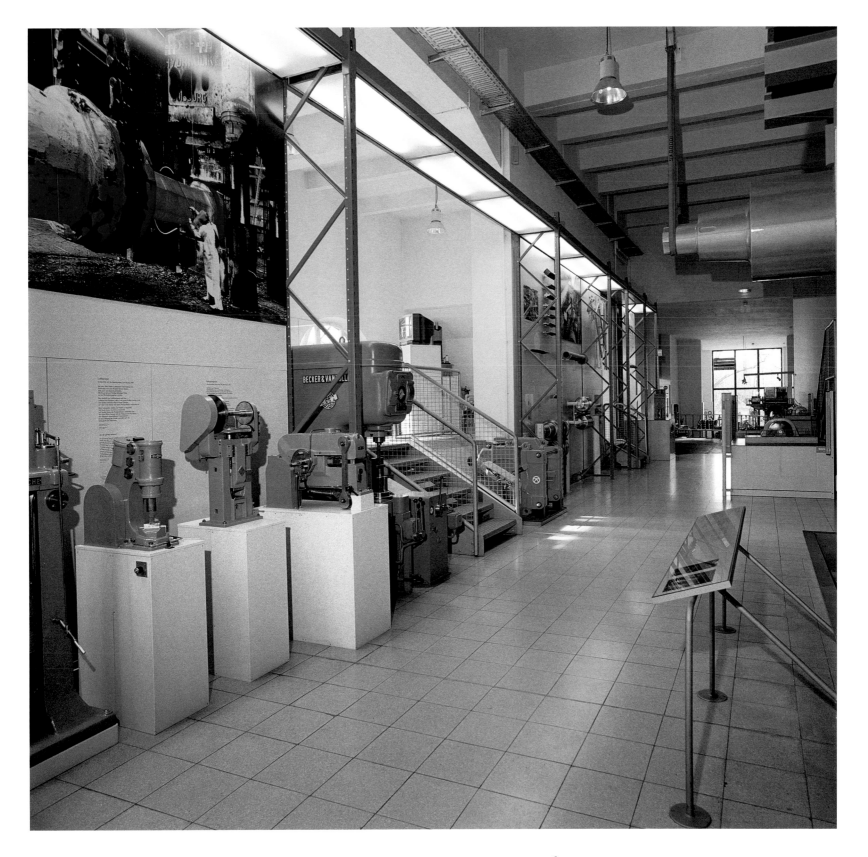

Machine Tools

"A hand, unburdened by memories, is always able to discover the benefits of tools for a second time—tools that do not age, but instead keep a hand moving in time."

René Char (1907–1988)

A model of a wheel-driven lathe. An apprentice would have had to keep the wheel in motion which, in turn, rotated the piece being worked on by his master who was able to concentrate solely on his work. Turning the wheel mechansim required strength, care and considerable experience.

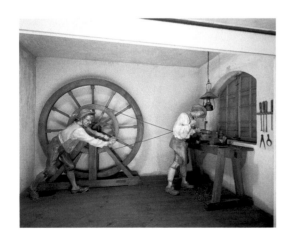

The early days of machine tool technology: this room shows a 19th-century machine workshop. The most notable feature is the transmission drive which is connected to all lathes, drilling, planing and moulding machines via belts and other devices.

The manufacture of machine tools has always been a key technology. From the Stone-Age fiddle bow to today's computer-controlled laser technology, machine tools have made a decisive contribution to the history of technology.

After the drastic advances of the nineteenth century, machine tools continued to develop steadily in the first half of the twentieth century. We are now on the threshold of a new phase of revolutionary change. Manufacturing process in tomorrow's factories, from the receipt of orders to quality control and dispatch, will be completely governed and monitored by a network of computer systems.

The first exhibits for the machine-tool display were acquired in 1909 and went on display in 1925 with various other machines in the construction department on the ground floor. In 1955, separate display rooms were first created, and were opened by no less a personage than the Federal President Theodor Heuss.

When computer-controlled machine tools came on the market in the 1980s that could work on an item from several sides at once, without resetting, and production systems were developed that brought together hitherto separate processes such as drilling, milling, grinding and welding, it was time to think of redesigning the 600-square-metre display. Following some rebuilding work, three newly furnished display areas were fitted out with help from the Machine Tool Manufacturers Association and opened to the public in 1991 with contemporary and up-to-date machinery. *ka*

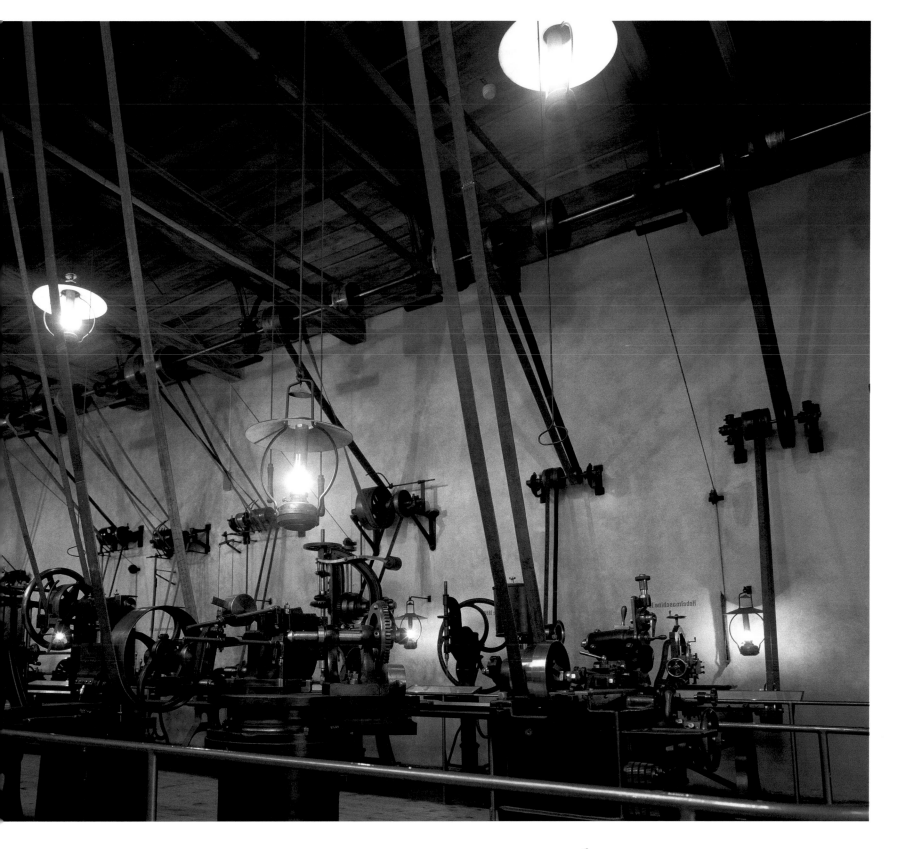

Machine Tools

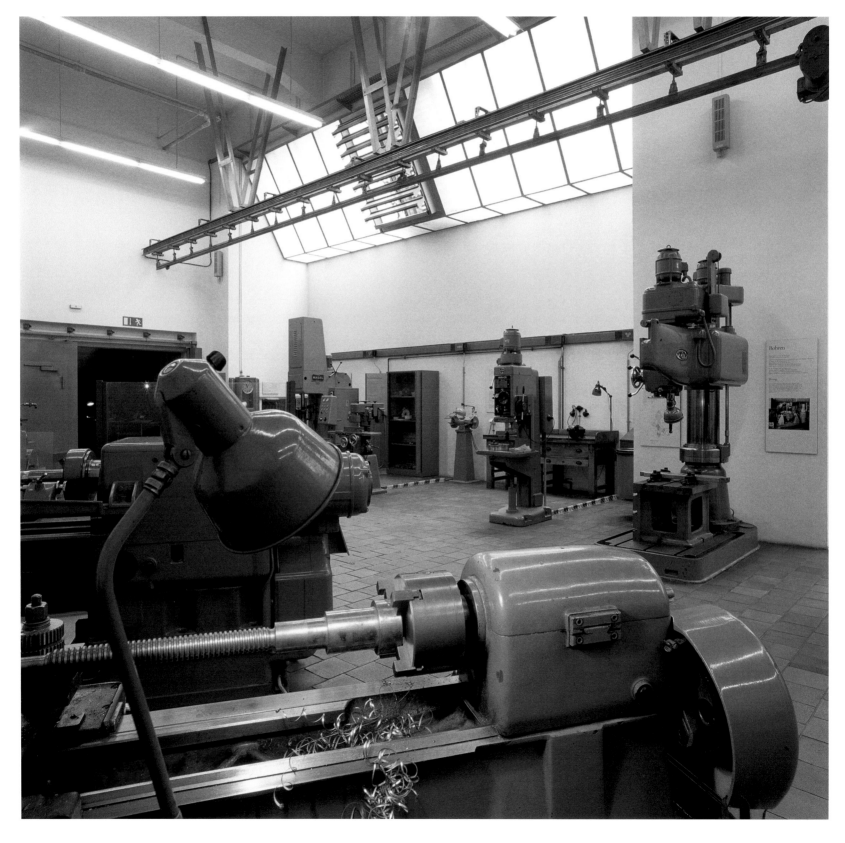

This room takes us back into a typical workshop from the early 1950s and '60s. Strip lighting guarantees a better overall light; operational safety has been improved by encasing the gear systems; more space has been created for the machine operators; a suspended crane facilitates the transport of materials and parts.

The focus of these halls is on a group of machines used in manufacturing including milling machines, lathes, grinding and erosion machines, a laser processing machine for metallic and non-metallic materials and a fully functioning model of a computer-integrated factory. This follows the fully-automatic manufacturing process of a machine part in a 'factory of tomorrow', from the time an order is placed through to the finished product. A video film and five monitors displaying graphics and animated sequences provide supplementary information to complement the model.

Ceramics

Stone on stone, stone on stone
The little house is soon our own.

(Old German children's song)

Ceramic products play an important role in the realm of food and drink. (below) A wine pitcher, a so-called Bartmann jug.

Roof tiles, bricks, crockery, vases, catalysers, abrasive discs, spark plugs—all made from ceramics in the name of a comfortable life. As soon as mankind switched to living off grain and preparing it by cooking and baking it, the need arose for utensils to drink from, eat off, and store and transport both dry foods and fluids.

Potters' wheels—in use since about 3,500 BC—improved both the speed of production and quality of ceramic products immensely. A first high point was reached in vessel ceramics in Greece with Attic ware, black and red figure painting on vases. Later, other types of ceramics made an appearance—wall and floor tiles, glazed tiles and decorated and glazed earthenware, crockery and everyday articles made of china or white and grey stoneware, appliances and containers for the chemical industry and stoneware drainpipes. The best-quality ceramics are made of porcelain, a material known since the Tang dynasty (from 618) in China, but not manufactured in Europe until Johann Friedrich Böttger's heroic endeavours in Saxony from 1708. Costly china, vases and figures became staple items at every German princely court.

Porcelain was also the first base material for technical ceramics, particularly insulators of various sizes. Soon other chemical compounds were discovered, notably aluminium oxide, to produce spark plugs, condensers, rectifiers, semi-conductors, engines, abrasive discs and catalysers.

Fired bricks—a typical ceramics product used in building—first appeared in Mesopotamia and India, but brick buildings (including roof tiles) really flourished only in imperial Rome from the second century AD. After centuries of decline, brick-built structures made a reappearance in northern European brick Gothic—brick as a building material influenced both the technology and design of impressive ecclesiastical and civil buildings. All important German roof tile styles until the nineteenth century were medieval in origin, including crown tiles, convex and concave tiles and Flemish pantiles. The most popular were crown tiles. Historicist styles of the post-Franco-Prussian War period (1871–95) generated whole series of decorative tile and brick products and sculptures. The architectural style of the period was dominated by their use in villas (for example, interlocking roof tiles), on towers and spires and for roof decoration and special purposes (see the 'Ziegel Live' display). *gk*

Visitors can see for themselves how bricks are
shaped, dried and fired—and then buy one too.
The brand new multimedia projection system
illustrates the processes involved.

Glass

"Glass, glass, what is that?
It is and yet it isn't;
It is light and yet it is not light;
It is air and it is not air;
It is scentless air.
And somehow it is hard,
An unseen hard presence
To a captive bird
Which does not see it
And yet is drawn into the wider
World beyond."

Gerhard Hauptmann

View of the glass display which was opened
in 1928 as part of the building materials exhibit.
Glass bricks make up the floor and a mosaic
decorates the ceiling.

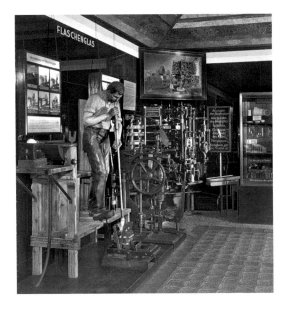

Glass is one of the oldest man-made materials. It
is made of sand, soda or potash and lime lique-
fied at high temperature (700°C to 1400°C).
Softened to a paste or glutinous fluid, the
molten glass is malleable and becomes rigid—
and more or less transparent—as it cools down.

The earliest objects made of it are luxury
objects or glass pearls produced about 6,000
years ago in Mesopotamia, or—as in ancient
Egypt—precious stone-type grave goods and
ornaments and small rolled hollow vessels for
valuable fluids such as perfume. None of these
are transparent. The most important advance in
the history of glass was documented by a still
unparalleled key find of a blowpipe dating from
around 200 BC—Roman times—probably from
the province of what today is Syria. This pipe, a
long tube, allows glass to be blown into a ball
and then shaped into different kinds of vessels.
The process depended on the fire reaching a
temperature at which the molten glass was fluid
enough to be blown and become transparent.

Glass was long a luxury, and still is for articles
with any presumption to artistic merit. However,
over the twentieth century, it became chiefly a
material of mass consumption in items of every-
day use. Many uses are so basic we don't even
notice them. In the case of windows, our gaze
literally passes through the glass, and the better
it is made, the less we notice it.

The changes in the importance of glass up to
its modern everyday use can be traced in the
exhibitions that the Deutsches Museum has
devoted to the material over its history. In the
first provisional display of 1906, glass was
included among painting techniques, in the

View of the glass sheets and panes section
of the present display. This follows the different
steps in the development of glass for windows,
from hand-made panes to mass production;
it also explains how mirrors are made.

Glass

form of stained glass, that is to say it was mainly a material of artistic interest. Three years later, however, in the room created for building materials, glass was represented alongside wood, stone and ceramics. In the second display (from 1928) in the present museum building on the Museum Island, the focus had shifted altogether. Glass was now classed only as a building material, though occupying a room of its own. This was a reflection of the particular importance of glass as a modern construction material during the Bauhaus period in the 1920s, though it was important not only for architecture but also for the motor trade. In 1959, following reconstruction after World War II, glass was lumped together with chemical technology in a wider context. However, it now had several rooms of its own and formed a separate department. These were subdivided rather academically as history, technology, the physics and chemistry of glass and new applications.

The present display dates from a 1990 rebuild. The keynote is a general introduction to glass as a material in terms of end products and applications. The divisions are consumer-oriented, matching industrial practice. Glassware is in everyday use as bottles and glasses, while sheet and plate glass surround us in the windows of buildings and vehicles. Special types of glass range from optically pure glass for spectacles and telescopes, through heat-resistant, chemically tough or radiation-absorbent compound materials, to fibre optics. Each is a separate development with a whole spectrum of applications.

Unlike handicraft museums, which show only end products, the Deutsches Museum endeavours to explain production methods for every glass display. In the two classic areas of glassware and sheet glass, which look back on long traditions, the story told is of development from handmade individual production to industrialised mass production. Dioramas, models and demonstrations provide not only a spectacle but also a means for the visitor to actively understand.

mbz

This diorama, built in 1959 in the model workshop, provides a glimpse inside a traditional working glass factory with its personnel-intensive operation.

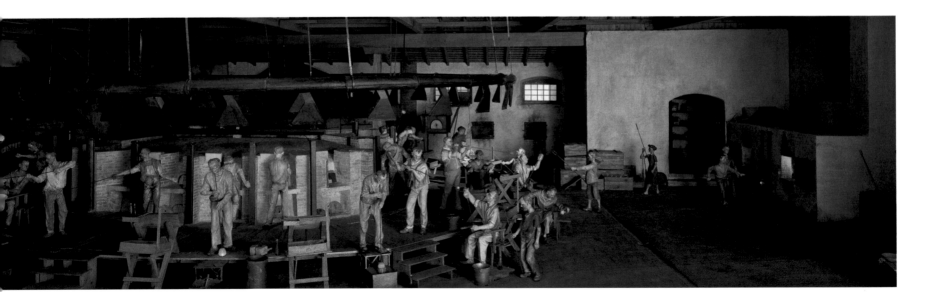

Using polarised light the stress in a pane of glass that has not cooled down evenly can be seen. This makes it unsuitable for optical instruments. The right hand pane is stress-free and therefore does not distort (*below*).

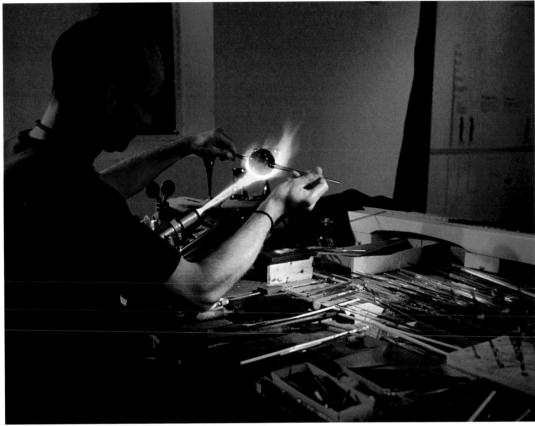

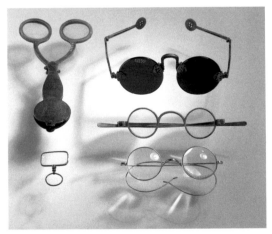

Glasses from days of old:
Scissor-spectacles from *c.* 1680 and a rectangular monocle *c.* 1820 *(left)*; Chinese silver spectacles, 17th to 18th century, temple spectacles and catroptic glasses, both 18th century *(right from top to bottom)*.

At the glass-blowers stand, visitors can watch how mass-produced glass tubes and sticks are transformed over a bunsen burner into vessels, jewellery and figures.

The smashed plate-glass window in the exhibition shows that although the different layers of the pane have shattered, the composite pane remains whole.

Paper

"The use of paper is a measure of a people's cultural level."

Carl Hofmann, 1897

Many activities in our daily life are associated with the use of paper, whether in the form of newspapers, coffee filters, handkerchiefs, copying paper or banknotes. There are around 3,000 varieties of paper and card, from which a huge diversity of products is made. In Germany, the per head consumption of paper per annum is around 200 kilos (440 lbs). Predictions that paper would disappear (for example, because of the use of computers) have so far proved false. Reading from paper has proved simpler, which is why (among other reasons) web pages or e-mails are so frequently printed out.

A display about paper runs up against the problem that paper machines these days are almost as long as a terrace of houses and can therefore scarcely be shown in the original. Other media have therefore to be used. Presentations show dipping paper by hand and a laboratory-format paper machine in operation. Once a week the presentation is supplemented by a live run, enabling production conditions at a paper-making factory to be shown in the Museum. It is important for visitors to experience paper by touch—to feel it, fold it and explore for themselves its characteristics in use.

wg

At the 'Paper Live' display, visitors see the laboratory paper machine in operation, and can then watch the Museum video on how paper is manufactured at a modern paper factory.

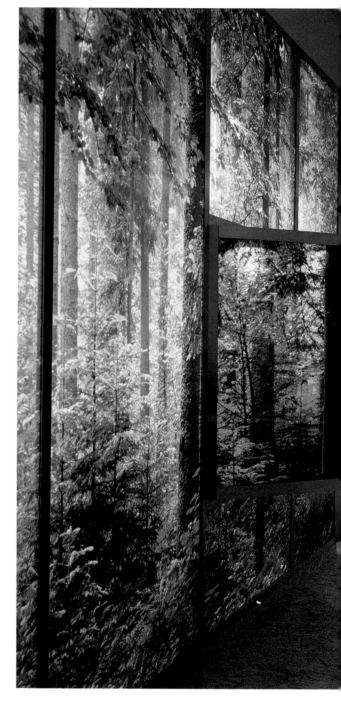

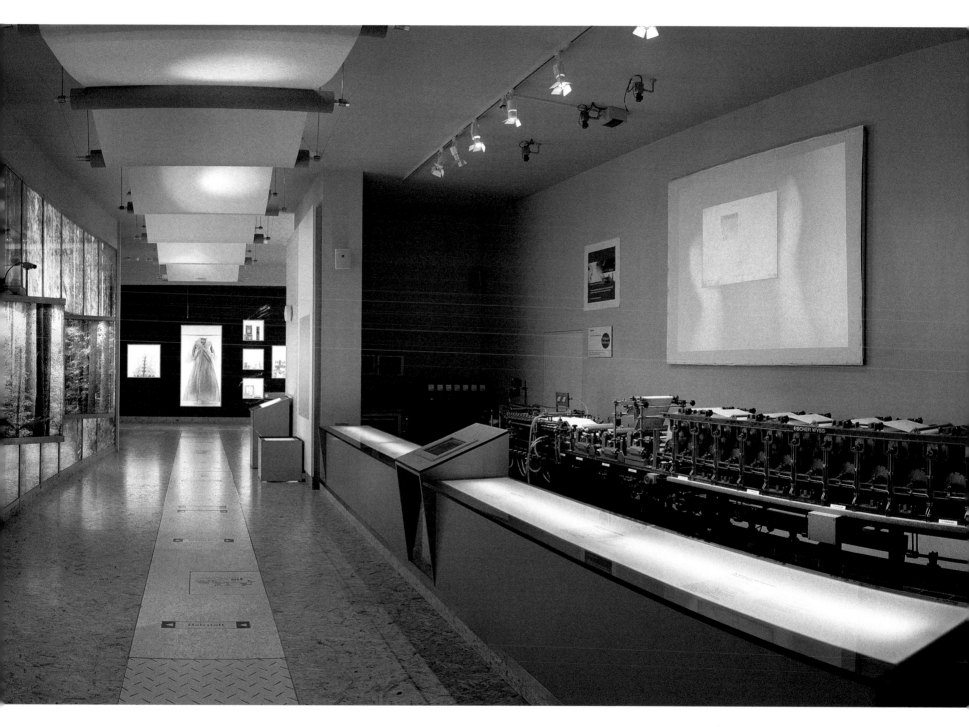

Paper is made out of wood, as symbolized by the wall of pictures on the left. On the right, a multimedia station explains how the paper machine works.

Paper

Model of a calendar roller which is used to glaze paper

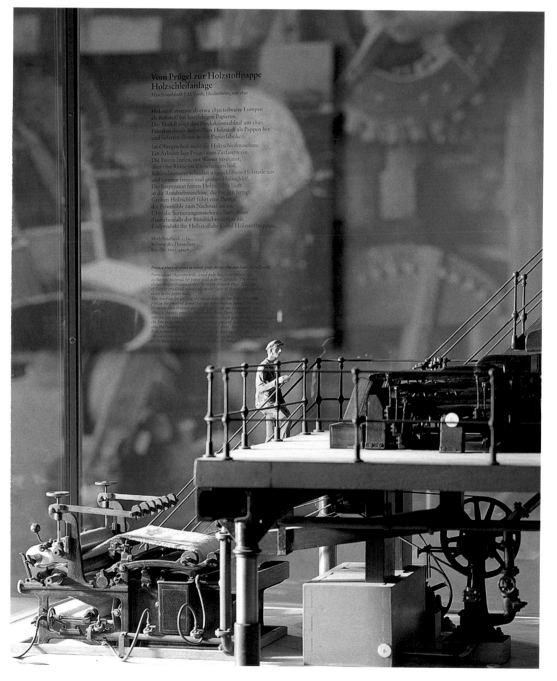

Robert's Paper machine of 1791

Wood pulp installation for making newsprint

The world's oldest original paper machine (*c.* 1820)

ENERGY

Energy is one of the raw materials of animate and inanimate nature. It plays a decisive role in all physical and biological processes. This is why the way we use the various sources and forms of energy is inseparable from the development of human culture and technology. Using fire, man fashioned tools of bronze and iron; using water and wind converted into mechanical energy in engines, he overcame his dependence on his own and his livestock's muscle power. Finally, there came the Industrial Revolution, ushered in by the invention of the steam engine in the eighteenth century.

Our everyday world of the twentieth century was transformed more by electricity—generated and distributed from the simplest generators to giant power stations and high-voltage plants—than any other form of energy. Population growth, rising energy requirements, shortage of resources and the destruction of the environment on a hitherto unknown scale, above all by burning fossil fuels, have forced mankind to develop new ways of converting energy efficiently and less destructively, such as the use of nuclear energy or regenerative sources of energy. New methods of converting energy that are kinder to the environment will have a decisive role in the future as well.

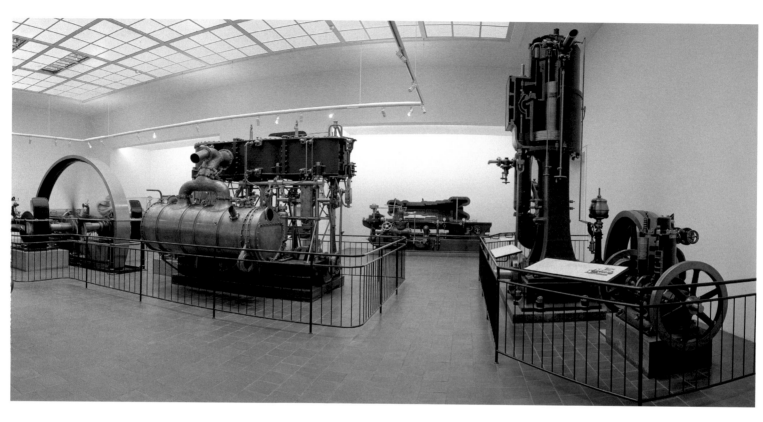

Power Machinery

"Almost all earthly powers have a common origin, and go back to a primary source, the sun!"

Fritz Gärtner, 1925

As drive assemblies, engines are the key element in the development of manufacturing and machine-tool equipment, land, sea and air transport systems and power generation, to mention just a few examples. Indeed, they are the 'engines' of all human technical, economic and social progress. That is why the Museum has, from the outset, endeavoured to document the basis phases of development of these machines by means of originals and explain to visitors how they work.

This then was the basic concept behind the display that opened in 1906 on the premises of the old National Museum. Since 1925, the department has occupied an area in the 'engine hall' on the Museum Island. The hall was badly damaged by bombing during World War II and in 1983 by fire, but was in both cases rebuilt in the original form.

In connection with the last reorganisation of the department in 1983–85, discussions were held among various workgroups as to a possible new approach. Suggestions ranged from a strong emphasis of social history via the introduction of factory architecture to the massive deployment of audiovisual media. In the end, the traditional museum architecture and now century-old basic concept won the day. In terms of the display, that means:
– a clear, largely chronological arrangement of the department;
– a variety of partly working originals, supplemented by static and demonstration models;
– easily understood summaries and explanatory texts, supplemented by diagrams and photographs;
– regular general tours during which guides answer visitors' questions and respond to requests to demonstrate particular machines.

ka

The artist Fritz Gärtner gave expression to the idea quoted above in 1925 in a large allegorical painting for the Engine Hall.

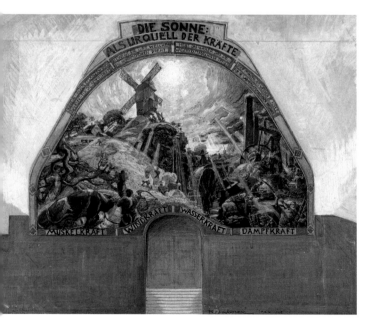

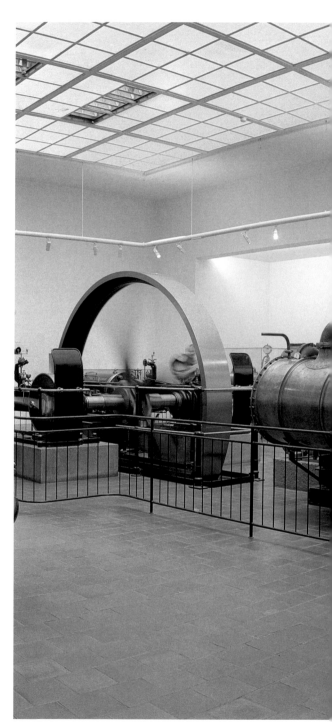

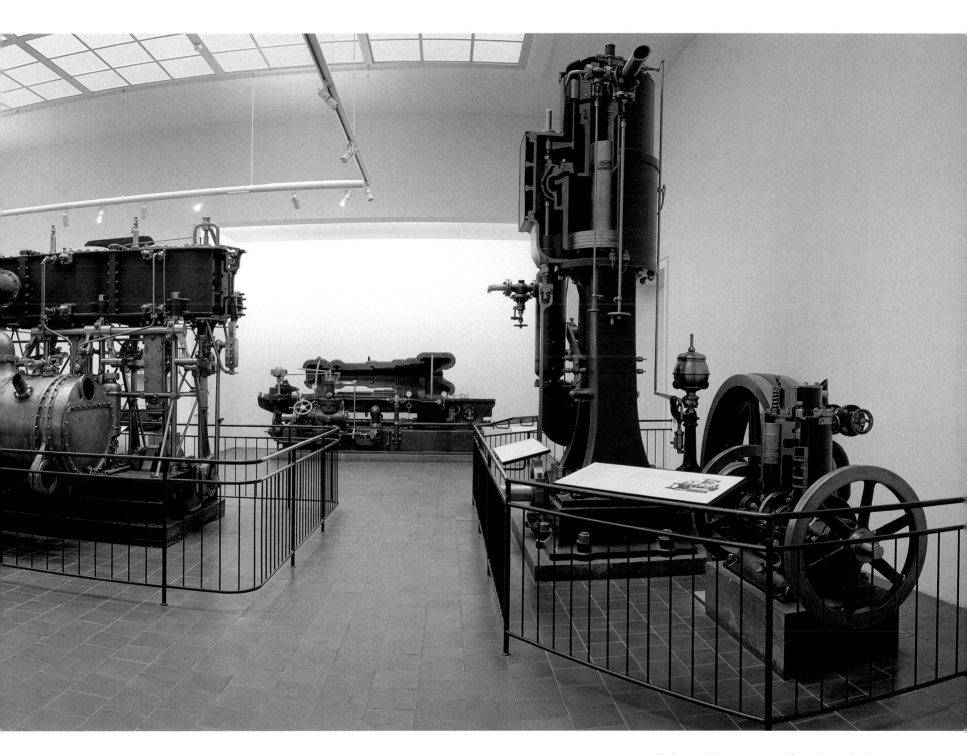

Well-designed steam engines from the end of
the 19th and early 20th centuries are centre stage
in the three-part Engine Hall.

Power Machinery

This photograph from around 1930 shows model windmills of various types of vane in operation. Windmills have been in existence for about 1,300 years and, according to the way their wheels are arranged, are classified as fast or slow-turning mills.

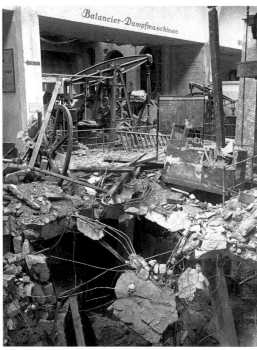

The Engine Hall, destroyed during World War II.

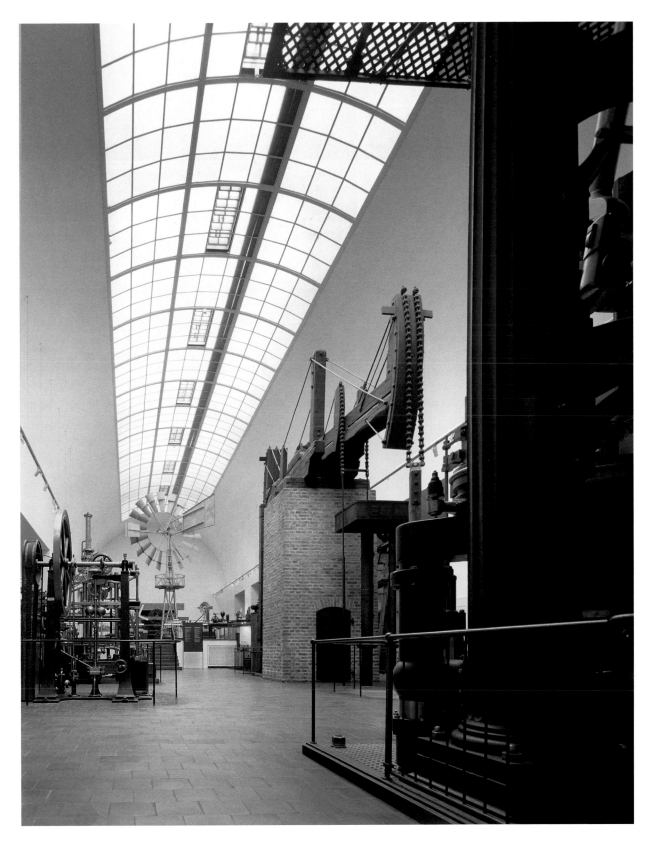

View of the oldest part of the
Engine Hall; *(right)* part of the
first in a series of valve steam
engines by the Sulzer brothers,
1865; *(centre)* Germany's oldest
remaining beam engine, by
William Richards, 1813.

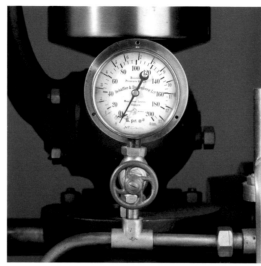

Control apparatus and lubricating vessels of various types of construction ensure that engines operate smoothly and safely.

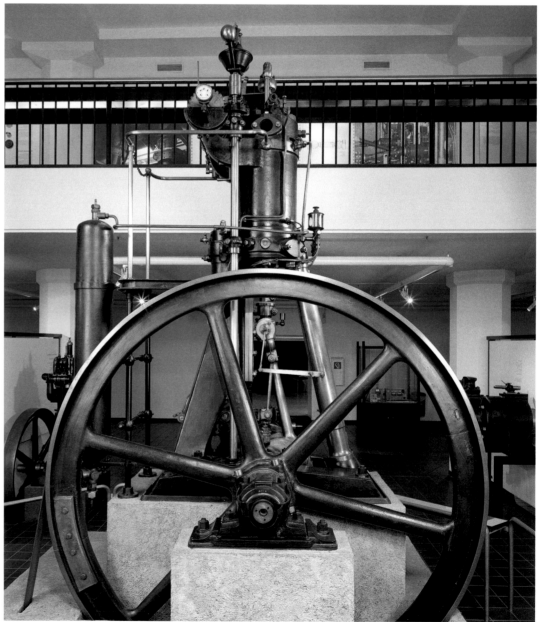

This experimental engine, developed by Rudolf Diesel and built by Imanuel Lauster at the Augsburg engine factory in 1896/97, is the third in a production series of experimental non-ignition engines. It was the first to undergo various performance and brakes tests on a test bench in front of an international audience. In his report, the head of the Testing Commission, Professor Moritz Schröter, wrote (among other things):
"Based on the overall test results and on the observations made during the operation of the engine, I can summarize our opinion of the same by stating that even in its current version, while not having realized its full potential as a single-cylinder four-stroke engine, it is already the world's leading motor engine."

The Deutz A engine, a stationary, four-horsepower gas engine with precompression, is from the first series of Otto engines built at the Deutz Gas Engine Factory in Cologne. The designer, Nikolaus August Otto, a colonial trader by training, developed it in 1876 and had the four-cycle principle, used for the first time, protected by patent on 4 August 1877 under the number DRP 532.

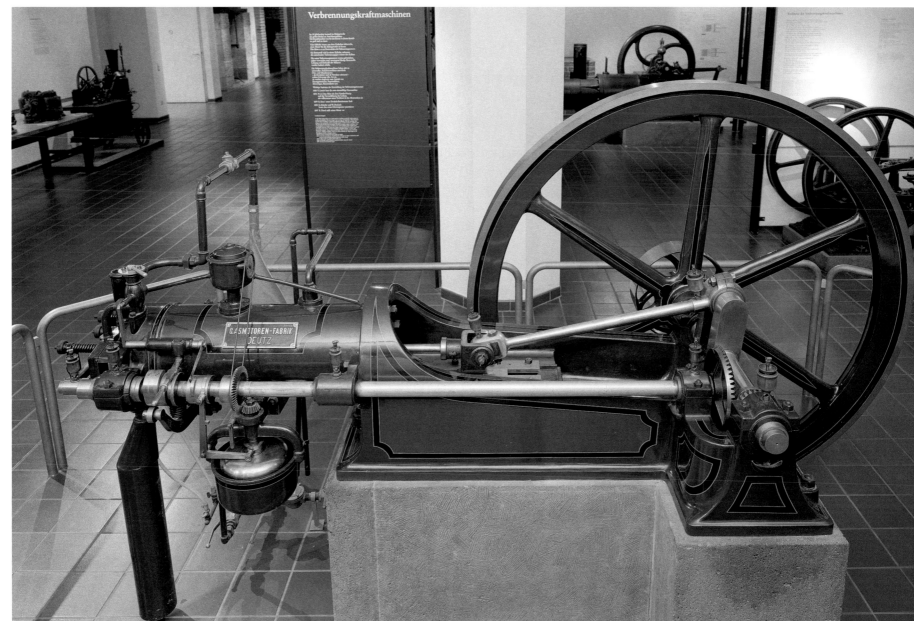

Electrical Power

"Technology currently has the means to generate electric power of unlimited voltage cheaply and conveniently anywhere where labour is available."

Werner von Siemens, 1867

View of electric engines and appliances in the first room: on the pedestal at the front is the first practical rotary current engine and an early mercury arc rectifier in glass and iron containers. Two early products from the Siemens & Halske company are visible in the background: *(left)* a lighting car, 1878, and *(right)* a DC inner-pole engine, 1887.

For convenience, electrical energy is called electricity or often just power. The physical process involved is the conversion of mechanical energy to electrical energy, taking advantage of the induction phenomena discovered by Michael Faraday in 1831. This conversion was initially used for illuminating large areas with magneto-electric machines. A major advance came with the discovery of the dynamo-electric principle, which was discovered independently and almost simultaneously in 1866 by Werner von Siemens, Alfred Varley and Charles Wheatstone.

Because of the historical familiarity acquired in dealing with DC and batteries, it was DC systems that were first established along with central stations in the area of demand. These were only operational morning and evening. They were first built in to the design following the invention of the rotary current squirrel-cage induction motor in 1889 by Mikhail Dolivo-Dobrovolsky.

However, electric engines needed more energy than electric lighting, and so the next step was to transmit the electricity from well-positioned power stations to centres of consumption, with transmission voltages being transformed on the way. Following the invention of transformers by the Hungarian engineers Ottó Bláthy, Károly Zipernovszky and Miksa Déri in 1885, the output of generators grew from a few kilowatts (kVA) to over 1,000 megawatts (MVA), and transmission voltages from several hundred volts to several hundred kilovolts (1,000V = 1kV), which was of course accompanied by the development of appropriate appliances and plant designs. The end result was the emergence of three separate kinds of technology: electrical engineering, electrical distribution systems and high-voltage technology.

Nowadays, demand is catered to by a joined-up European grid system extending from the North Cape to Sicily capable of distributing 500,000 MW in parallel operation, and there are proposals for an inter-continental grid

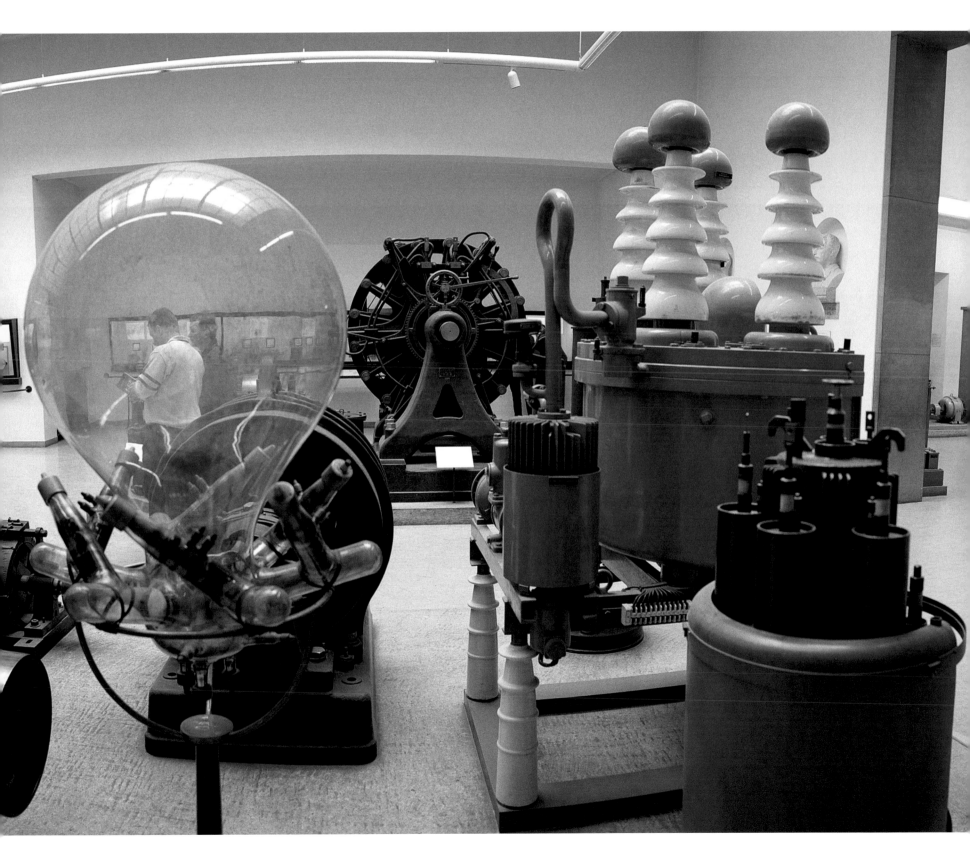

Electrical Power

Generation of electrical energy: *(in the foreground)* an early turborotor, by the Brown, Bovery & Cie., 1902; *(behind)* the generator for the world's first DC transmission from Lauffen to Frankfurt, a claw-pole generator from the Oerlikon company, 1891.

(global link) capable of exchanging output globally during the course of the day and covering demand.

The electrical power display occupies two rooms, and basically shows the generation and distribution of electricity and its application. Visitors can structure their tour accordingly, informing themselves about the two major subject areas of electrical engineering and electrical distribution systems first and then taking part in a demonstration on the subject of high-voltage technology.

The first room shows the historic beginnings and the subsequent development of electrical machines. It starts with Siemens's first dynamo and goes on to improved machines with greater output. It also depicts the development of alternating and rotary current systems, especially the steps leading to the developer of transformers and squirrel-cage induction motors. Visitors can see DC and rotary current systems in operation by pressing a button.

This and the next room contain two areas featuring the contribution of the Museum

founder Oskar von Miller to power engineering—notably two key experiments transmitting energy over great distances (35 miles [57 km] from Miesbach to Munich with 1,400 V direct current in 1882, and 109 miles [175 km] from Lauffen to Frankfurt with 15,000 V rotary current in 1891) and the construction of the first Alpine power station at Walchensee in 1924.

The second room shows the principal objects in the chronological development of electrical equipment and plant, starting with the generator for the power transmission from Lauffen to Frankfurt.

The high-voltage installation in the second room is a great favourite of visitors, with three demonstrations a day. Visitors can see high-voltage technology at work in alternating voltages from 50 Hz to 300,000 V and impulse voltages up to 800,000 V lasting two-millionths of a second, simulating lightning striking buildings. *th*

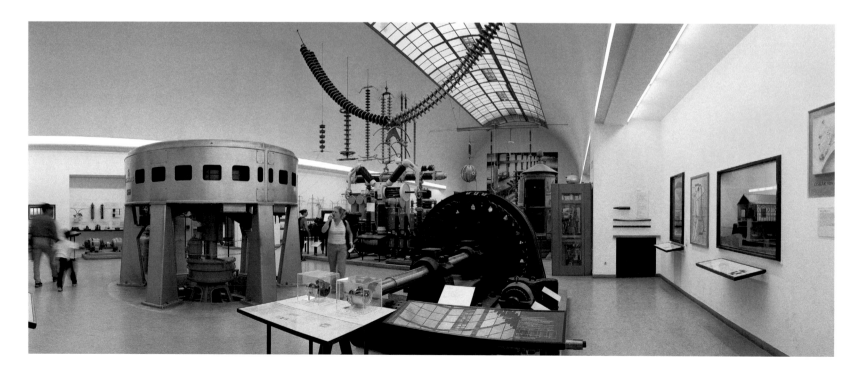

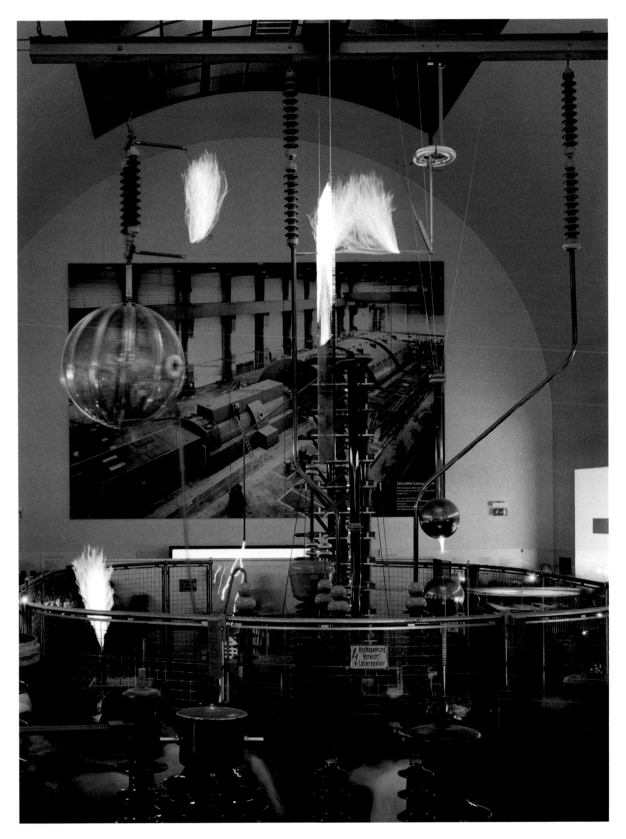

AC voltage of up to 300,000 V is used to demonstrate tracking discharges and the protective function of a Faraday cage, voltage measurement by a sphere gap, electric lines of force, travelling electric arcs, and other effects of electric power. An impulse generator using voltages of up to one million V is employed to simulate lightning striking a model church and trees, and to vaporize thin wire.

This photograph of the high-voltage plant (at the back: a blow-up of the Biblis A nuclear power plant) was taken using multiple exposures. The safety equipment allows only one test device to be in operation at any one time.

Energy Technologies

"Energy cannot be created but only converted from one form into another."

Julius Robert Mayer, 1842

The subject of energy recurs in many of the Museum's displays, for example as primary energy in Mining or Oil, as secondary energy in Power Engineering or as an energy service in the transport of passengers and freight in the Transport department. Yet, with all this, an overview display on the causes and consequences of our energy consumption was missing.

What could then be more obvious than to set up a department about energy technologies based on the need for power? The demand for heat, light, mechanical power and communications is the trigger for the use of energy resources in energy conversion chains. But what initially seems rather abstruse becomes all too real on an energy bicycle, when you're lifting weights or heating water just with muscle power!

What does the average family use energy for and how is this requirement distributed worldwide? Interactive systems supply answers to this and similar questions. The CO_2 problem reinforces the search for carbon-free energy resources and efficient energy converters.

As a focal point, the display therefore deals with the use of solar energy and nuclear power. Along with the historical development, it shows the opportunities and risks of the converter systems associated therewith.

How much solar energy is at our disposal? A pyranometer (solarimeter) on the Museum roof measures solar radiation, while a solar fountain fluctuates according to the degree of cloud cover, showing how much the available solar energy depends on the time of day and weather. The original mirror of a parabolic solar collector demonstrates the way modern equipment works.

Nuclear reactors have contributed to power generation since the end of the 1950s. The tour of the display starts with the production of fuel, goes on to how reactors work and finally deals with the long-term storage of radioactive waste. The fusion of atomic nuclei—nuclear fusion— is the goal of international research projects. The original torus of a stellarator and a section of a tokamak illustrate the tricky physics this technology involves. *sh*

The plasma of a nuclear fusion reactor enclosed by magnetic fields. The demonstration show how plasma streams are affected by magnetic fields.

A never-ending spiral of energy?
At the very centre of this
display, visitors can find out
how various forms of energy
are used worldwide.

Energy Technologies

Information boards on solar energy in the Power technology display. Renewable energy from the wind or water will have an increasingly important role to play in the future. A video installation highlights interesting details.

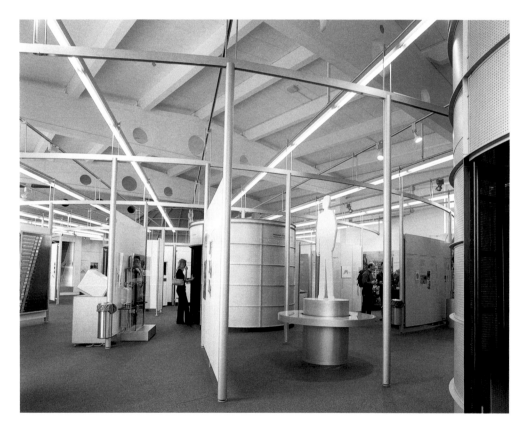

This working model on a scale of 1:1 demonstrates the ASDEX Upgrade fusion experiment at the Max Planck Institute for Plasma Physics.

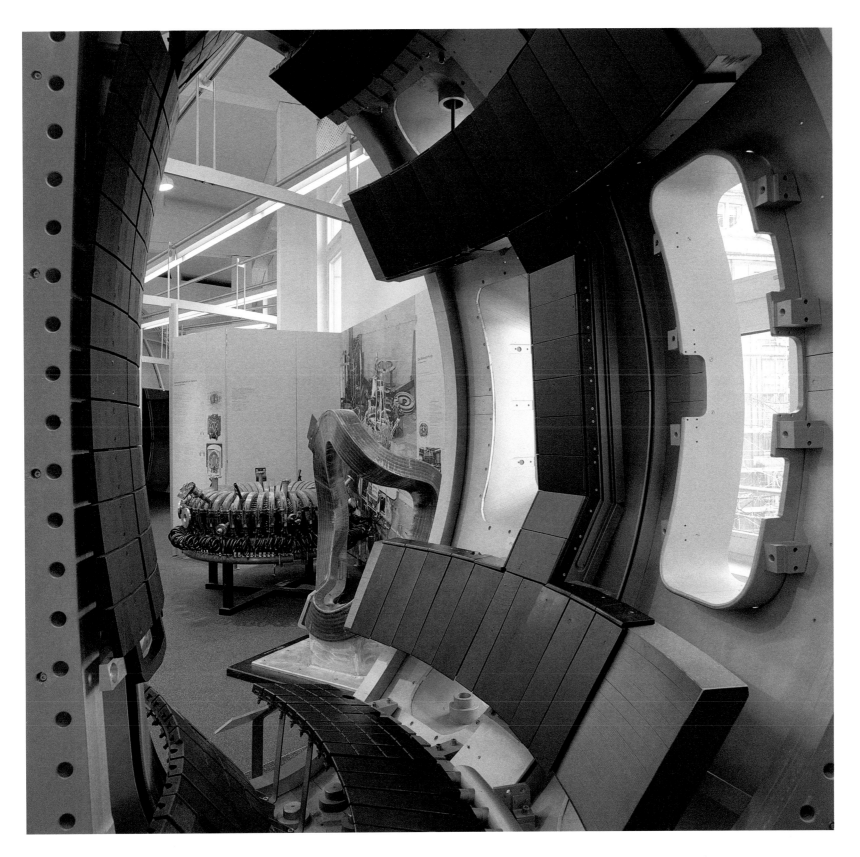

ASDEX Upgrade fusion equipment at
the Max Planck Institute for Plasma Physics
in Garching, 1989.

COMMUNICATIONS

From the rock drawings in the Altamira Cave to multimedia—communication is always involved when people deal with each other, exchange information, acquire knowledge, in religions ceremonies or normal conversation.

The use of pictures marks the transition from hominids to homo sapiens; the development of writing and number symbols around 3,000 BC, allowing any factual content to be written down in a simple abstract form, was probably man's most important cultural achievement. Since that time, forms and techniques of communication have undergone a wide variety of changes. From the mid-fifteenth century, printing and paper technology made written knowledge available to a broad section of the population. The history of musical instruments, which likewise goes back thousands of years, is similarly interesting in a communications context. More recently, photography and film have brought an unparalleled inundation of pictorial matter into our modern lives.

Finally, the science of computing and achievements of microelectronics have enabled us to transmit data by means of electric currents, from the early Philipp Reis telephone to the global information system of the internet.

Printing

"Yes, the art of printing is a factor … the second stage of world and art history dates back to it, and it is quite different from the first."

Johann Wolfgang Goethe, *Conversations with Johann Christian Lobe,* July 1820

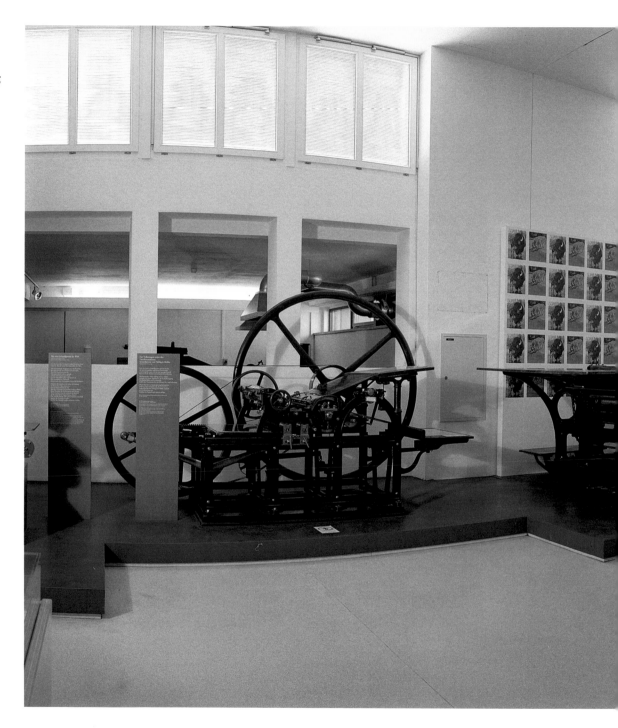

One of the oldest surviving flatbed printing machines (1844, *left*); an early intaglio printing machine *(centre)*; a Guillochier machine, used for drawing designs on bonds *(right)*.

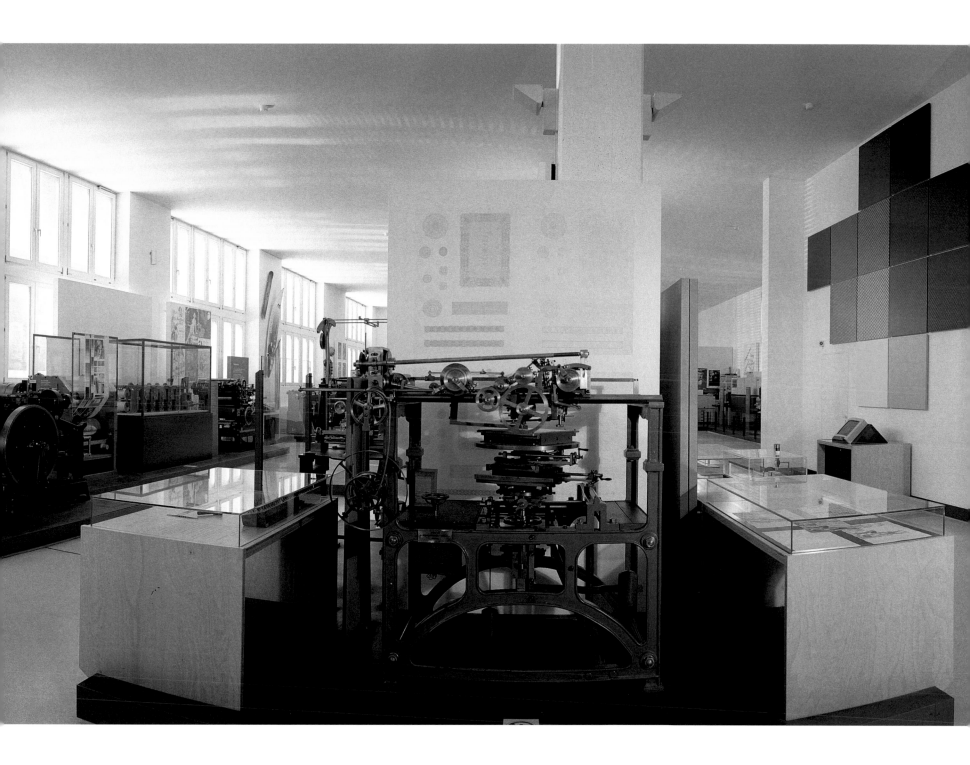

Printing

Portrait of the inventor of the printing press, Johannes Gutenberg.

Packaging, newspapers and books are all printing products that we use every day and take for granted. Printing dates back to around 1440/1450, when Johannes Gutenberg, the son of a Mainz patrician, created a system for duplicating texts in almost any quantity. It was a media revolution, the threshold to the modern era. The imminent demise of print-based media has often been forecast as a result of competition from rival media such as radio, TV or the internet, but the number of specialist magazines or new book titles continues to rise. It seems that printed matter is particularly suited to the way we are, and printing will continue to enjoy a distinguished role in the media palette of the twenty-first century.

Printing featured at the Museum from the beginning. The first display at the Old National Museum of 1906 took an even broader view of the subject than now. A fifth of the display area was devoted to painting techniques as a preparatory step to text, while photography, which provided the intermediate tools for printing, formed an integral element of the exhibition. From 1925, the new rooms on the Museum Island provided enough space to exhibit original machinery and large dramatised set-pieces. The third display was opened in 1965. It was divided according to types of printing—relief printing, intaglio printing and surface printing, but quickly became out of date as technology changed. The present display dates from 1995 and spans topics from letterpress to desktop publishing and wooden handpresses to offset machines.

Many printed products are done in stages, so that the story has to document not only the adoption of machinery but also illustrate individual processes with printed samples and phases of development. These form a major focus of the collection. The *pièces de résistance* are original items by inventors such as Aloys Senefelder (lithography) and Georg Meisenbach (glass screen for halftone printing). These reached the collection in the early days, and have since formed a fundamental part of the presentation. But also processes that only date back a few years and yet are already half-forgotten, such as the beginnings of photo-setting or offset printing, are preserved for posterity in important examples. *wg*

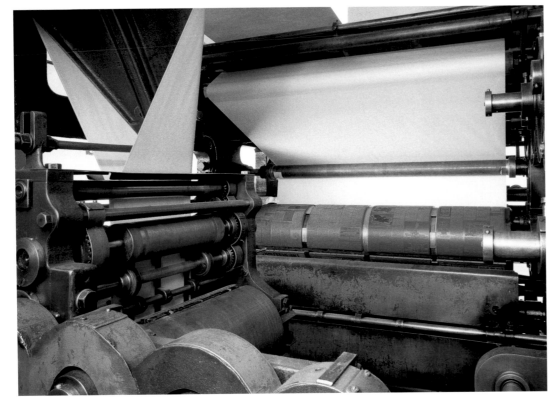

A multimedia station explains to visitors how the print workshop functioned, c. 1800.

The VOMAG high-pressure rotary machine (1925) is compactly built and requires little space. It can print 8,000 copies of a single-colour, 16-page newspaper in one hour, which is ten times faster than a flatbed printing machine.

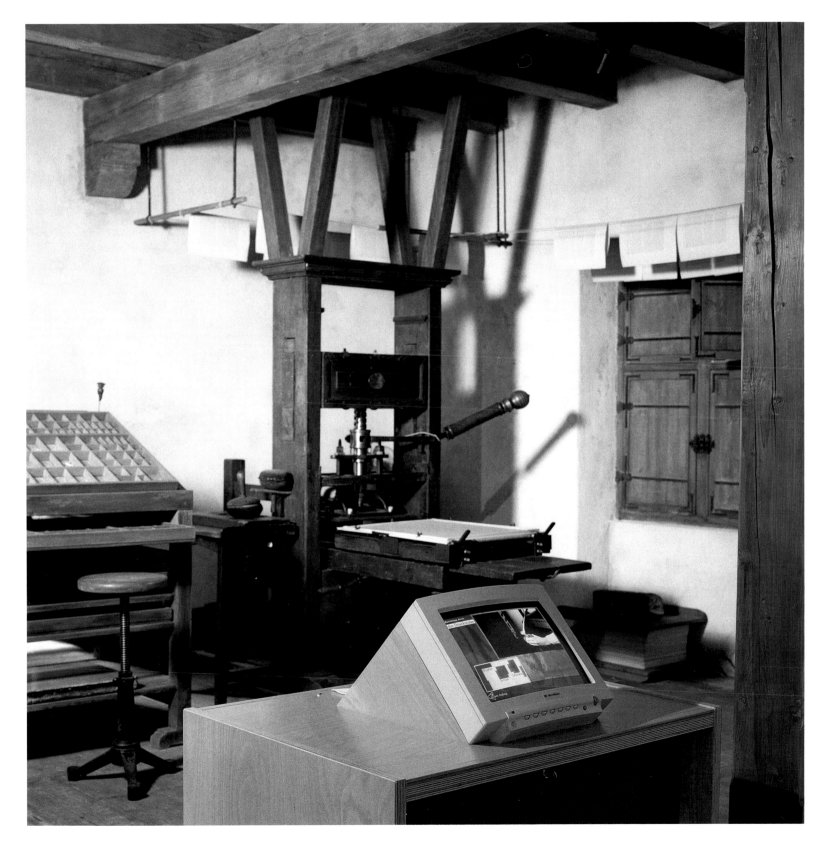

Photography and Film

"The fanatical enthusiasm with which photography is now pursued at all levels suggests that photographic ignoramuses will be the illiterates of the future."

László Moholy-Nagy, 1927

Photography, literally 'drawing with light', has developed into an omnipresent medium of information over the last 160 years or so. The documentation of this cultural technology began at the highest level as soon as the Museum was founded, and received continual support from the German photographic industry, for decades the European leader. Particular attention was also paid from the first to photographs themselves, with their great diversity—especially in the early days—of photographic and copying processes.

The 'living image', which opened up new dimensions of perception by means of cinematographic technology, was a further focus of collections along with early cameras and projectors, and these are complemented by the video and TV technology of telecommunications in more modern times.

Special exhibitions in recent years have been in response to current issues thrown up by interactive media systems and imaging processes of medical technology.

The development that began in the 1960s with the automation of photographic technology by electronic means and that has now led to a great variety of simulations by means of digitally created pictures will in future form a counterpoint to the historic documents. More recent processes of visual information have largely ousted the once predominant analogue picture. The 'technical' picture and its take on reality have opened up fascinating insights into current fields of knowledge, such as nanotechnology and genetic engineering and the exploration of space. *ck*

Colour micro-photograph of a slither of rock; autochrome by the Lumière Brothers from 1909. Taken from the Museum's comprehensive collection on the different techniques throughout the history of photography (original size: 9 x 12 cm).

We have long gained optical information from
other areas than classical photography as well. The
special display entitled 'Under the Skin' (1999)
threw light on the image in the field of medicine.

Computers

"The benefits of liberating oneself from accidents of technical development in order to make more dependable statements should not be underestimated."

Friedrich L. Bauer, 1970

Arithmetic and geometry, woodcut, from *The Mirror of Life* by Rodericus Zamorensi, Augsburg, c. 1475. The woodcut shows a merchant on the left, doing his calculations on an instrument that consists of a table with a pattern of lines and counters. The building designer on the right of the picture is working on a drawing board, with T-square, dividers and right angle. Both men are using their instruments according to established rules to solve their problems. Such instruments have made a comeback as software tools for computer-based graphic work.

This was written by the co-founder of IT as a science subject in Germany in the foreword to his influential manual for the new subject. What he meant by 'accidents' is illustrated nowhere better than at the Museum, where centuries of development can be followed. Computing was to be more abstract and general than traditional engineering but not as abstract as mathematics. Quite a few engineers considered the acid remark of the mathematician who defined and demarcated the new technical subject a provocation.

Eighteen years later, the same F.L. Bauer initiated and designed the permanent display on the subject of IT at the Deutsches Museum. Faithful to Oskar von Miller's precept, masterpieces of traditional, instrumental and mechanical mathematics were presented in chronological order alongside those of IT. The point of overlap is occupied by two calculating machines by Konrad Zuse, the Z3 and Z4. From the first, there were critics who thought that the mathematical instruments, calculating machines and computers displayed could not be representative of IT, and they cited Bauer's own words.

That the displays at the Deutsches Museum can reflect the disciplines of natural science and technology only within narrow confines was perhaps felt particularly strongly in the still young science of IT. This is a problem as old as the Museum itself, and has never constituted an obstacle to the latter's continued success. Even when the Museum was founded, Walther von Dyck, professor of mathematics at the Technische Hochschule in Munich and an influential colleague of Oskar von Miller, was convinced that mathematics should also have an important place. After all, it did form a fundamental part of modern sciences and technology.

Continued on page 208.

The Telefunken TR 4 of 1962 (prominently displayed here) and the Siemens 2002 of 1959 (reflected in the glass with two white-coated operators standing next to it) were among the first 180 computers developed and produced in West Germany. The model 20 from the IBM 360 computer family (visible in the background) was also a German product.

Computers

The increasing application of calculating procedures in natural and technical sciences demanded precise and versatile scales on simple, mechanical instruments.

Proportional dividers made of brass, mid-17th century, German or Dutch.

Universal compass with crosspiece, by Christopher Schissler, 1586, gilded bronze. Inscription: *Christophorus Schissler junior artifex Augustae vindelicorum faciebat Anno 1586.*

Protractor, gilded brass, 1653.

There has been a Mathematics display at the Deutsches Museum ever since the Museum was founded. This photograph shows the room after 1925. The Computing display opened in 1988 took up the theme of mathematical instruments from a new perspective.

A 13-column suan-pan computing table (Chinese abacus), c. 1980. Counting on an abacus is closely related to the 15th-century merchant's counting table and requires a constant mental arithmetic.

Computers

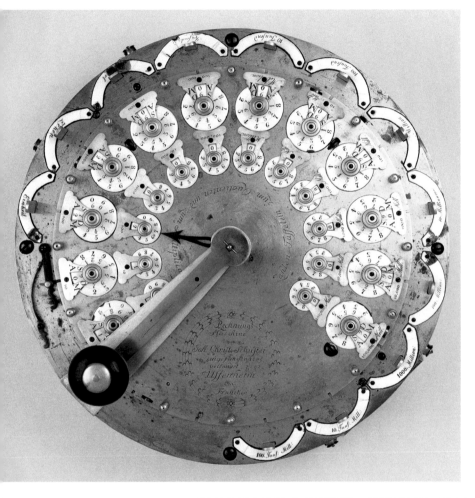

Adding machine by Johann Christoph Schuster, 1792.

When the new museum building on the island was opened, Oskar von Miller expressed his awareness of his colleagues' criticism:

"To demonstrate the essence, content and objectives of mathematical research in its totality is not the job of a museum, but the trends can be shown according to which the material object in mathematics is an end in itself or a means to an end. And though this covers perhaps only a small part of mathematics, it still covers a large number of the mathematical issues that have engaged the human mind since ancient times and that people have endeavoured to solve with imagination and acuity."

These words can be directly applied to computing, which is related to mathematics. It is instructive to interpret the instruments and machines used for sundry calculating jobs and precursors of modern computers and look for the differences, Over the centuries, mathematical relationships and functions were made clear to the human eye by means of scales and mechanisms, in order to make calculating easier. From a modern point of view, we may admit that this benefit was bought at the price of ever greater circumscription by mechanical technology.

Electronic, software-driven computers have turned the tables. Everything that all the mechanical instruments and machines could do can also be done by computers. Their potential goes far beyond this, however, to the point of universality. Taking the historical and technical step to computers also meant foregoing the directly sensory perception of the mathematical and technical processes. Anyone who uses them must determine himself what is shown on screen or heard on the speaker. Everything else remains invisible. *hp*

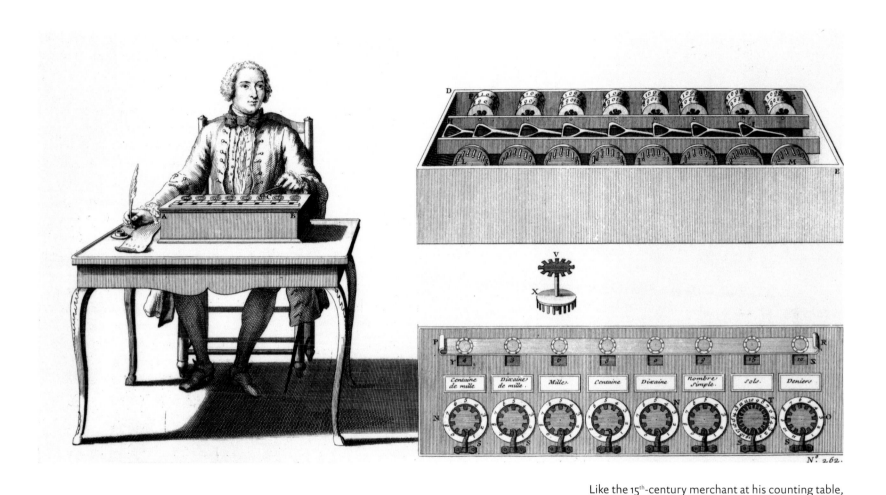

Like the 15th-century merchant at his counting table, the 17th-century French tax official also sat at his table, with the adding machine developed by Blaise Pascal and a sheet of paper filled with columns of figures.

(opposite page) Gottfried Wilhelm Leibniz's calculating machine, c. 1710 (1923 reconstruction), interior view from below. The crank, introduced by Leibniz towards the end of the 17th century, was the most important component in the development of the calculating machine. Whereas one factor had to be set digit by digit, the number of crank rotations corresponded to the other factor. This is how the mill-like calculating machine came into existence, and which, some 200 years later, could be connected directly to an electric motor. The mill-like character became more pronounced in the 18th century with the overall round configuration of the adding machine. However, this arrangement meant that the individual digits combined to produce the end result were barely legible. The routine use of adding machines in the 19th century soon led to the reintroduction of the earlier box-shaped system, in which the individual numbers forming the end result were arranged in a single row.

Computers

Konrad Zuse's programme-controlled Z4
computer, 1945/49. The Z4 was the fourth version
of Zuse's programme-controlled digital computers.
It was in routine operation for five years at the
Electro-technical University in Zurich.

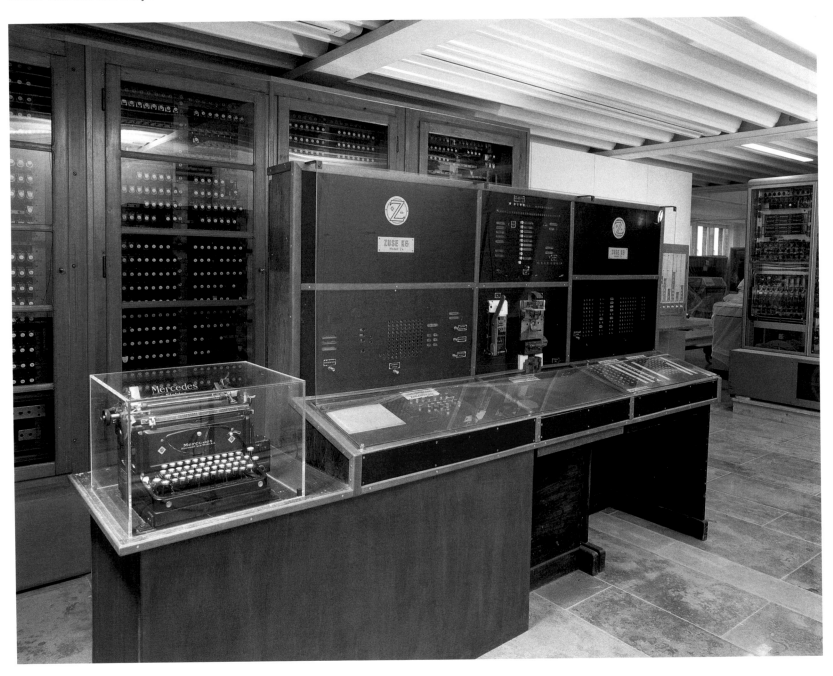

The numerous shiny glass electric valves protruding from the front were a typical feature of early electronic computers. These included the Programmed Electronic Reckoner Munich (known as PERM) developed at the beginning of the 1950s. By the time they were phased out at Munich Technical University on 1974, work was already underway in the USA on the development of the compact high-speed Cray 1. While PERM was capable of performing about 10,000 simple multiplications a second, the Cray 1 was able to do 80 million in the same time. Zuse's Z4 computer needed three seconds to perform a single multiplication. With some practice and a little routine, the 15th-century merchant, with his counting table and counting coins would probably have needed 30 seconds for the same multiplication.

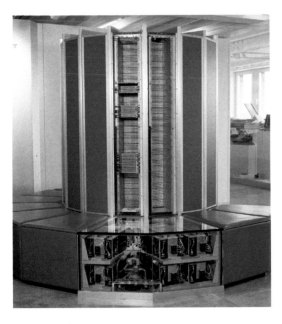

High-speed Cray 1 computer.

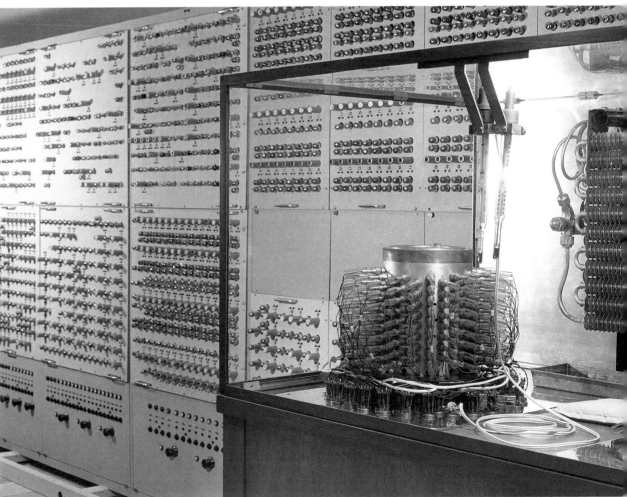

Programmed Electronic Reckoner
Munich (PERM), 1956.

Telecommunications

"Barteczek says that the electro-magnetic telegraph between Baltimore and Washington has produced extraordinary results. Often, orders placed in Baltimore at 1 pm are dealt with the same afternoon, and the goods and parcels are ready for dispatch from Washington around 3 pm, and small parcels requested around 4.30 leave with the 5 o'clock convoy from Washington, reaching Baltimore around 7.30. 75 English miles or 25 French miles. That's pretty quick, in my view!"

Frédéric Chopin, July 1845

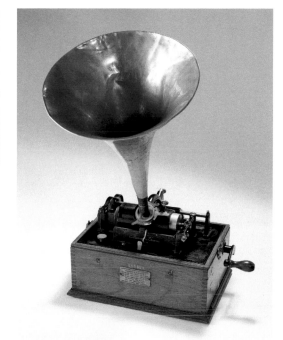

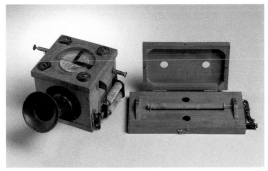

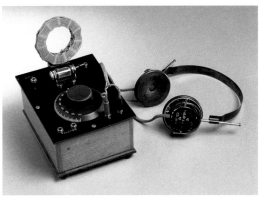

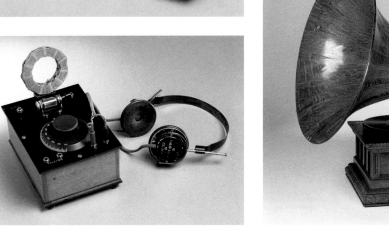

(top left) Telegraphic device by Steinheil, 1836.
(top centre) Morse key, 1846 (reconstruction)
(centre left) Philipp Reis's 'telephon', 1863
(centre) Telephone by Alexander Graham Bell, 1877
(sectioned model)
(bottom centre) Detector receiver (amateur device),
1925
(top right) Phonograph by Thomas A. Edison,
c. 1900
(bottom right) Gramophone made by Deutsche
Grammophon AG, c. 1905

Telecommunications

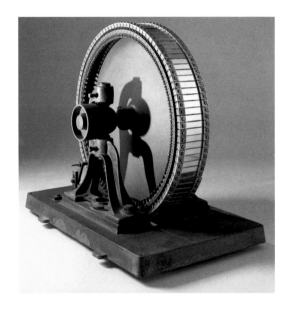

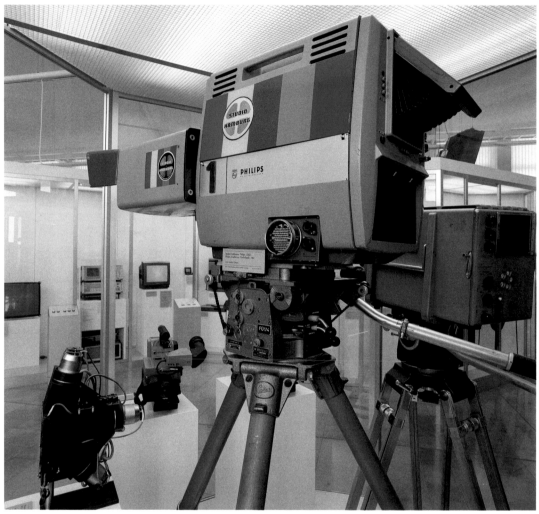

(top) Mirror drum made by August Karolus and Telefunken GmbH, 1928. 100 mirrors placed next to one another directed the light of the scene to be transmitted line by line on to a photocell. At the receiving end, a synchronously revolving mirror drum projected the remote image on to a screen.

(above) Satellite dish made by Kathrein Werke KG, 1989. The 60-cm parabolic antenna receives TV pictures from the Astra satellite. An integrated transformer converts the signals received to a lower frequency and strengthens them so they can be processed in the TV receiver.

Showcase of TV cameras, 1990. In the foreground is the Philips LDK3 studio colour camera used in the first colour transmission vehicle in the Federal Republic in 1967. Three Plumpikon pick-up tubes convert the colours red, green and blue into TV signals.

Manually operated exchange by E. Zwietusch & Co., 1905. The drop board handles 50 subscribers. The operator connects a subscriber by connecting the jacks of the subscriber concerned with a pair of plugs.

Selector by Siemens & Halske AG, 1922. This selector connects 100 subscribers automatically. If the number 23 were dialled, it would go through two upward steps and three turns.

TRANSPORT

Transport and mobility are basic human needs. Throughout history merchants and travellers needed roads. In our modern industrial society, with its multi-national economic system, a high-performance transport system is fundamental.

The means we use to get about have of course changed considerably over time. The first phase mainly involved our feet, but once wheels and axles had been invented, to which a box could be attached to load up or get into, a principle of land transport was evolved millennia ago that is still valid today. The development of wheels also meant building highways on which waggons could roll.

Of course, water transport, which is as old as land transport, initially used only natural water channels. But even in ancient times canals were devised and constructed, to extend these water systems deep into the interior.

In transport as in all fields of life, the development of the modern world in the nineteenth century revolutionised things. As the world industrialised, so it began to move. Goods were produced and transported in large quantities. Cities sprang up, and with them extensive flows of people and goods evolved.

On land, railways accommodated the fast-growing traffic, while on the high seas ships carried products all over the world. Like other branches of technology, transport also underwent mechanisation—wind and muscle-power were replaced by steam machines or motor engines, in ships, trains and road transport. The consequence was an enormous acceleration of transport, which also promoted the growth of the economy.

With the arrival of cars and aviation, opportunities to travel multiplied. Cars meant individual mobility and freedom of choice, though when enjoyed en masse these benefits threatened to result in general immobility. Modern transport thinking therefore aims at the sensible integration of all forms of transport. The development of aviation is an expression of growing acceleration and globalisation: people and goods no longer pass just across national borders but over continents.

Individual forms of transport and their development are presented in the Deutsches Museum by means of numerous exhibits. Visitors will no doubt identify the connections between means of transport and other areas of technology.

Marine Navigation

"Gentlemen …, at sea sailors have no other points of reference except the stars. You can establish the height of a star above the horizon with instruments, work out the distance from the zenith, and once you know its declination—because the distance from the zenith plus or minus the declination gives the latitude—you know immediately what latitude you are at, or in other words, how far north or south you are of a known point. I think that is clear."

Umberto Eco,
The Island of the Day Before, 1995

With the Earth rotating around its axis every day, the calculation for ascertaining latitude described by Umberto Eco was much simpler than determining longitude. To be able to find this 'island' of the day before again later, and to avoid being wrecked on adverse coasts, astronomers, mathematicians and instrument-makers of the eighteenth century had to develop very precise procedures, octants, chronometers and tables.

These tools were also a *sine qua non* for the seagoing powers to dominate the world. Around 1900, Germany, seeking its own place in the sun, also wanted to be numbered among them. Emperor Wilhelm II was an enthusiastic fleet planner, and Oskar von Miller, as an equally dedicated museum developer, could hardly ignore this penchant when he asked his sovereign for a foundation present for his new museum. The lavish sectional model of a modern service ship (that Wilhelm II provided) demonstrated the Museum's intention of explaining current technology. It also contained such explicit detail that it earned the Emperor an accusation of high treason. The imperial present prompted other patrons to emulate his example: Friedrich Krupp paid for models of the ships built at his Germania shipyards, while shipping companies such as Norddeutsche Lloyd and finally engineers and inventors developing the new technology joined the ranks of donors.

From the 18th century onwards, an octant, for determining the angle of incidence, and a nautical almanac containing the most important information about stars formed the basis of scientific navigation.

The north-German fishing vessel, the "Maria", of 1880, with its traditional sailing ship features, was in use at a time of great technological change. Motor-driver steel ships, such as the steam tug "Renzo", seen in the background, ultimately became the norm.

Marine Navigation

Miller created a historical panorama by commissioning various artists to commemorate important seafaring events in series of pictures. After World War I, he had a secrecy-shrouded technical fossil, the first German submarine U1, over 40m long and weighing 200 tonnes, brought to Munich.

The damage sustained by the Museum in World War II, a result of the selfsame weaponry that it exhibited, was devastating. At the end of the war, a new start was made with the arrival of the fishing lighter *Maria* HF 31. Though at first seen as a necessary but retrograde return to the normality of seafaring, it was a piece of luck for the preservation of regional vessels. Sympathetic shipping companies followed suit by collecting a colourful variety of exotic boats they came across on their global routes. Nordic oak was now joined by tropical mahogany.

A subsequent—internal—catastrophe, a fire, made a redesign possible, during which the small steam tug *Renzo* from the iron and steam age display was added to the fishing lighter in the display of the wood-and-sail age. The Theodor Heuss, installed in 1987, is the first lifeboat to reach landlocked Bavaria and forms the highpoint of a technical aspect of seafaring.

In its manner of presentation, the shipping department adopted the proven pattern of the Museum. Its ships' models continued the craft tradition of illustration in miniature. The cultural dimension finds expression in the legends and myths surrounding the Viking ship, almost a monument in itself. Later, the department benefited notably from the leisure activities of private modellers, who contributed many remarkable masterpieces of their art.

Beside the presence of the steel industry in the monumental screw in the open-air section, it was the contemporary exhibits from world exhibitions that would mark the industry's achievements. Sectioning the products—a mortal sin to curators—illustrated the thirst for knowledge in exposing the anatomy of the technology meticulously and conscientiously.

As the Museum rapidly gained a reputation and acquired historic objects, redundant machines were obtained from clapped out ships' hulls and yards. Their often moving simplicity was to demonstrate among other things the need for progress. In stealthily introducing these exhibits into its displays like a Trojan horse, the Museum was bringing pieces of history and individual stories into the building—objects in their uniqueness representing original human endeavour bearing traces of their use and the fingerprints of the past.

The cabin and promenade scenes became fantasy areas in which visitors could enter and almost feel the boards pitch and sway beneath their feet, possibly rekindling memories of distant sea journey.

When Umberto Eco launched his novel *The Island of the Day Before* in the Museum among masts and sails, he did not conceal that he had visited this historic setting as a place of inspiration and checked the imaginary world of his heroes in the opened-up model hulls. Visitors alternate between instruction and entertainment when they become absorbed in a diorama, guess something of the loneliness of the explorer inside a diving bell, or yield to the bubbling, vital water of a hydrodynamics demonstration, untroubled by dim recollections of school physics.

jb

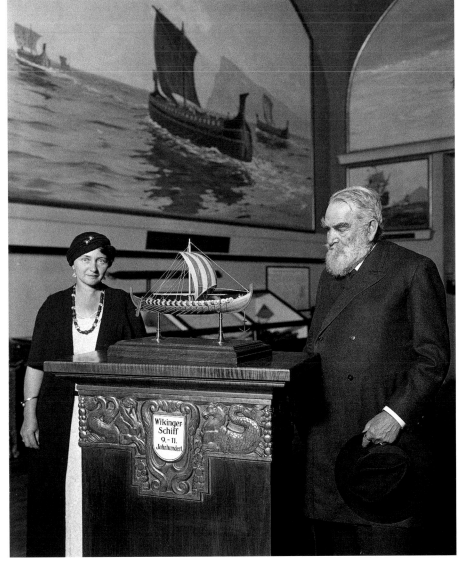

(top left) A lavishly detailed cutaway model of the liner *Rheinland*, donated by Emperor Wilhelm II to the Deutsches Museum and its founder, Oskar von Miller. The donation was recorded in an imperial document.

In the race by the world's nations for the last blank areas on the world map, Erich von Drygalski's expedition to the South Pole at the beginning of the 20th century in the research vessel *Gauss* was both a scientific undertaking and a sensational event.

By the time the Museum commissioned the above painting from marine artist Claus Bergen in 1925, von Drygalski had already become a professor of geography in Munich.

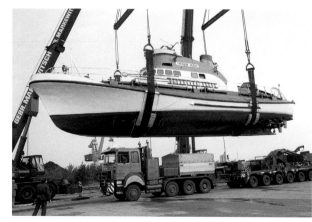

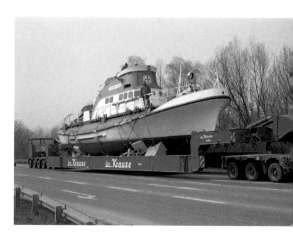

Emperor Wilhelm II's gift of a model ship set the standard for other donators. Other valuable models followed, such as the luxury express liner *Kaiser Wilhelm II* (*above left*), a cutaway model of the first submarine *U1* (*above right*), the liner *Braunschweig* (*far left*), and the five-masted, full-rigged *Preussen* (*left*), one of the world's largest sailing ships. This tradition of donations continues to today. The *Silja Europa* (*below*) is representative of the large passenger ships built at the renowned Meyer shipyard.

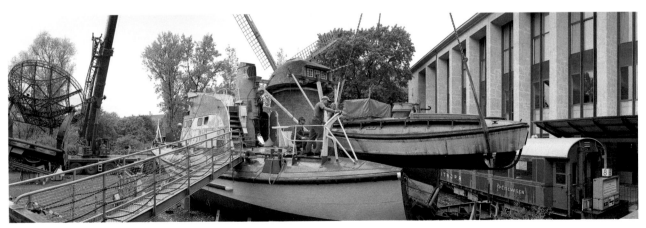

We're on our way. This message of humanitarian assistance, customary in the sea rescue service, was transmitted by the rescue cruiser *Theodor Heuss* on its last voyage—this time inland—along waterways to Nuremberg and from there by land to the open-air grounds of the Deutsches Museum.

Shipping

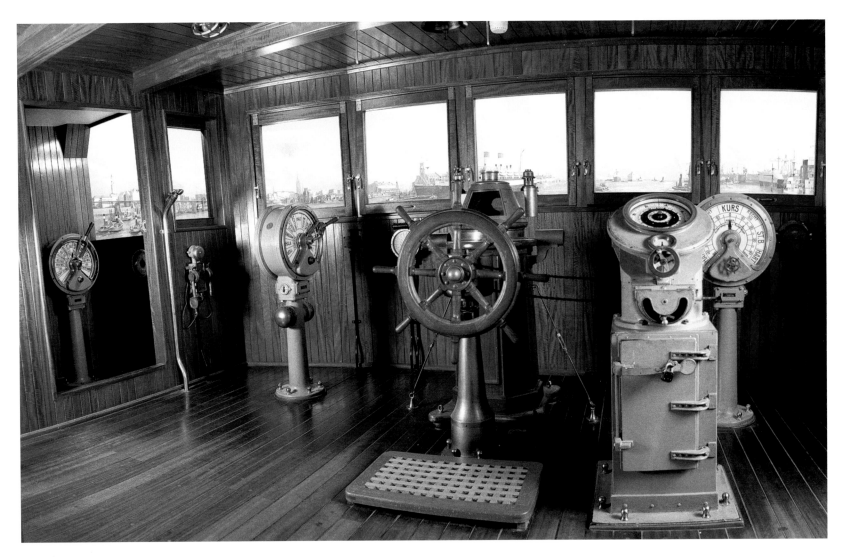

Mahogany and brass navigational and steering apparatus set the atmosphere in the wheelhouse of the TS *Adolph Woermann,* from the Blohm & Voss shipyard, Hamburg, 1922. The mechanical instruments have since been replaced by electronics and monitors.

A cutaway exhibit explaining the construction and anatomy of the technology. This cross-section of a compass was originally created for the 1906 World's Exhibition in Milan.

The 12-cm-thick steel walls of the diving bell with which Jacques Piccard explored the ocean depths in the Marianengraben convey some idea of the enormous power of the deep sea.

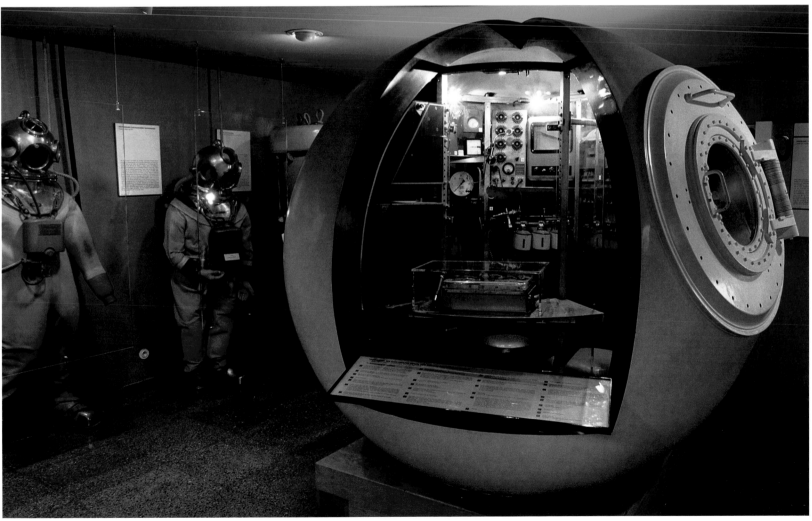

Railways

"Railways kill space, leaving us just time. If only we had enough money to kill off the latter decently as well. You can now get to Orleans in 4 ½ hours, or to Rouen in the same time. What won't we have when the lines to Belgium and Germany are completed and joined up with the railways there! It's almost as if the mountains and forests of all the world were getting closer to Paris. I can already smell the scent of German lime trees. The North Sea breakers are pounding at my door."

Poet Heinrich Heine, writing from exile in Paris, 1843

The modern world was created in the nineteenth century. Natural philosophy and science joined hands with a modern, liberal form of economics and an ever more libertarian social order to establish the basis of the new, dynamic age. In England and France it was textiles, in the USA and Germany the railways that spearheaded the turbulent process of industrialisation. The emblem of the Industrial Revolution was the machine. In its wake came mechanisation, division of labour and not least the ever denser network of rails linking industrial centres.

Railways were an essential form of transport in modern industrialised societies. Without them, we would not have been able to transport such huge flows of goods. Like the whole industrialised era, railways were driven by steam and fired by coal, the supreme source of energy in the nineteenth century.

Much has changed since then. Railways are now one form of transport among others, while steam has long given way to more efficient sources of energy. Yet even today, railways are

indispensable forms of transport for both passengers and goods. In fast, long-distance traffic they are still superior to cars, and without high-performance urban and suburban transport systems, traffic in cities and conurbations would be almost beyond managing.

Rail transport has been part of the Deutsches Museum's collecting, research and exhibition work right from the first because of its technical and economic importance. Railways are fascinating. The rail transport section has always been among the most popular departments of the Museum, a major reason for providing still more space for transport in the new transport centre on the Theresienhöhe. When the Museum opened in 1925, rail transport was initially accommodated in the main building, in the area now occupied by high-voltage technology.

From 1951, the department was reconstructed, but this time in a hall built in 1937, where at first the Museum's road vehicles were installed. The rail vehicles remain here until the move to the new transport centre. In 1969/70, the hall was rebuilt to provide two floors for railways and cars—a basement level was added for motor vehicles. In the middle of the hall a heavy-duty bridge was installed to accommodate a two-track 'museum platform'. The galleries of the Railways Hall housed a display about the history of rail transport and safety technology.

The close connection between the Deutsches Museum and Munich-based locomotive manufacturers Krauss-Maffei is reflected in the collection. The Museum possesses mainly locomotives made by this firm.

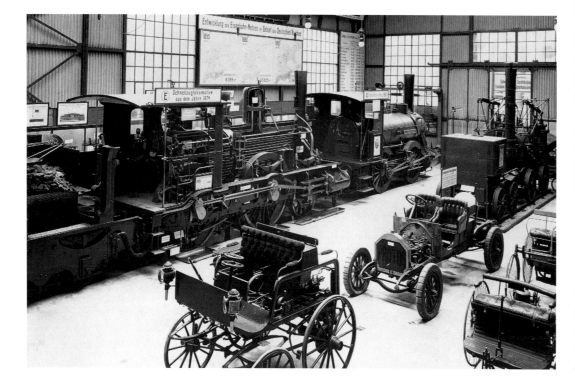

Vehicles, vehicles ... There was a section on the subject of transport even in the temporary collection of the Deutsches Museum in the Old National Museum. This photo was taken around 1912.

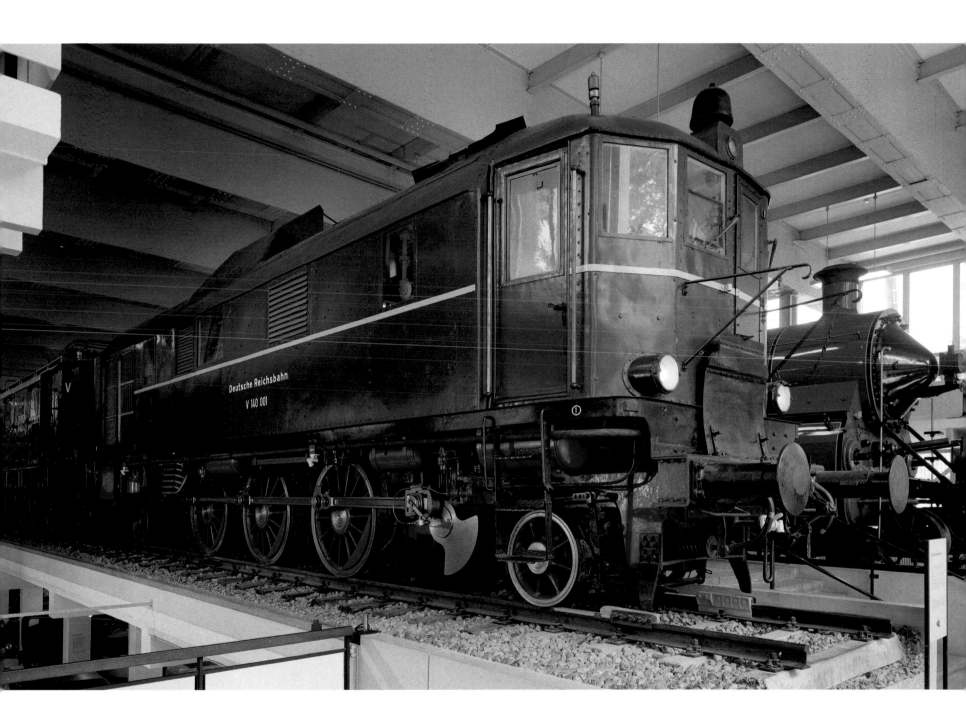

This was the railway department: two tracks
beside an island platform accommodated examples
of steam, diesel and electric traction.
Explanations of the historical background
were displayed in the gallery behind.

Railways

Many of the exhibits in the Railways Hall were either badly damaged or destroyed during the heavy air-raid on 21 July 1944.

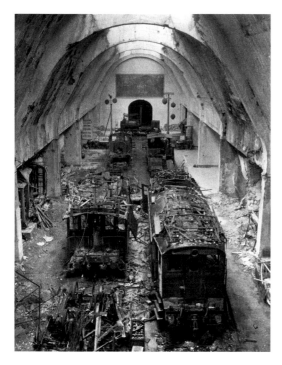

All types of traction are represented by high-status exhibits, but there is a preponderance of electric traction. The exhibits (which include the loaned E-44 class of locomotive) illustrate the thread of technical development.

The collection has a regional bias in that the history of electric traction is documented technically by means of Bavarian vehicles. In other respects, this regional focus is not pursued—the exhibition is about the history of railways in general.

The railway hall was an example of a classic German museum—visitors looked, were amazed and admired masterpieces of technology. But they were also able to touch, experiment and familiarise themselves. In exhibitions of the past, displays were supposed to be educational in their treatment of technology. 'How does it work?' was the principal question they addressed and illustrated with the objects on display. Pictures and texts slotted the technology of the exhibits into a general railway-historical context. Anyone who wanted to know more had to read about it.

There was a tradition of guided tours several times a day, when numerous exhibits were set in motion. For example, the replica *Puffing Billy* coal mine locomotive (converted to compressed air operation) could be seen in action, to show its original steering. Even the running gear of the large S 3/6 express locomotive could be operated for visitors to see the connecting rods in operation. Anyone particularly interested could set off the tamping machine, which proceeded to compact ballast with a great roar. Naturally, signals, bells and clocks were all operational and could be worked.

There was even a hint of cultural history in the railway hall—three carriage compartments impressively illustrated changes in travel over 70 years. This theme of the history of travel is taken up much more fully in the new transport centre.

The Museum's tradition of organizing presentations and demonstrations for its visitors will, of course, continue, as will the expansion of its collection with new and attractive exhibits, such as the IC Experimental, a compartment from Munich's first underground train, and a Pullman carriage from the Rhätische Railways. *le*

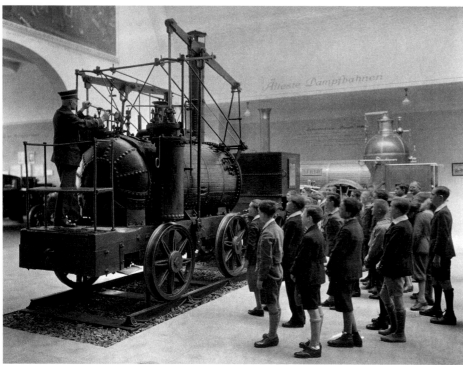

Watching, in amazement, and understanding technology: a group of schoolboys look on as a museum attendant starts up the *Puffing Billy* steam engine.

The rail traffic section draws visitors' attention to the historical development of the exhibits, above all, to the technical aspects and how the various construction types are connected. *Clockwise, from top left:* the engine of a cog-wheel locomotive; a *B IX* drive axle; the engine driver's place on the reconstructed *Puffing Billy* steam engine; the 'face' of the first electric locomotive by the Siemens company.

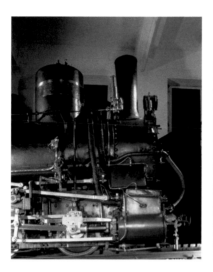
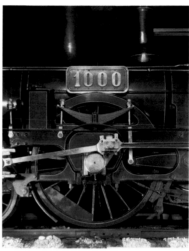

Railways

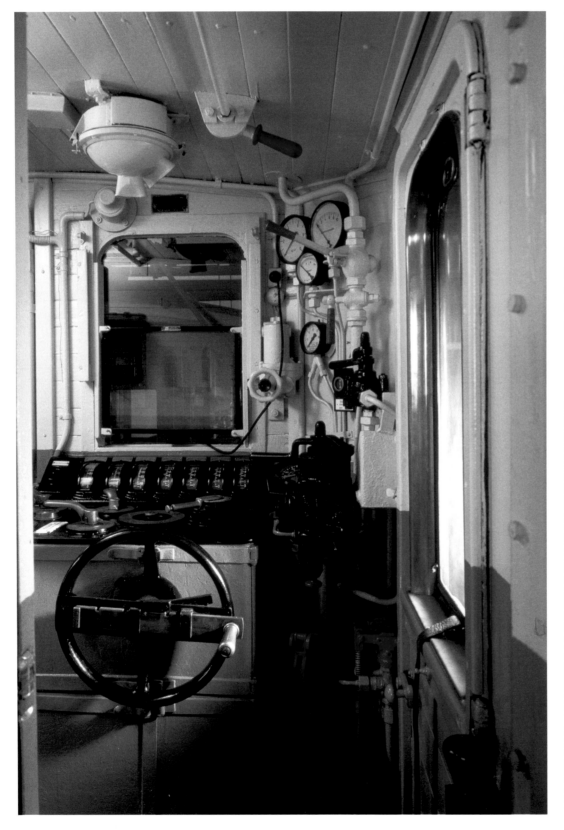

This is where an engine driver on an old-type electric locomotive such as the E 16 used to work: standing up in a narrow, spartan space. Compared to the open, draughty and dusty driver's cabin on a steam engine, however, it marked an enormous step forward.

Trains travel so that people and goods can be transported. Visitors to the Railways Hall are reminded of this by three compartments reconstructed according to original designs, which also illustrate the way travel has changed throughout the ages.

This photograph of the S 3/6 being brought into the Railways Hall shows that the Deutsches Museum is expert not only in the history of technology. Even now, the Museum works together with experienced removal companies to organize the transport of large and complex exhibits.

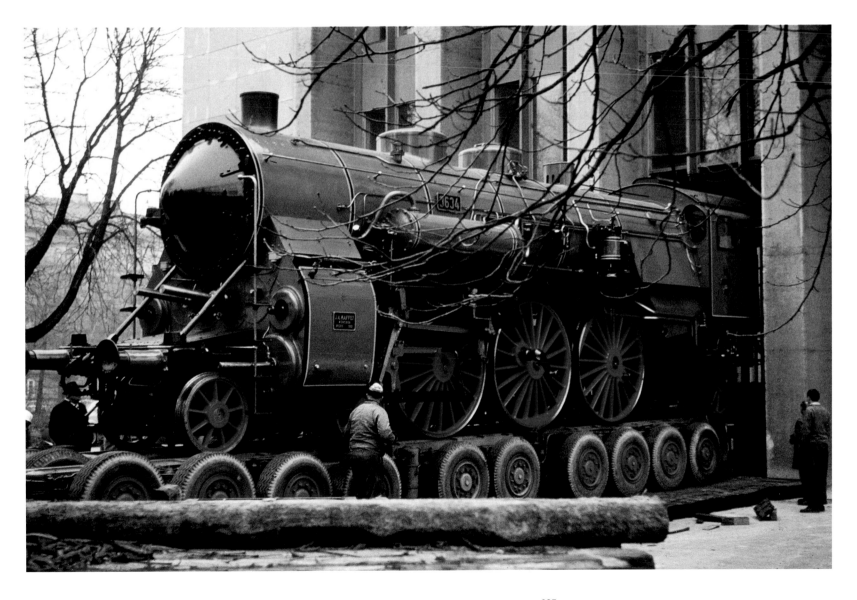

Automobiles and Motorcycles

Even Benz has built a car that runs on petrol, something that caused much excitement at the Munich Exhibition. This application of a petrol-driven engine probably has as promising a future as steam does as a means of locomotion for the horse and cart.

Jahrbuch der Naturwissenschaft (Natural Sciences Yearbook), 1888–1889

A century ago, cars—now our most important industrial product—were still so unimportant that the founder of the Museum did not think them worth a separate department. Until the 1930s, the development of road vehicles was just part of the section of land transport. Oskar von Miller didn't like cars. When he went on an outing with Rudolf Diesel, they went by bicycle. The inventor of the diesel engine never got the hang of the steering wheel, while the pioneer of electricity preferred trams. In the year the Deutsches Museum was founded, 1903, there were 183 motor cars in Munich and 186 motor bicycles. Their unreliability was a source of much merriment. In the words of one contemporary Munich jest, "… and a motor is a car that doesn't want to." Cars were still a long way from being technical masterpieces. The principal form of land transport was the railway. At first, there were more locomotives than cars in the Museum. After all, they ran at speeds five times those of the first cars and were admired accordingly. After the move to the Museum Island, the trains got a hall of their own, immediately to the right beside shipping. South of this a—car-free—transport hall of fame was set up. The area in between was occupied by two steam cars and seven petrol-driven cars. Most were Daimlers and Benzes. Though produced by the million, no Model T Ford was on show.

When Henry Ford visited the Deutsches Museum in 1930, the American car magnate (the world's richest man of his day) promised to donate a Ford. In advance, he gave Oskar von Miller, who up to then had refused to have anything to do with cars, his latest Model A for his personal use. He could hardly suspect this would bring him great misfortune—Miller's wife died as a consequence of a road accident with this car.

In 1933, Adolf Hitler came to power. On the occasion of a visit to a model armoured cruiser in the shipping hall, he criticised the meagre car display. "I love cars more than anything, because they opened up Germany to me" was the Führer's message beneath the imperial eagle and swastika in the new hall for German cars when it was opened in 1937. The high ceiling is carried on riveted steel beams as in a railway station, allowing copious natural light in through the large windows.

No German car museum has ever been laid out so liberally since. Unfortunately, visitors did not have long to enjoy it. During World War II, Munich was the target of numerous air raids. The 37 historic road vehicles were removed to less exposed places such as Seifriedswörth and Lenggries. They thus escaped the fate of the locomotives, which remained on the Museum Island.

Continued on p. 240.

During the course of the 20th century, the car developed into a consumer item.

Automobiles and Motorcycles

"German wood is fuel! Fulfil your national obligation. Drive on wood gas." This is what Germany was propogating as early as 1938, when the Adler *Diplomat* was still running on petrol. The addition of a wood-gas producing oven may not have made the car look more attractive, but certainly more suitable for the war and post-war period.

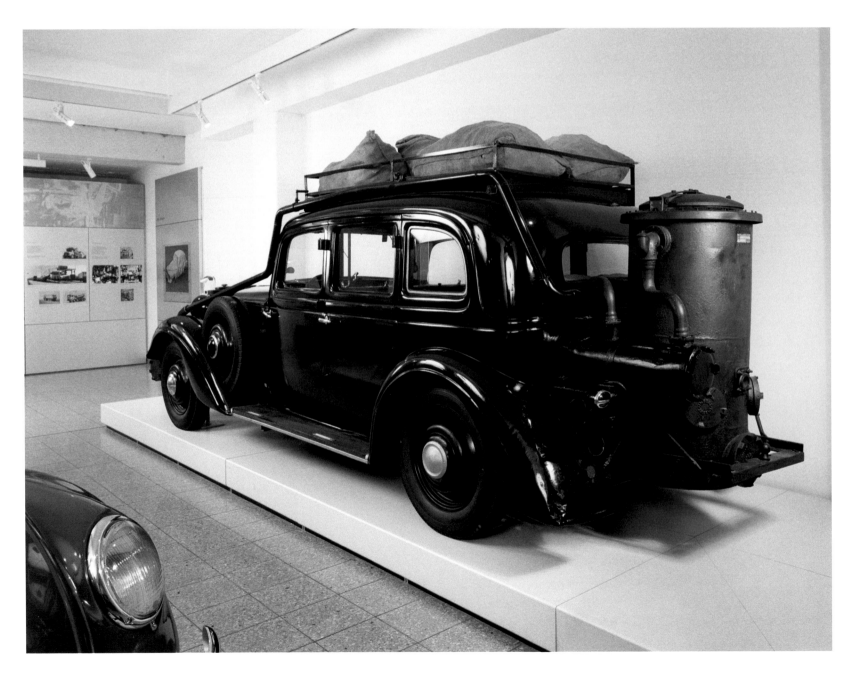

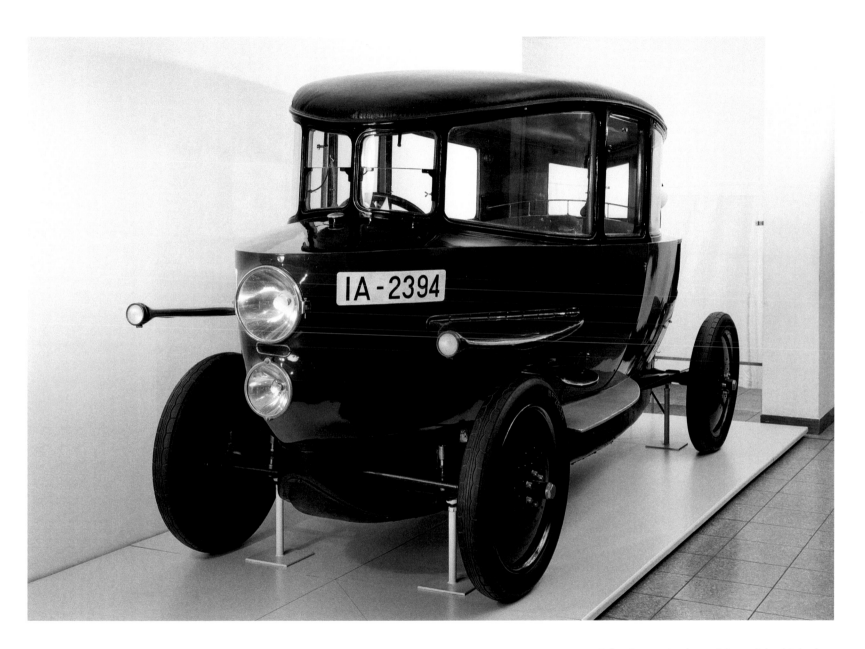

A floating car, is what a visitor might think when confronted with this unusual limousine. The designer, Edmund Rumpler, hoped to achieve lower air resistance and kick up less dust on the road with his aero-dynamic vehicle. These advantages did not, however, result in higher sales for the Rumpler 'Teardrop'. No more than 100 were sold.

Automobiles and Motorcycles

In 1944, the locos were severely damaged by hits from four bombs, one being completely destroyed. They were in part left under the rubble of the collapsed Railways Hall until 1949, after which they were no longer exhibited in their accustomed spot but went in with the cars, which by then had returned to their hall. The latter had also been damaged by atmospheric pressure from the bomb hits in the open-air area of the Museum. Once it was repaired, it provided sufficient space for all-round viewing of motorised road and rail vehicles for 20 years.

Space only became a problem when cars and their history grew immensely popular and visitors clamoured for more of their favourite children than hitherto. The question was, where could more space be found? So a cellar level was installed. In the 1970s, the car display again became cramped and the motor trade association VDA in Frankfurt started collecting funds for a future expansion.

In 1986, it became reality. The centennial celebrations of the first petrol car provided the occa-

sion, the rebuilding of the air and space hall provided the space. The reorganised display was opened by Bavarian Minister President Franz Josef Strauss with a paean to the car:

"Cars have become the object of political dispute … Ever since people have sought something to blame for damage to the environment, cars have been in the firing line … But those who expect salvation from banning cars are on the wrong track … 80% of private transport in Europe is currently by car … In opening a new hall for cars, the Deutsches Museum is marking a milestone."

The 2,200 square metres of exhibition space now contained 135 road vehicles, from the first motorcycle to the latest BMW limousine (the driving seat of which was installed and fitted out by robot). There were trucks, tractors and fire-engines as well. Nowhere was a century of motor technology illustrated so fully as here. The new transport centre on the Theresienhöhe will add more about the great engineering achievement of humanity. *hs*

Today's Railways Hall in 1937 was used exclusively to display motor vehicles.

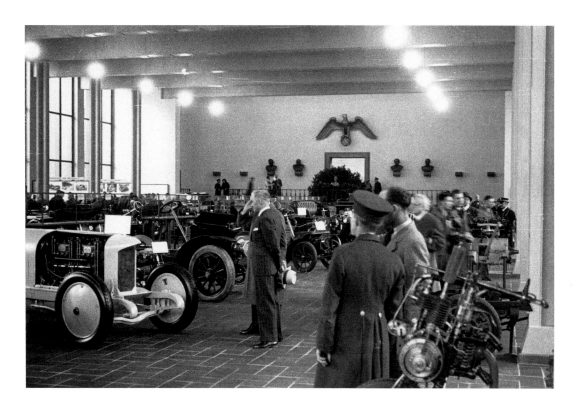

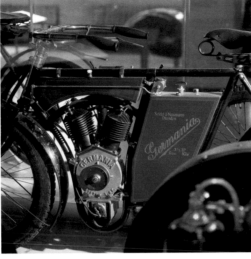

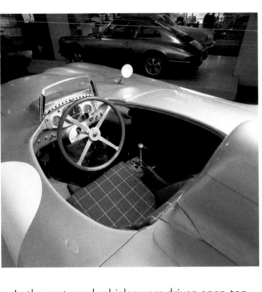

In the past, road vehicles were driven open-top—even in the early days of motorization. Man and machine were exposed to the elements. Did this mean more fun for those behind the wheel? Or more frustration? Either way, it involved more cleaning afterwards.

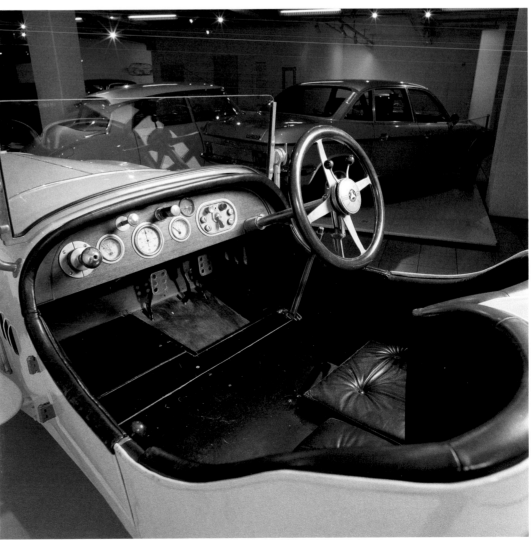

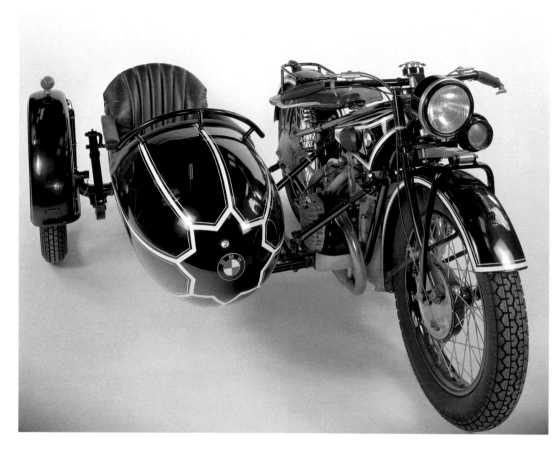

In Germany in 1928, there were more motorcyles than cars on the roads. Especially popular were motorcyles with sidecars, such as this BMW R 62 touring machine with a Royal sidecar.

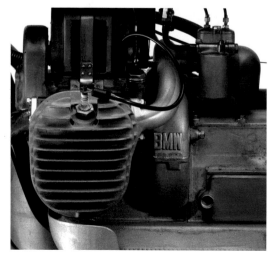

Two victorious Kawasakis being moved to
the new Traffic Centre, where they will be
shown to their best advantage.

Bridge Building

*"Everything in life is a bridge—
a word, a smile that we give to
others. I would be very happy if I
could be a bridge-builder between
east and west."*

From an interview with writer Ivo Andric,
winner of the 1961 Nobel Prize for
Literature for his novel *The Bridge over
the Drina*

Bridges create connections, bring people to-gether, leave their mark on cities and landscapes. They take knowledge and skill, courage and dar-ing to build. As works of art, symbols and monu-ments, they become part of the fabric of history. Bridges as Andric conceives them are present in many forms. They not only provide paths for us but they are also mentally present in our thought, language and action.

Their prime function is to create practical, good-value connections, but often they acquire fame as historic monuments or symbols, even entering popular sayings. Just as nature itself can create bridges, bridges can trigger off the human imagination. But most often, the bridge-builder's experience is that the confidence people have in him is constantly put to test anew. His experi-ence is based on ongoing learning from mistakes and occasionally tragic accidents.

Civil engineering is the practical application of scientific insights. Of its works, bridges in partic-ular are load-bearing structures in their purest form. Of course, the static and dynamic aspects need to be expertly settled before perfectly designed, aesthetic solutions come into play.

The bridge-building department dates back to the earliest days of the Deutsches Museum, when it was part of the construction industry section, whose subject matter used to range from building materials through house-building to domestic machinery. From 1905 to 1925, these displays were accommodated in the upper floor of the Schwere Reiterkaserne in the Zweibrück-enstrasse. The oldest surviving exhibits date from this period, for example the models of the stone bridge in Regensburg and the Kinzig Bridge near Offenburg in Baden.

Once the Museum moved into permanent premises in 1925, the bridge-building section moved into its now familiar location. At the time it was only a quarter of its present size, and it shared the space with the waterway, water con-struction, road-building and railways sections. Tunnel-building was also in the same place it now occupies. Other types of construction took

up rather more than half the space on the sec-ond floor. One model dating from the exhibits from 1925 is that of the pre-war Elizabeth Bridge over the Danube in Budapest.

When the Museum was rebuilt after World War II, bridge-building and road-building were reunited in a single hall, opened in 1959. A great number of the exhibits now on show date from this period, including the construction site mod-els of the Seine bridge at Neuilly. Shortly after it was opened, the hall was shut once again while the next-door section on waterways, canals and ports was rebuilt. By the time it reopened in 1963, further exhibits had been added. The dis-play then remained unchanged until September 1995, when it was removed prior to the forth-coming rebuilding.

The former display on bridge-building includ-ed a total of 194 bridge-building items: 26 origi-nal parts, 44 models and copies, 125 photos and a demonstration experiment. In content, the display was divided up according to building materials used. Huge copies of bridge compo-nents made of stone, wood, steel and pre-stressed concrete subdivided the section spatially as well.

In addition to bridge-building, which is the-matically included with civil engineering along with road and tunnel building and hydraulic engineering, the Museum also has a major col-lection of original items and models on the sub-jects of construction technology, house-building and urban infrastructure. Since the war, these no longer form a separate display, but over the years they have, one by one, been the subject of cura-torial attention and restoration work. Since 1998, they have been put on show at irregular intervals in the special exhibitions area.

The present display was opened in 1998. It focuses on load-bearing structures as the basic elements of bridges, together with the building methods and techniques used in practice. Three areas of display home in on the history of the three basic load-bearing types—arches, girders and cable suspension designs. Tracing history, the exhibition illustrates the development of

The display gives visitors the chance to construct arches playfully with building blocks.

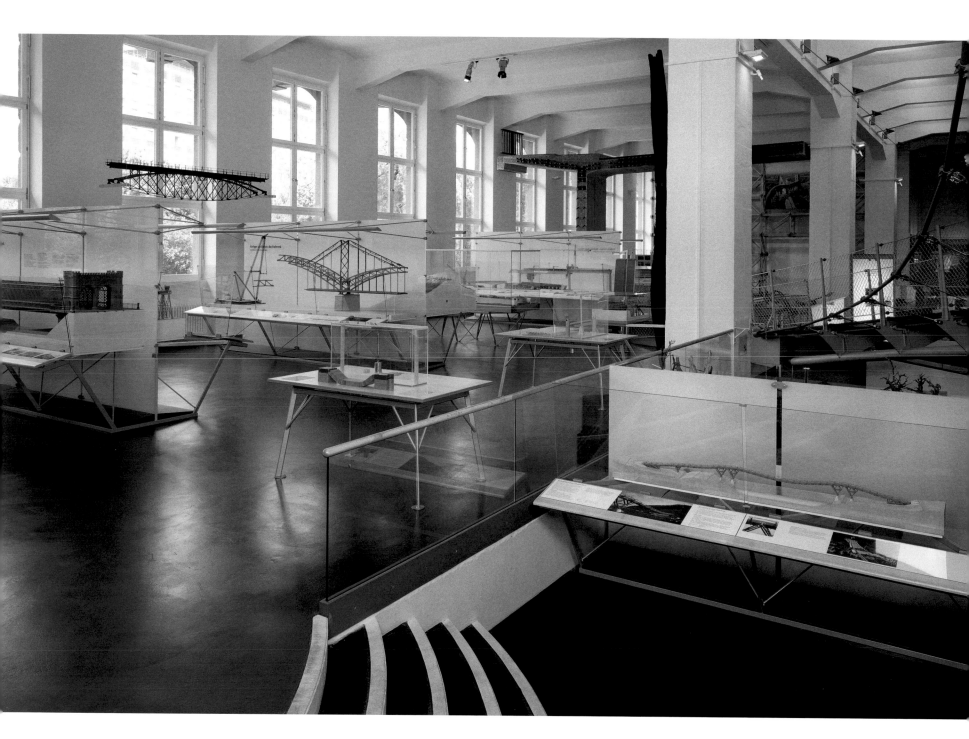

This view of the Bridges Room, which opened in 1998, shows the display of girder bridges. The cable anchorage of a foot-bridge and the model of a pre-stressed wooden bridge across the Main-Danube Canal in Essing can be seen on the right.

Bridge Building

these basic forms into ever bolder, lighter structures that are often impressive for their individual formal idiom and visual appeal as well. Technical progress and human creativity interact.

It was decided at an early stage in the reorganisation that a real, walk-on bridge should form the principal exhibit of the future exhibition. This was not just a matter of symbolising the subject matter. The intention was just as much to bring home the uniqueness of an actual bridge that would draw on the technical opportunities of modern bridge-building and present it as an experience. Implementation was undertaken by Professor Jörg Schlaich, and the result is masterful, both technically and aesthetically.

The principal exhibits of the new display are 19 original items, 30 models, five reproductions, one diorama and 11 experiments, plus five audio-visual presentations with films and computer animations. Some of the exhibits came from our huge reserve stock, which were put through the Museum's workshops for restoration before going on display. These items form

mainly the historic part of the display, but some exhibits were acquired new or specially made. As three-dimensional objects, these are the highlights of the display, and they are backed up by around 300 illustrations. A video room with seats shows films about wind-tunnel tests, the construction of large suspension bridges and the technical opportunities of bridge-building.

The eleven demonstrations and experiments that explain the load-bearing behaviour of the bridges exhibited are thematically allocated to one of the three load-bearing types mentioned above (arches, girders and cable suspension designs). They were tested with visitors even during the construction phase, so that the best possible and above all long-term use is ensured.

db

In 1996, during construction of the bridge across the Great Belt, this cable spinning wheel was still being used to position the main cable. In 1997, it was brought straight from the construction site to the Deutsches Museum.

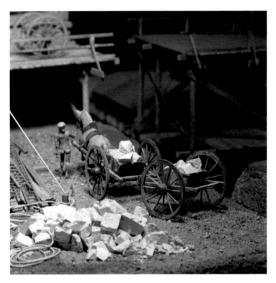

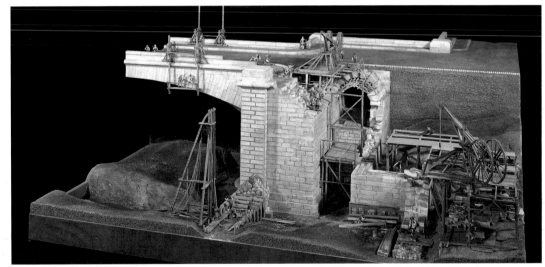

The construction of the bridge over the Seine near Neuilly from 1768 to 1772 was extremely well documented by the architect, Jean Rodolphe Perronet. Based on his notes, the Museum workshops were able to construct one of their finest models in the 1960s. Shown in detail are the pile drivers (*top left*), the lifting devices (*top centre*), the 'prismatic' wagon (*top right*), a crane (*bottom left*) and the final stages of work on the completed bridge (*bottom right*).

Bridge Building

At the centre of the display is a bridge designed for the Museum by Professor Jörg Schlaich, Stuttgart. The two main cables of the circular ring bearer suspended from one side lead to a flexibly positioned mast. The traction cables over the tension beam are clamped into place on both sides of the bridge in cast-iron anchoring *(top right)*. The suspension cables are attached to the main cable to within a millimetre by high-grade steel clamps *(centre right)*. The three traction cables are passed through cast-iron clutches which are connected to the tension beam *(bottom right)*.

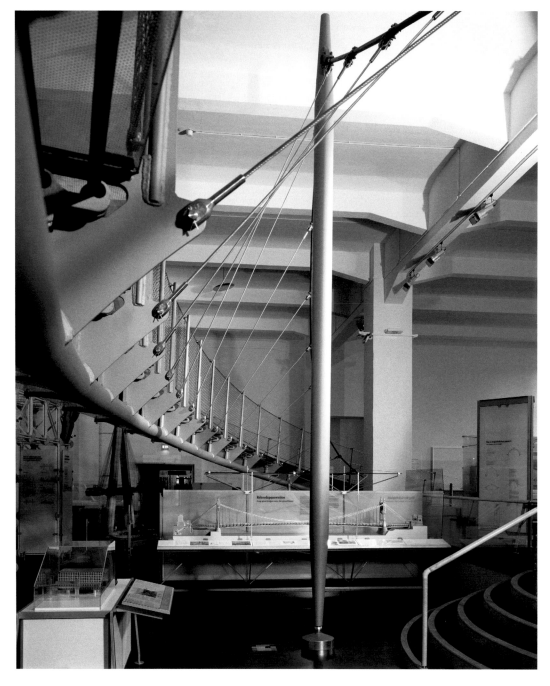

The new display simply had to include a model
of the Rialto Bridge in Venice, completed in 1592.
It was lovingly constructed with a great eye for
detail by the Museum Workshops.

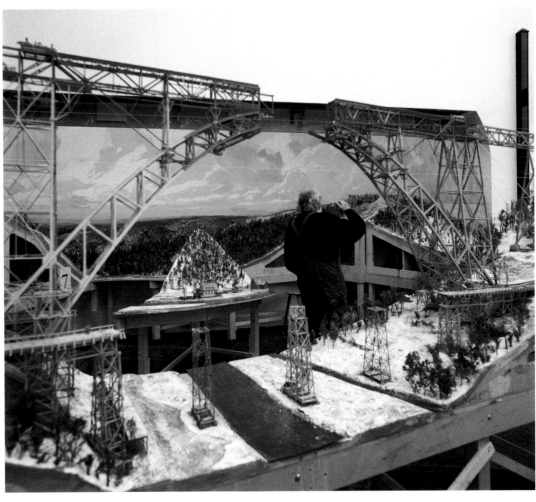

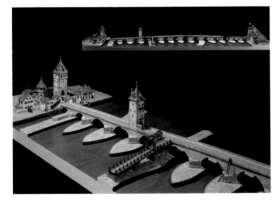

The model of the bridge across the Danube at
Regensburg shows the medieval construction the
way it looked in the mid-18th century. The model
was a gift to the Museum from Prince von Thurn
und Taxis in 1908.

Professor Günther Voglsamer at work on the
diorama background for the Müngsten Bridge.
The original was built between 1893 and 1897 and
is still in use today for railway traffic.

Hydraulic Engineering

"'It makes the desert beautiful,' said the Little Prince, 'if it has a well somewhere.'"

Antoine de Saint Exupéry, *The Little Prince*

The liveliest part of this exhibition is the entrance area with the twenty-five-foot high water sculpture, which with its elegant design and soft plashing of the water flowing down through a flight of basins lures visitors into the display area. As soon as they enter, children and young people make straight for the basin with the various water-raising devices—they turn the Archimedean screw, activate the hand pump and get the flow of water running to fill the buckets of the water wheel, which then empty into the outflow duct. A drinking fountain is at hand to quench the thirst. In short, visitors are still in the entrance, and yet all their senses are already alerted to water. On the walls there are things about hydraulic engineering and water management to read and look at before people finally move on to the detailed objects and experiments to do with building waterways, the use of hydroelectric power and even the mostly moveable models of structures built in water. *db*

These pictures show how much fun our younger visitors have with the element water.

In the foreground of this view is the imposing and unmistakable water sculpture, which gets the view attuned the subject of water.

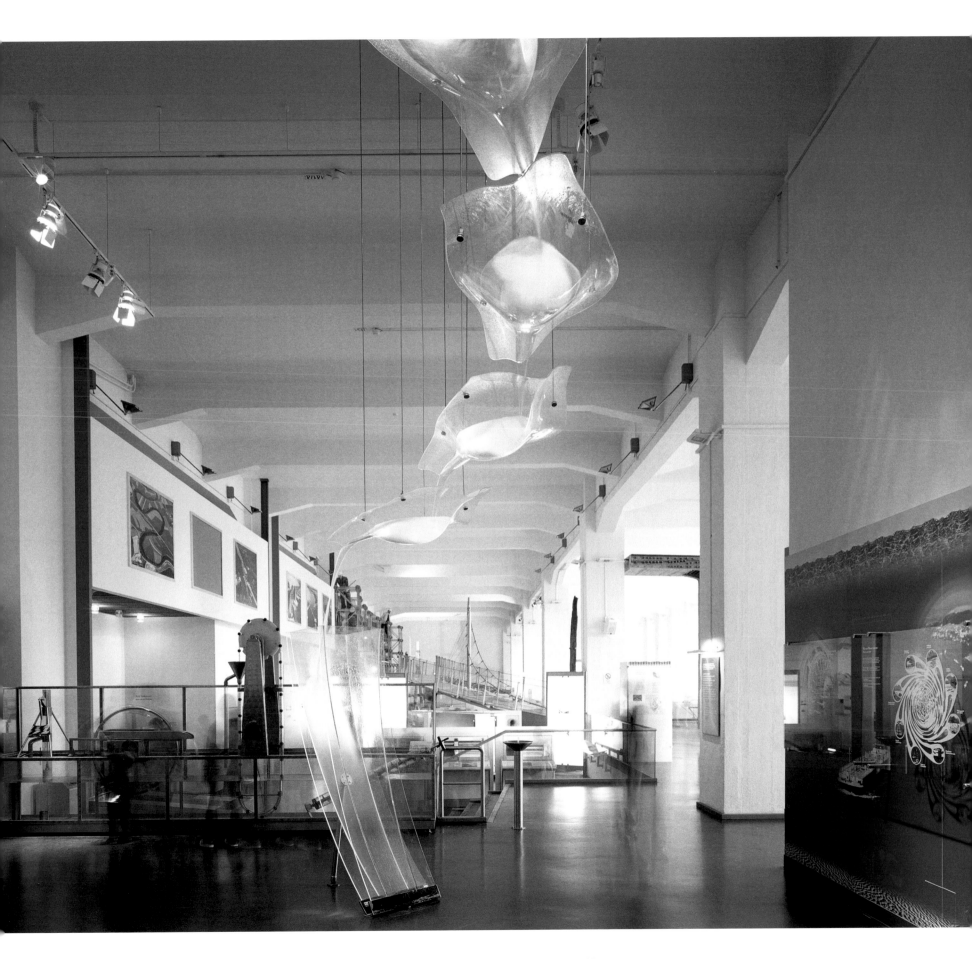

Aeronautics

*"Inventing a flying
machine is nothing.
Building a flying
machine isn't much either.
Putting a flying machine
to the test is everything."*

Ferdinand Ferber, 1904

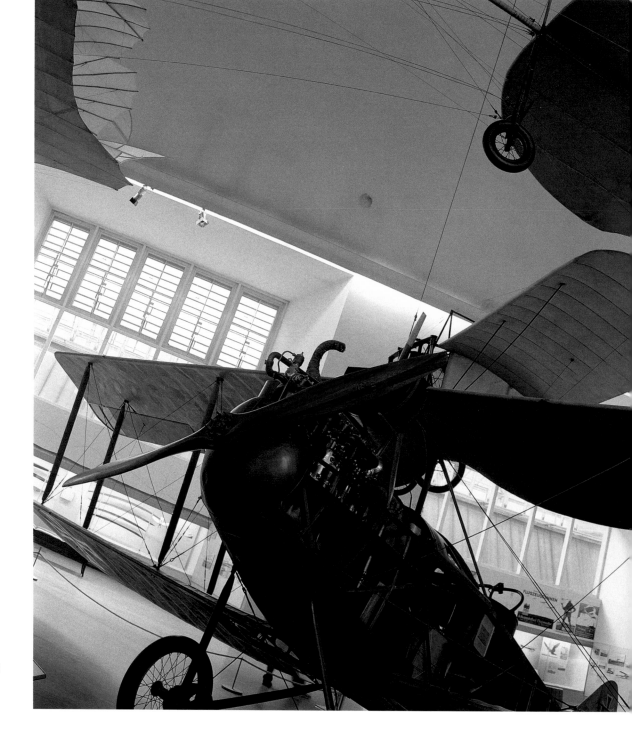

The Wright Brother's bi-plane symbolises the
birth of motorised flight. The Wrights performed
their sensational demonstrations in Europe
in 1908/09 in this plane.

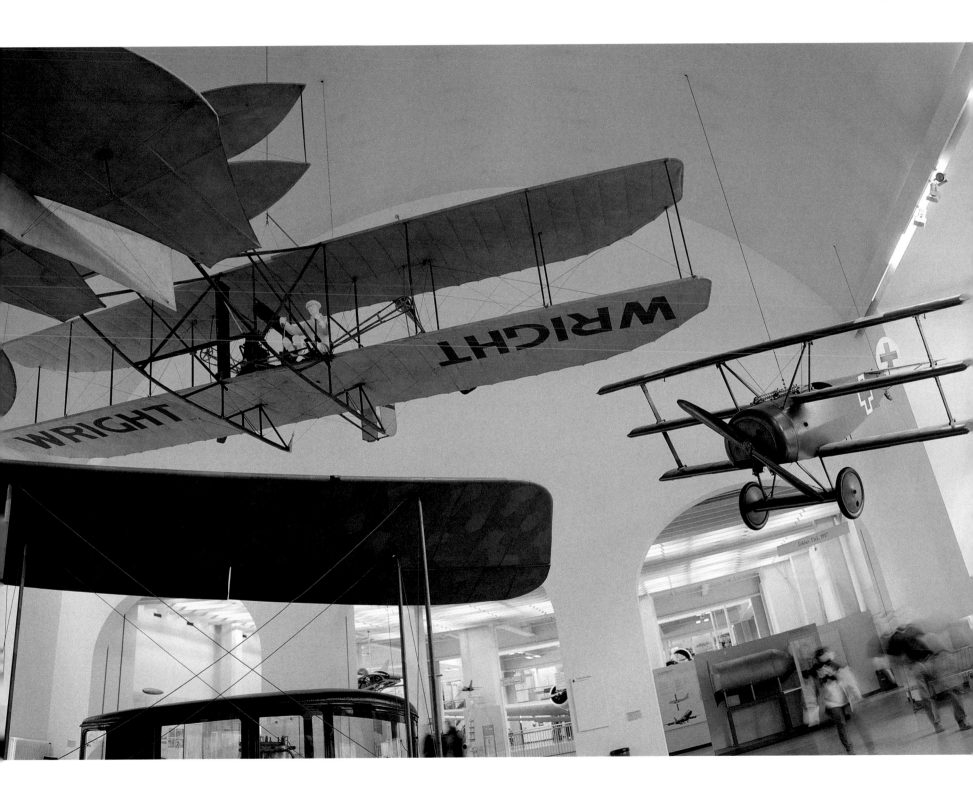

Aeronautics

In 1904 the French aircraft engineer Ferdinand Ferber described the increasing difficulties after the first successful flights by the Wright Brothers in going that last decisive step from concept to reality. In a nutshell, it also sums up the development from the initial 'dream of flight' to its actual realisation, beginning with ideas of flight based on imitating birds in the eighteenth century through technically sophisticated flying machines of the nineteenth century to the first airworthy powered flights of the twentieth century.

The Deutsches Museum tracks the development of aeronautical engineering under the headings Flight in Nature, Balloons, Airships, Parachutes, Dragons, Aircraft and Aircraft Engines. Aeronautics has always been seen as a modern technology, and it merited a very detailed display even in 1906.

Further milestones in aeronautical engineering were quickly integrated in the display as Masterpieces of Science and Technology. Among exhibits were Otto Lilienthal's glider, the gondola of the first Zeppelin airship, the Wright Brothers' first series-production motor engine, the first all-metal aircraft by Hugo Junkers and the first prototype of the Airbus wide-bodied aircraft. Prominent pioneers, scientists and industrialists of aviation—including Ferdinand von Zeppelin, Hugo Junkers, Ludwig Prandtl, Claudius Dornier, Hugo Eckener and Ludwig Bölkow—joined in to support the Deutsches Museum as comrades-in-arms.

Apart from the flying machines, demonstration models illustrate the technology of aircraft and theoretical considerations such as aerodynamics.

The aviation section was modernised and substantially expanded with the first extension building of the power-war period, a new three-storey air and space hall on Museum Island completed in 1984. The section on astronautics dates from this time. Additional display space was subsequently acquired at the historic airfield at Schleissheim on the outskirts of Munich, opened as the first offshoot of the Museum in 1992. With this expansion, the air and space section became the largest and most popular display of all. *whz*

The science of flight is made clear in many different demonstrations. An experiment in a wind tunnel shows the pressure to which a wing is exposed.

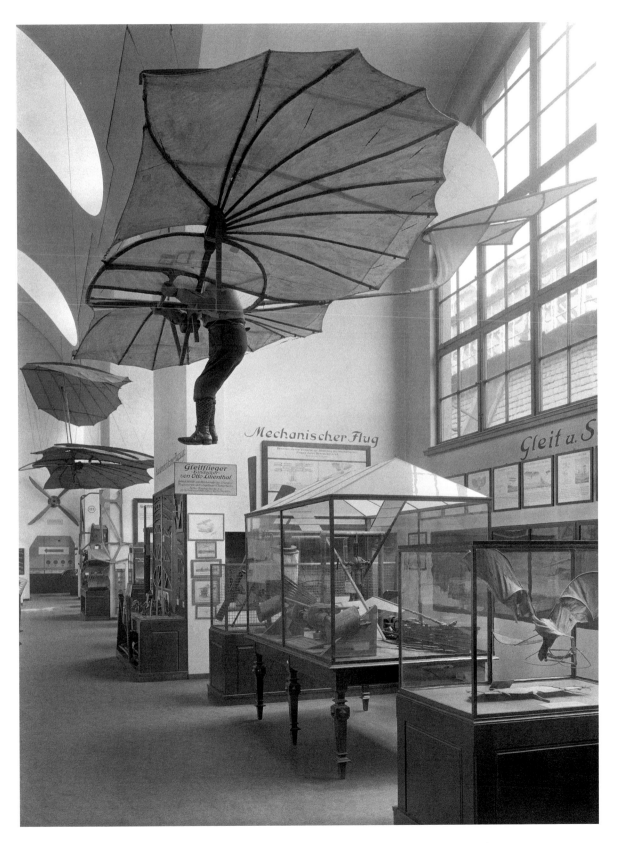

Otto Lilienthal's glider marked the beginning of man's flight through the air. Lilienthal constructed and sold several of these hang-gliders—the first of their kind to actually work.

255

Aeronautics

A view of the aeronautics hall from a modern
helicopter pilot's cockpit.

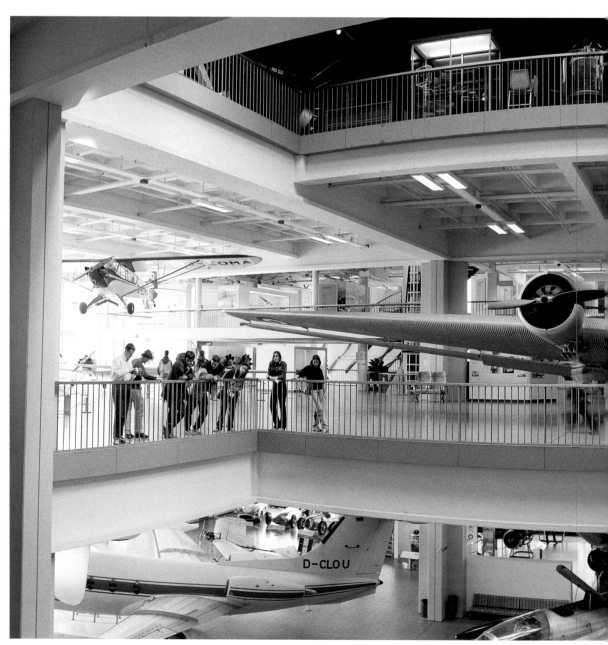

The new three-storey air and space hall is open and clearly divided into different sections. Even large aircraft can be shown in their entirety such as the civil transport plane the Junkers Ju 52.

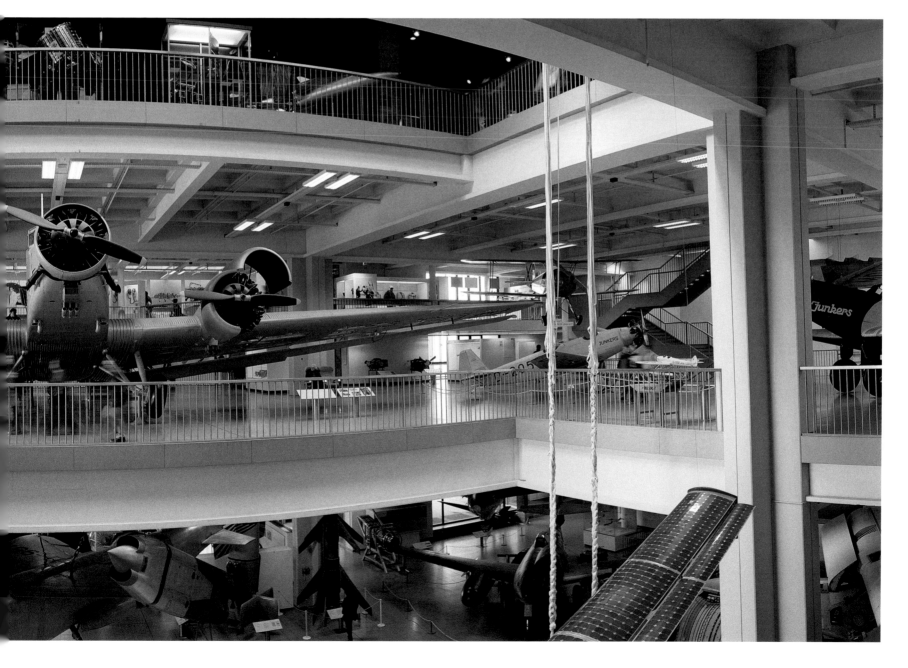

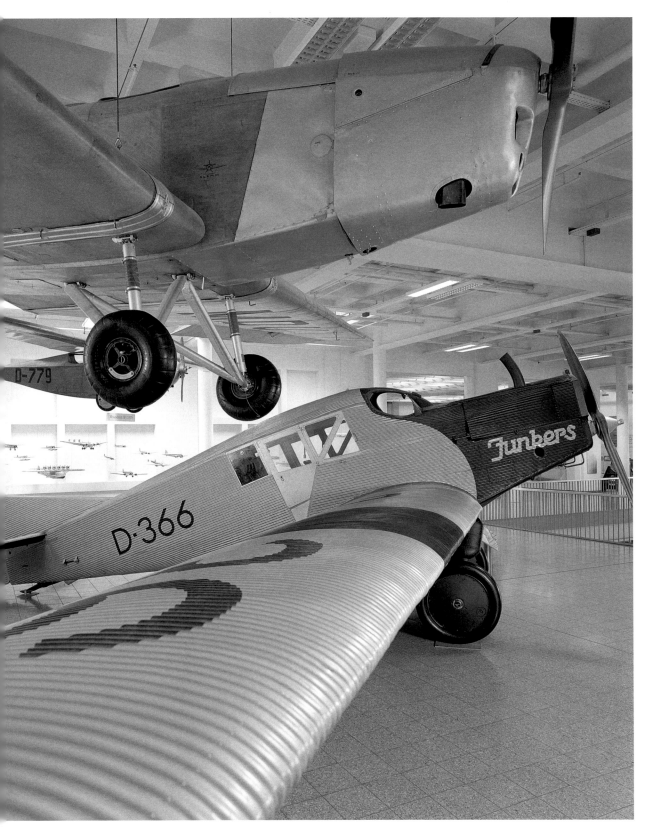

Hugo Junkers was the first to break with tradition after World War I: instead of using 'flying boxes' made of material stretched over a wooden frame, he constructed the first civil transport planes made of aluminium and corregated iron sheets.

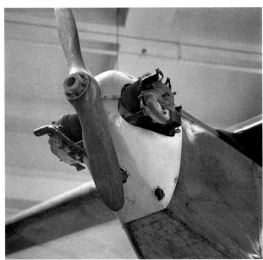

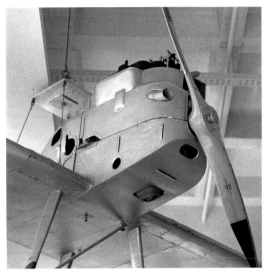

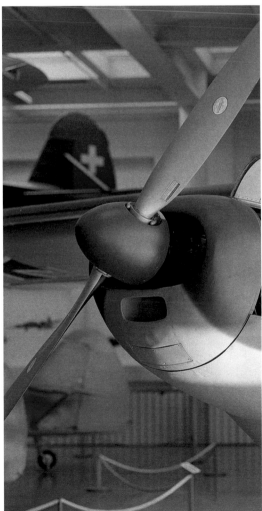

The streamlining of the engine and the shape of the propeller are crucial to a plane's economic viability.

Aeronautics

Original sections from the first prototype made for
the European airbus include a wing, a part of the
back of the plane, an engine and an undercarriage.
They clearly show the dimensions and complex
construction of a large modern passenger plane.

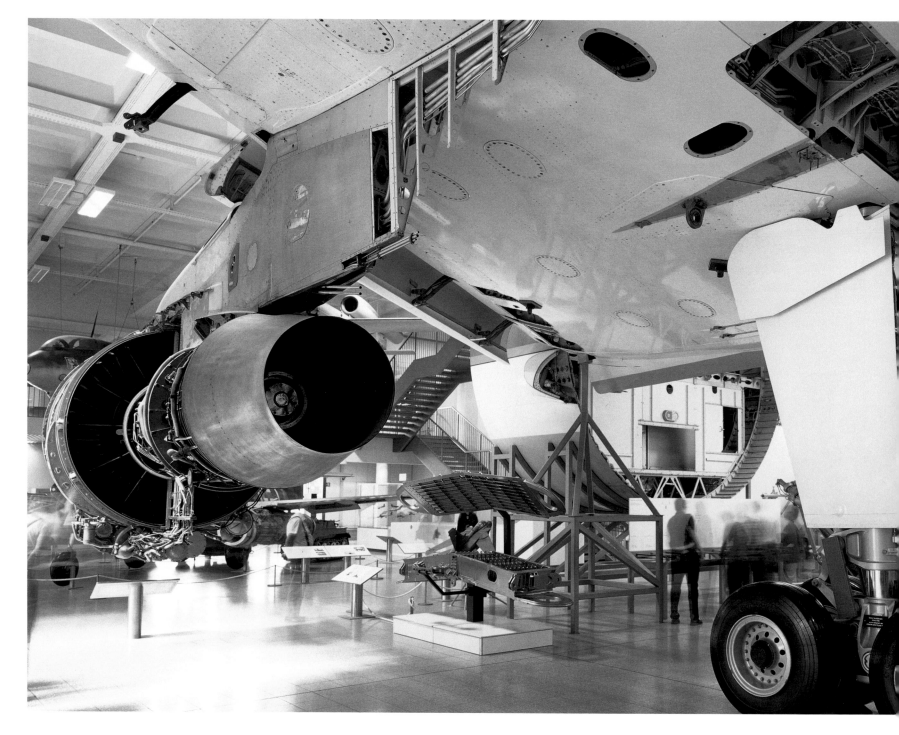

Steel engines propel the planes of today. Vast quantities of air are drawn in through the slits and enormous amounts of hot gas are then expelled at high speed through thrust jets.

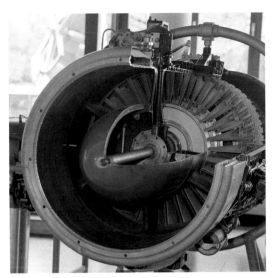

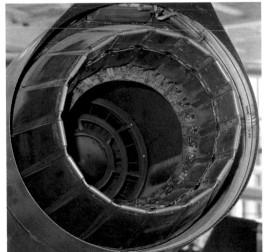

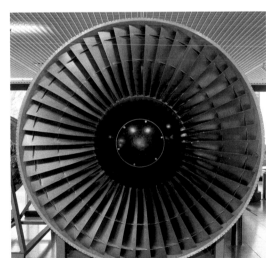

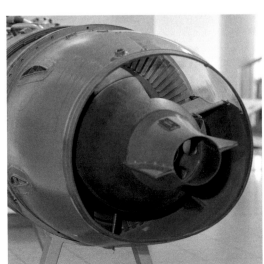

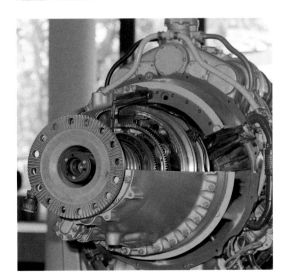

Astronautics

"This time when I looked out, the sight I saw was unforgettable. In the deep black that surrounded our spaceship a narrow crescent of delicate turquoise opened up. As each second passed, the crescent grew, gleaming transparent blue before fading and expanding—not into a rainbow but into a radiant hemisphere. I was experiencing my first real cosmic sunrise."

The German astronaut Sigmund Jähn, on his space flight, 1978

Deutsches Museum-founder Oskar von Miller would undoubtedly have merely nodded without surprise if someone had told him in the 1920s that there would one day be a separate department in the Museum recounting man's first steps on the moon. Even so, there were contemporaries of his who did believe that rockets would not work in a vacuum. The transition from space travel fantasies to a serious engagement with the physics of rocket science and its technical improvement came with Hermann Oberth's work *By Rocket into Interplanetary Space* of 1923. Oberth deployed precise mathematical calculations to demonstrate that space travel was technically feasible.

The Deutsches Museum initially treated the new technology with some caution, and no separate display was planned at that stage. However, exhibits were collected, and valuable historic pieces that entered the collection even before World War II include Alfred Maul's camera of 1906 and Max Valier's rocket car of 1929.

It was not until 1963 that a special display of rocket technology and astronautics was set up in the Deutsches Museum in the wake of the first spectacular successes of space travel. Many visitors had their first sight of a V2 rocket, which at that time was still an object shrouded in mystery.

It took a new museum building to do justice to the rapid development of aeronautics and astronautics. A new hall was added to the existing historic building, and this opened in 1984. With 1,110 square metres of floor space, space travel now had a permanent place in the Deutsches Museum.

Equally in demand from visitors and employees these days are the latest photos from the digital receiving station for weather satellites, which—along with the latest addition to the display 'German Space Researchers'—is a highlight of the department. *mk*

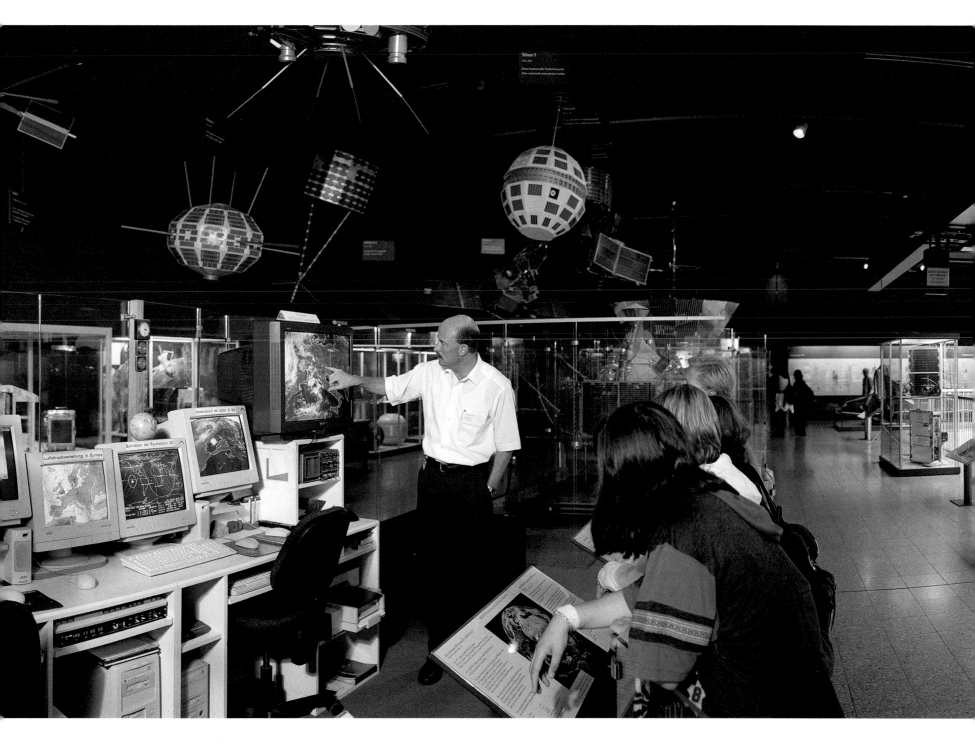

This station receives digital signals from the geo-stationary European METEOSAT weather satellite and from the NOAA satellite circling above the polar region. Computers use the signals to update meteorological reports.

Astronautics

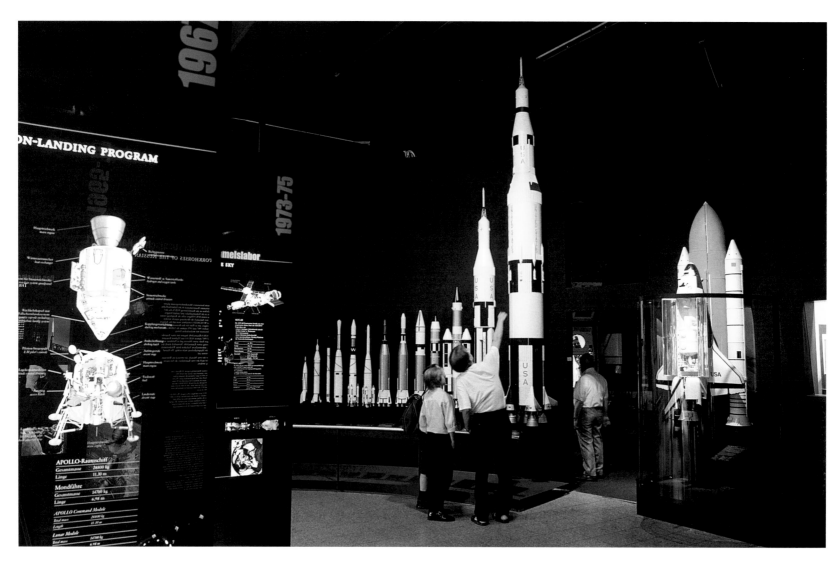

Launch vehicles in comparison: from the V2
to the U.S. Space Shuttle.

This moonstone, brought back by the crew
of Apollo 17, was given to West Germany
as an official state gift by U.S. President
Richard Nixon.

In 1965, Russian cosmonauts and American astronauts performed their first spacewalks. This reproduction commemorates Edward White's spacewalk on 10 June 1965, during the Gemini 4 mission. White spent 22 minutes floating in space, attached to his spaceship by only a supply line and a holding cable.

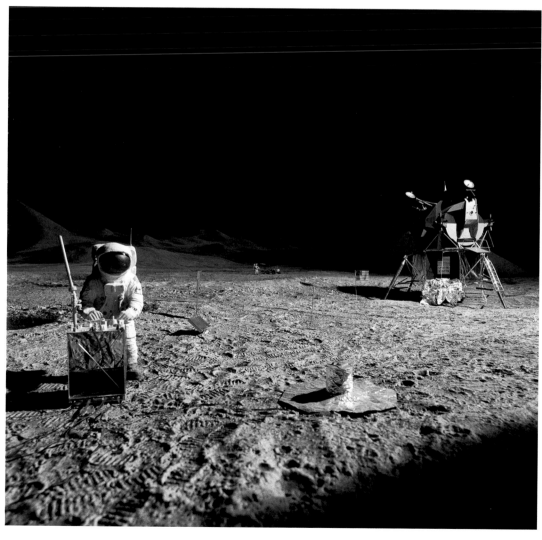

Diarama of the APOLLO 15 moon landing.

Astronautics

Visitors can create a small quantity of oxyhydrogen by turning a dynamo to generate electric current. The explosion that this causes is enough to propel a small wooden rocket upwards.

This rocket-sledge by Max Valier, 1929, is one of the oldest exhibits in the display. Valier used to shoot across the frozen lakes of Upper Bavaria in this vehicle to publicize the use of rockets as a means of propulsion.

Helios space probes, constructed in Munich, and put into operation in 1974 and 1976 to explore the closer regions of the sun. A third probe is on display at the Deutsches Museum.

Schleissheim Airfield (Flugwerft Schleißheim)

"Leaning on one of the two wings of the machine, instantly recognisable, stands Blériot, cool as a cucumber, closely watching his mechanics working on the engine. Can he really intend to take off in that? People doing it on water for example have it much easier. They can practice first on puddles, then in ponds, then in rivers, and venture out to sea only much later. In this case there's only a sea."

Franz Kafka, *The Aeroplane in Brescia*, 1909

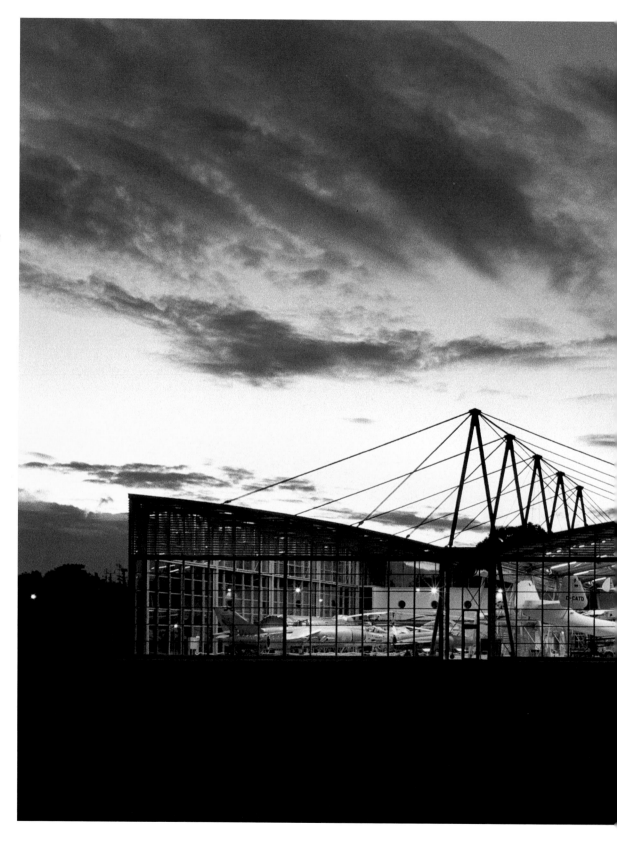

Functionality and transparency characterise the new exhibition hall. The supporting cables recall some early types of plane.

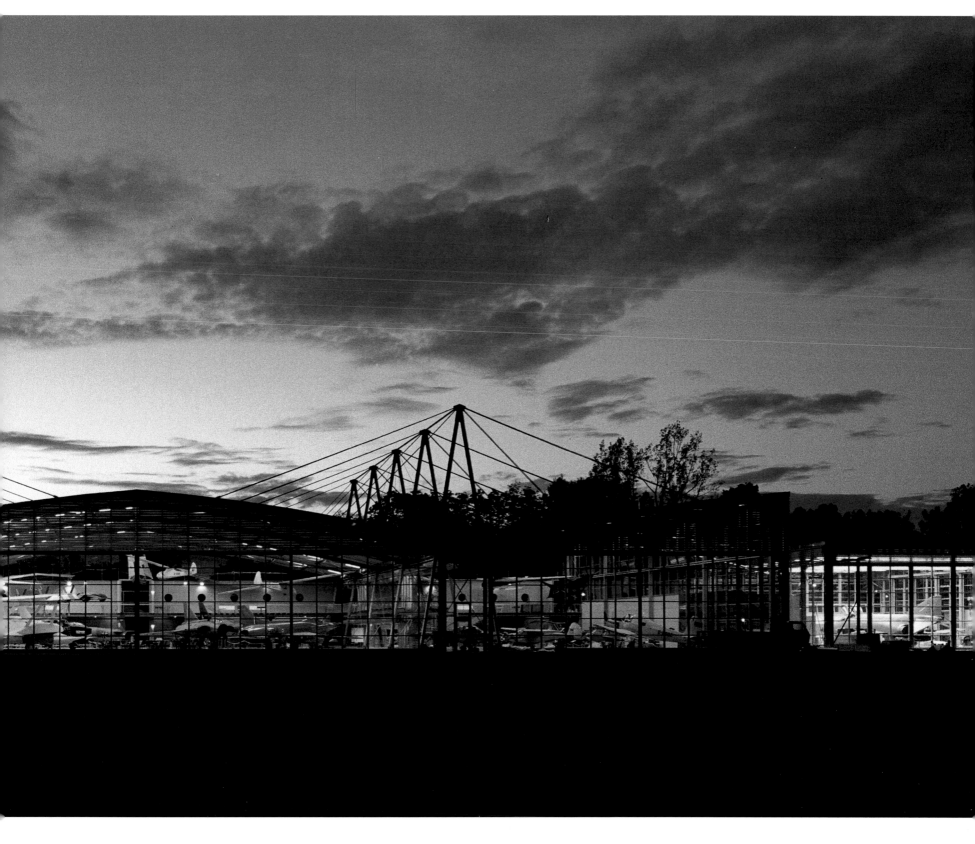

Schleissheim Airfield

In his account of flights from Brescia, Franz Kafka notes the sheer bravado of the first pilots, who exposed themselves to great danger in rickety flying machines. Some months earlier, Louis Blériot had crossed the English Channel in an aeroplane. It was the first time a pilot had flown over sea, where landing was impossible. The feat triggered off a fever of flying, and flying competitions were organised, aircraft factories and flying schools sprouted from nowhere and airfields were established. Initially, aircraft had no obvious application. Flights were spectacles to tickle the public's desire for sensation. Before long, however, the German military authorities recognised the potential of planes, and set up a flying school at the parade ground in 1910 in Oberwiesenfeld near Munich, though in 1912 the school was moved to Oberschleissheim. There, in the close vicinity of Schleissheim's palaces, a 'military flying station' for the new Royal Bavarian Flying Corps was established. It had an air-

field, aircraft hangars, accommodation buildings and an HQ building. These, together with the hangar built in 1918, form the core of today's museum at Schleissheim Airfield. These historic buildings are among the oldest surviving airfield buildings. As the importance of aviation grew, Schleissheim Airfield was steadily expanded, and it is still operational today. It is an excellent location to explain the history of aviation in Germany.

Schleissheim Airfield has been a branch of the Deutsches Museum since 1992. In addition to the historic buildings saved from demolition, a new exhibition hall was constructed in a modern architectural idiom, with an attached restoration workshop. A viewing gallery allows visitors to watch restoration going on.

Schleissheim Airfield contains numerous exhibits from the development of aviation, supplementing the long-standing aeronautics display on Museum Island in Munich. Along with a display telling the story of Oberschleissheim and its facilities, the 6,500-square-metre hall has 55 aircraft and helicopters on show, together with numerous hang-gliders, aircraft engines and manufacturing facilities. *gf*

The historical hangar is at the centre of the museum. This photograph from *c.* 1930 shows the building then used by the German pilot training school for civilian aircraft.

The planes used by the German pilot training school were kept and serviced in the hangar. The workshops are arranged around the hangar.

Schleissheim Airfield

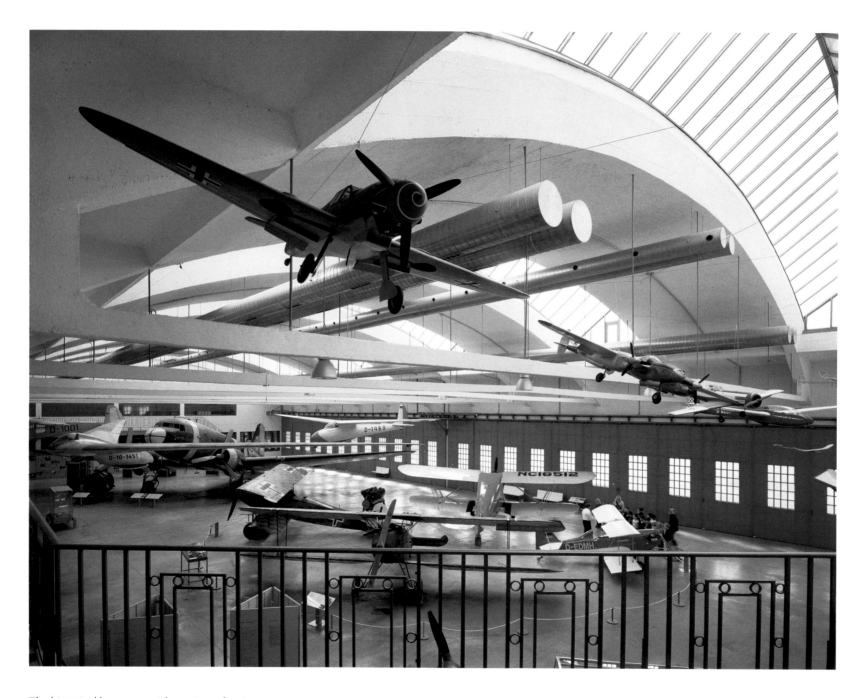

The historical hangar provides an introduction
to different fields of aeronautics: air-borne sports,
military aircraft and passenger transport.

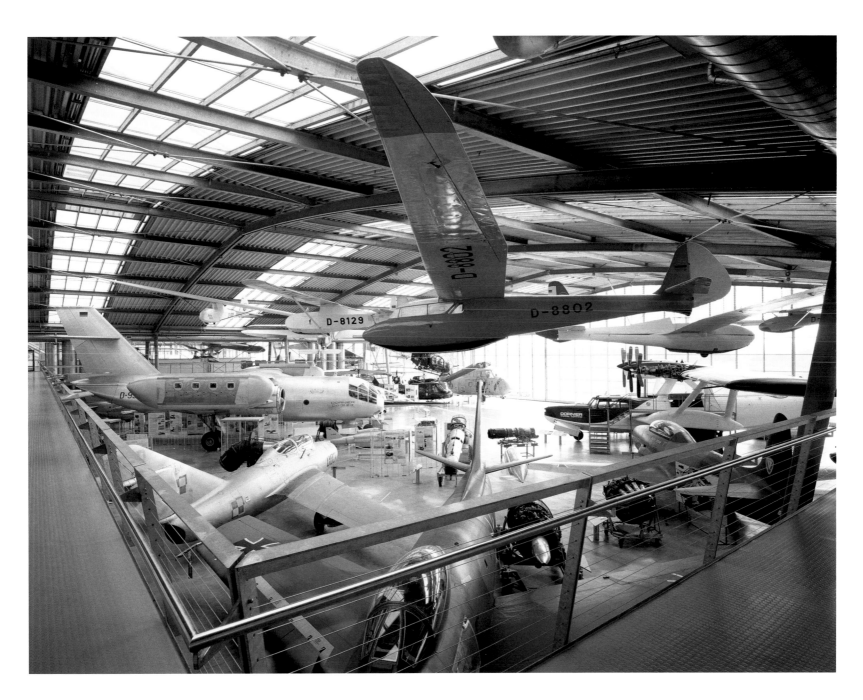

From the viewing gallery, the visitor can gain a general impression of the exhibits in the new hall before looking at the individual thematic areas in more depth.

Schleissheim Airfield

The restoration workshops at Schleissheim Airfield handle all restoration jobs on exhibits in the air and space sections at the Deutsche Museum.

Not all aircraft that arrive at the museum are in working order. Some, such as the 'Heinkel He 111' need the help of a transport helicopter while most exhibits are dismantled beforehand and transported by road.

Events and other activities underline the character of a 'living' musuem such as this hot-air balloon event at Schleissheim Airfield.

The Transport Centre (Verkehrszentrum)

"We need a new understanding of the world; we must learn a new view of reality so as to be able to develop networked strategies, models that are evolved from the system context and do justice to the complexity of our environment."

Frederic Vester

In 2003, the latest branch of the Deutsches Museum will be opening at the Museum's new Theresienhöhe facility in Munich, where three historic former commercial fair halls are being turned into a new Transport Centre. The Centre will be both a historical museum of land transport and a forum for transport matters.

The halls date from 1907/08, and are now listed as buildings of special interest in Munich's architectural history. They are, in their own right, fine examples of regional, large-scale trade fair architecture; Hall 3, for example, being among the first cantilevered reinforced concrete buildings in Europe. The three halls are being rehabilitated and restored in a phased programme lasting until 2005.

During their 90-year history as exhibition halls, the buildings hosted transport shows several times. One show of particular note was the German Transport Exhibition in 1953. Coming so close to the end of World War II, it demonstrated that the 'German economic miracle' was particularly based on the rapid motorisation of the population in the postwar period.

The Transport Centre will provide an opportunity to rearrange the extensive collections of land transport vehicles thematically within the contexts of transport and mobility. The displays provide information about the development of land transport to date and give a selective view of the concepts and technologies of tomorrow.

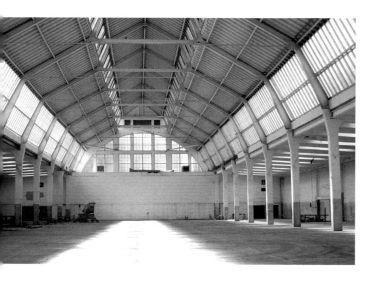

View of Hall 1 at the Transport Centre before restoration.

Halls 1 and 2 at the Transport Centre in 1998, seen from the front square.

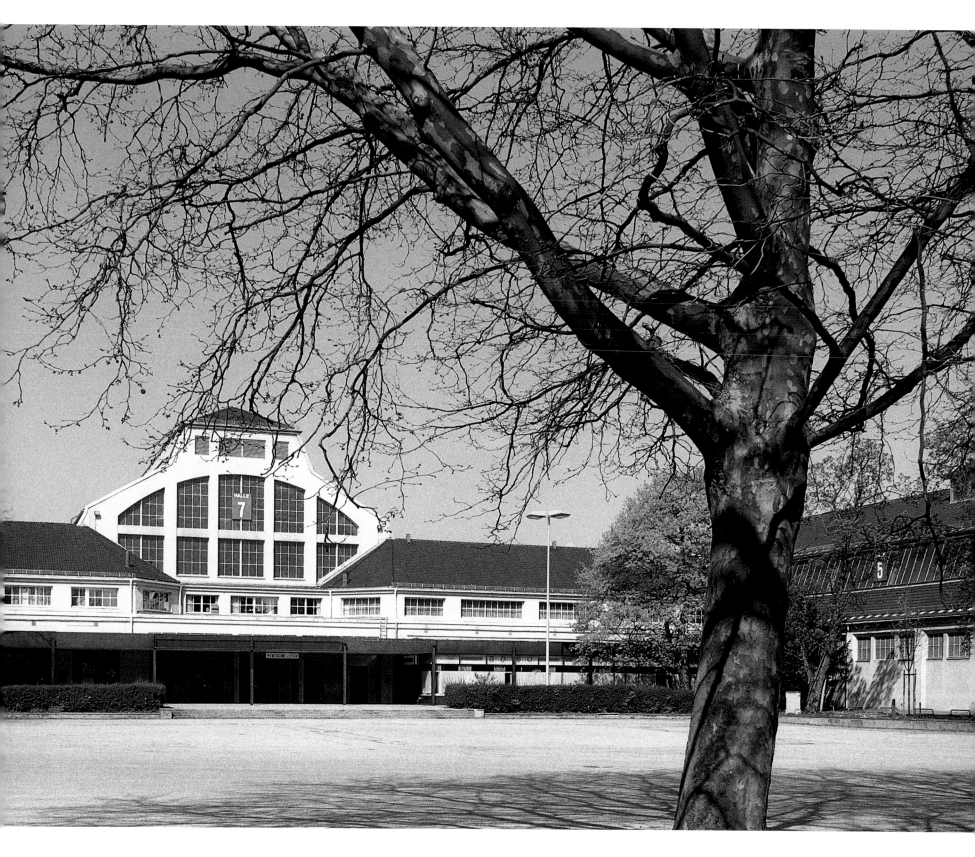

The Transport Centre

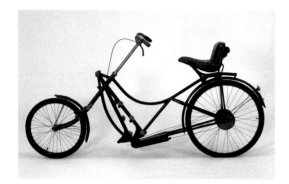

Jaray bicycle with swing pedals, 1925.

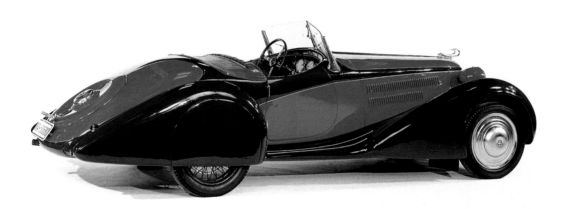

Alfa Romeo o6C 'Gran Sport' sportscar, 1931/36

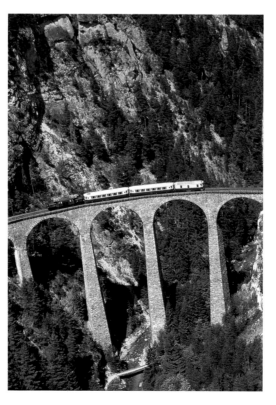

Nostalgic trip with the historical train belonging to the Rhätische Railways, crossing a viaduct, 1998. This rare locomotive, known as the 'Crocodile' (Ge 6/61), and a 1st-class carriage are to be shown in the 'Travel' exhibition hall.

Three subject areas occupy the three halls, which house the many large and countless smaller transport objects of the Deutsches Museum:
– Hall 1 focuses on urban transport. It contains a collection of horse-drawn carriages, bicycles, city cars, taxis, buses, trams and metro vehicles plus various more detailed displays illustrating the history and development of transport in conurbations.
– Hall 2 is devoted to travel generally: it contains the museum railway platform with several trains and the encircling 'long-distance road' with coaches, touring vehicles and caravans, coaches, motorcycles and bicycles, showing how the development of new means of transport and infrastructure creates new travel cultures.
– Hall 3, 'Mobility and Technology', looks at the physical and technical dimension of mobility. Motor racing has its niche here along with milestones of transport technology or the physical bases of driving.

Where possible, the design of the Museum takes up thematic interrelationships in special assemblies of exhibits and scenarios. These include a busy traffic scene from the late 1950s and an infrastructure cube in Hall 1, the museum railway platform, tableau of a historic filling station and travel bureau desk in Hall 2, a racetrack bend and moving figures in Hall 3— all of them are examples of a design approach of making the content visually accessible by means of special scenarios.

Nevertheless, the core of the display is still the exhibits. The use of media installations in the Transport Centre was therefore subject to considerable caution. They are employed only where they can bring transport to life and make complex concepts easier to understand or allow us to look at the work of researchers and transport planners.
bg

Design for the 'infrastructure' display in the urban transport hall.

The Transport Centre

Hands-on technology: this demonstration devised in our own workshops shows how a viscose clutch works.

Children in the Museum: an actor is telling stories about the different objects.

In the model building workshop a movement study is transformed into an exhibit for 'The Urge to Move.'

Deutsches Museum Bonn

"I am very pleased that this unique museum will also be able to keep its doors open to the public in the years to come."

Johannes Rau, Federal President of Germany

A big fat bag of air that saves lives? A plastic casing that keeps any screw in the wall? A prison for atoms? A clock that loses under a second in a million years? The Deutsches Museum in Bonn has them all—an airbag, a Fischer plug, a cage for ions and an atomic clock.

These and another 100 highlights from contemporary research and technology, including nine Nobel-prizewinning inventions and discoveries, have been on show here since 1995. This branch of the Deutsches Museum was set up—in its science centre—at the initiative of the Stifterverband für die Deutsche Wissenschaft.

It's a small but select collection. The museum, whose motto is 'talking to science and technology', has been a success. It's a good mix—a varied programme containing exhibitions such as 'Noblel! A Century of Nobel Prizes', series of talks with TV star Ranga Yogeshwar, lectures, museum nights, Hits for Kids, plus an innovative permanent museum display aiming at illuminating the cultural interaction of research with politics, the economy and society. The displays are divided up not by subject areas but according to five overall themes: basic research (Elementaries), technology in a divided Germany (Breaking the Ice), the ambivalence of research and technology (Between Heaven and Hell), interdisciplinary science (Frontiersmen) and applications-related research (Tradition and Vision). This means that interaction between subjects can also be depicted. Elementaries, for example, can range over discoveries from physics and chemistry or biology and medicine. A further 'element' that surprises most people is music. The 'mixing trautonium' is the lethal weapon with which composer and physicist Oskar Sala composed the menacing sound effects in 1961 for Hitchcock's thriller *The Birds*.

The Bonn museum opted to make extensive use of modern media for its displays. News reader Ulrich Wickert and his ex-colleague Sabine Christiansen present fifteen-minute infotainments on current issues in technology. At the press of a button, visitors can obtain information

The Transrapid TR 06 right outside the main entrance has become a symbol for the Deutsches Museum Bonn. The actual exhibition rooms are on the level below the science centre, occupying a space of around 1200 square metres.

283

Deutsches Museum Bonn

about exhibits and have complicated technologies explained to them, whether it's the hover principle of the Transrapid, or the orbit of particles in the first European accelerator, the 500 MeV synchrotron of the University of Bonn. A board game illustrates the works of antibodies in the fight against viruses, with the work for which Georges Köhler won the 1984 Nobel Prize for medicine being explained in the form of an interactive experiment. In the 'technical dialogues', Helmut Schmidt, Artur Fischer, Konrad Zuse and other prominent figures bring contemporary history to life, while in the Im Dialog internet magazine you can just click the mouse to drill a hole or affix a Fischer S-plug.

The Museum's small but motivated team has set itself the goal of making modern science and technology an experience. This will make it a focus of interest not just in the Bonn museum landscape.

an

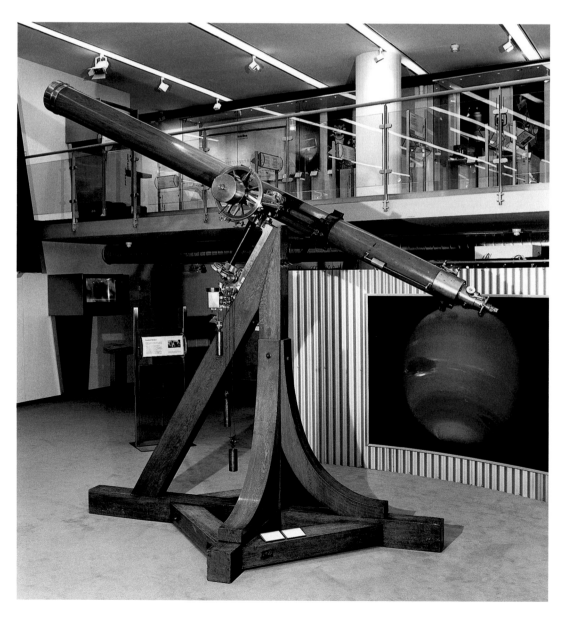

A visitor from Munich: as part of the successful series of exhibitions on 'Masterpieces from the Deutsches Museum' in 1998 and 1999, a number of important collector's pieces found their way to the museum in Bonn, such as Joseph von Fraunhofer's refractor *(left)*.

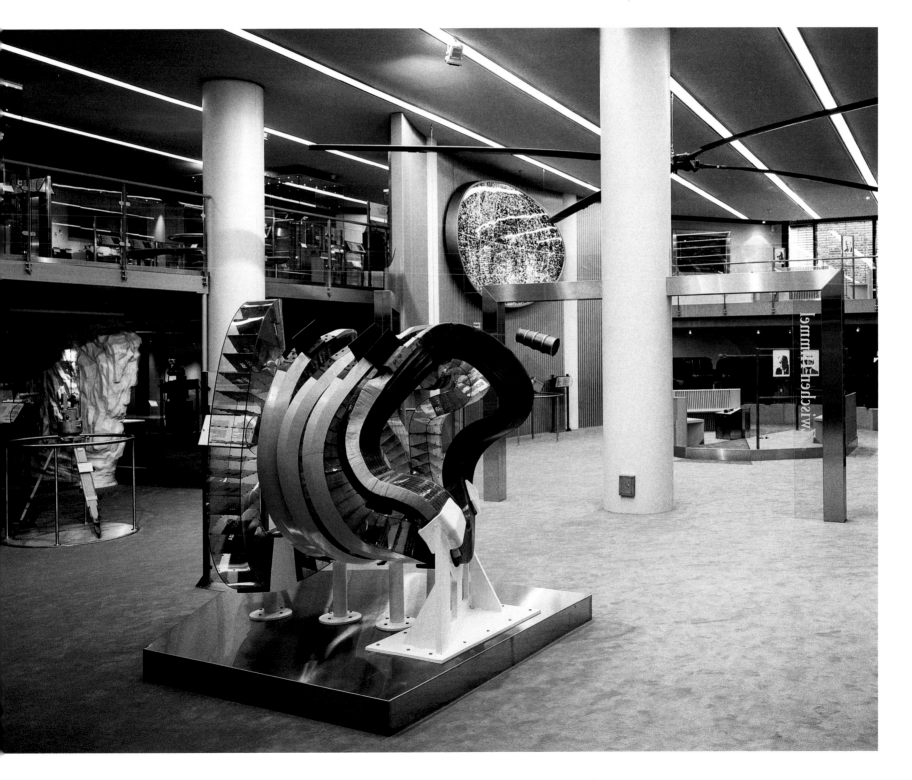

From swimming pool to museum: the interior designers were the film architect Rolf Zehetbauer (who won an Oscar for 'Cabaret') and Cornelia Ott.

Deutsches Museum Bonn

Using a scanning probe microscope Wolfgang Heckl succeeded in rendering life's building blocks visible—the four molecular modules adenine-thymine and guanine-cytosine—for the first time in 1993. The project for schools 'Manometre: Nanometre' also deals with nano-technology.

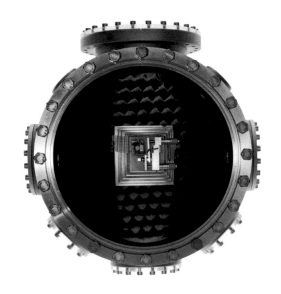

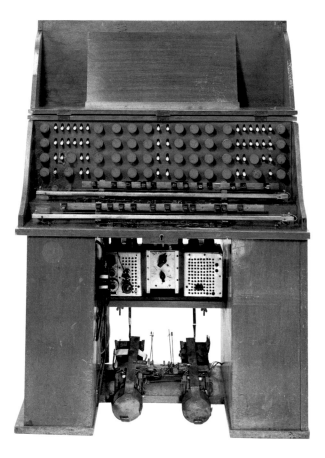

Alfred Hitchcock was fascinated by the first electronic musical instrument, the mixture trautonium. Its inventor, Oskar Sala, composed the sounds needed for the thriller *The Birds* as well as numerous other pieces.

Using the patch-clamp workstation, the size and duration of the ion channel through individual channels in a cell membrane could be measured for the first time. Erwin Neher and Bert Sakmann from the Max Planck Institute for biophysical chemistry in Göttingen were awarded the Nobel prize for medicine or physiology for their discoveries in the field of cell communication.

Dialogue is at the core of the Museum's work: 'In Dialogue with Science and Technology'. The 'Science in Dialogue' initiative is put into practise every day. Karl-Heinz Althoff from Bonn University explains Nobel prize-winner Wolfgang Paul's 500 MeV electron synchronotron to some of his students.

The special exhibition 'Nobel Prizes over 100 Years' was the Deutsche Museum Bonn's first international exhibition in collaboration with the Smithsonian Institute. Apart from Alfred Nobel himself, many Nobel prize-winners can be heard.

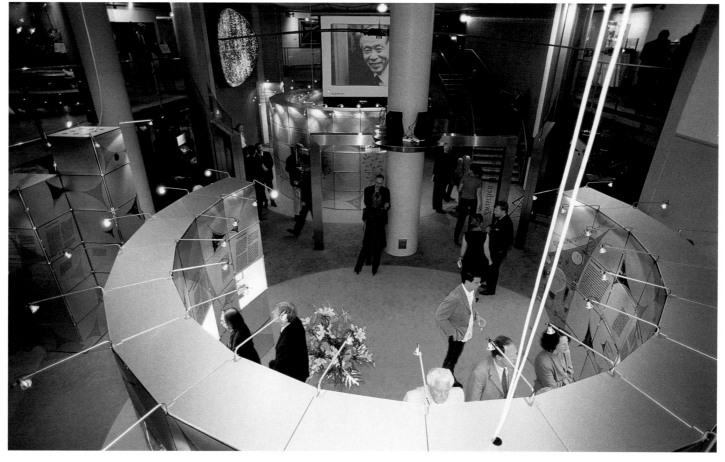

Centre for New Technologies (Zentrum Neue Technologien)

"…to make an understanding of advances in science and technology common property of the whole country."

Oskar von Miller

Everyone can carry out tests and get to know the apparatus and methods used in genetic research in the 'Visitor Laboratory', first opened in 2002. In a relaxed game-like atmosphere, genetic fingerprints of the visitors can be made and a 'culprit' identified. This 'glass laboratory' has been sited in the middle of the display area in the Centre for New Technologies.

At a time when there is widespread talk of a 'public understanding of science' or indeed a 'dialogue' between science and the public, Oskar von Miller's old educational brief for the Deutsches Museum holds good more than ever.

Museums tend to be lugubrious institutions devoted to collecting and preserving—at first sight not the sort of places you would think of as capable of keeping up with the breathtaking speed of scientific and technical progress. Moreover, new technologies do not generally supply objects you can look at. In fact, where innovation is invisibly microscopic in dimension or is hidden away in software, just looking at objects is no sort of response any more. It takes new media such as 'scenographies' to render the invisible visible and comprehensible.

A technical museum is especially called upon to keep redefining itself. Land transport's move to the Theresienhöhe provides an occasion to do just that. The space thus vacated will create room for a Centre for New Technologies (ZNT), a kind of laboratory for the whole Museum where topical and sometimes even controversial themes can be explored. It will focus on key molecular and digital technologies of the twenty-first century, and the Museum will be opened up to new fields where technology has made its mark only very recently, such as life sciences, associated technologies of living and indeed knowledge technologies. The fields constitute the arena in which the great research topics of our day such as mankind and health, or Earth and environment are studied. The Centre will devote a series of exhibitions and accompanying events to these topics.

So prepare for the pleasant surprise of a 'new' Deutsches Museum, with expeditions ongoing and already planned into the global network of climate research, the pygmy realm of nanotechnologies and genetic engineering or the spare parts department of the medics, with their artificial limbs, transplants and synthetic organs. The trips will not be along the familiar routes of traditional disciplines but will cut across them. Less

an opportunity for the experts to hold forth than an occasion for discussion, they will nonetheless maintain sight of the magic that is science and technology.

The display areas in what was the railway hall will in future be grouped round a central, open forum. At a time when science and technology have become pugnacious players in the public arena, it is no longer enough simply to display exhibits. But what more appropriate venue for a well-informed dialogue on the subject than here in the Deutsches Museum?

Yet collecting 'masterworks'—ranging from a Cray electronic superbrain to high-throughput robotic agents for genetic research—will remain one of the fundamental tasks of the Centre. Even in an age of virtual realities, originals can come up with surprises and the wow! factor for anyone curious about 'real' things from the R&D world. With this mixture of authentic objects and modern media that involves all registers of 'scene-setting', the Deutsches Museum will thus continue to be a vital, distinctive institution even in the media and knowledge-dominated society of the twenty-first century. *wh*

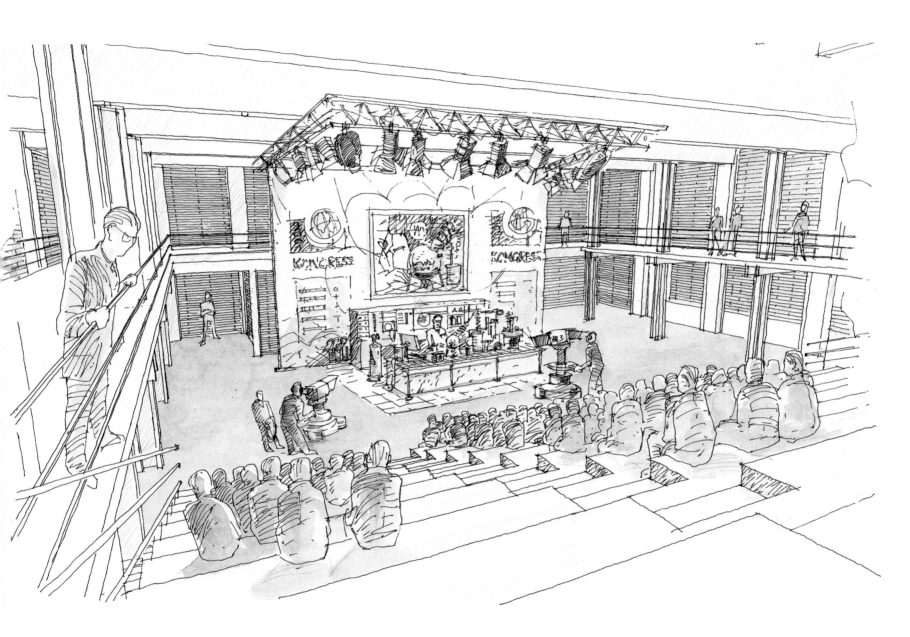

Lectures and discussions can be held in the new
forum as well as being able to film live from
the research laboratories. The open events forum
will be integrated into the exhibition space
in the Centre for New Technologies.
(Sketch: Wolfgang Moser).

Children's Department (Kinderreich)

"The child was astonished—and transformed his astonishment into a gesture, a question mark: a born teacher."

Donata Eschenbroich, *What seven-year-olds know about the world*

Children are scientists! They understand and conquer the world through play. Children learn by playing. They investigate everything and want to know everything.

This is why the Deutsches Museum has installed an attractive new interactive display for its smaller visitors. Here they can explore the greater and lesser wonders of technology to their heart's content and try to fathom the underlying phenomena of science.

The sections are:

The world out there	Nature, world, water
You and me	Communication
Fast and forceful	Energy, motion, power
Light and dark	Light, optics, astronomy
Loud and soft	Sound, acoustics and music

Each section explains what adults have discovered and smaller people need to know. After all, people who know a lot get more out of life. Opening planned for the beginning of 2003.

cg

Almost 30,000 children under the age of six visit the Deutsches Museum every year. A new department is being opened mainly for pre-school children—a permanent display that resulted from special seasonal events at Easter and Christmas.

Playful exploration of the world they live in: at the *Entdecken, Staunen, Probieren* (Discover, Marvel, Experiment) section of the Children's department, youngsters are encouraged to explore the realms of mechanics, optics or music. Here, the Deutsches Museum is, in its own way, following the example of major European natural science museums.

Chronology

1903 1 May Oskar von Miller's first letter to Munich industrialists and scientists containing the suggestion to found a museum
5 May First session of the provisional committee
28 June Establishment meeting of the association 'Museum von Meisterwerken der Wissenschaft und Technik' (Museum of Masterpieces of Science and Technology), during the annual general meeting of the Association of German Engineers in Munich

1906 12 November Opening of the provisional collections in the Old National Museum
13 November Emperor Wilhelm II lays the foundation stone for the new building on the 'Coal Island'

1909 1 January Opening of the provisional collections in the former 'Schwere Reiter' barracks
14 January Start of construction on the 'Coal Island' supervised by the architect Gabriel von Seidl

1911 5 October Topping-out ceremony

1925 7 May Opening of the Museum building on Oskar von Miller's seventieth birthday

1928 Construction begins on the Library and Congress Hall supervised by the architect German Bestelmeyer

1932 7 May Opening of the Library

1934 9 April Oskar von Miller dies in Munich aged seventy-nine

1935 7 May Opening of the Congress Hall

1937 7 May Opening of the automobile section

1944/45 Partial destruction of the Museum by World War II aircraft bombing

1945 November The Library opens again

1946 January Reopening of the Congress Hall

1947 First special exhibition after the war: Fifty years of the Diesel Engine

1963 1 July Establishment of the research institute 'Geschichte der Naturwissenschaften und der Technik' (History of the natural sciences and technology) at the Deutsches Museum

1973 Museum breaks the one-million visitor mark

1976 25 November The Kerschensteiner Kolleg is established

1978–1984 7 May Construction of the Astronautics Hall

1992 12 September Opening of the Schleissheim Airfield branch museum
5 November Opening of the Centre for New Technologies in the former Congress Hall

1995 3 November Opening of the Deutsches Museum Bonn

1996 23 May Government statement by the Bavarian Minister President; transfer of the listed trade fair halls on the Theresienhöhe to the Deutsches Museum

1997 5 December Establishment of the 'Münchner Zentrum für Wissenschafts- und Technikgeschichte' (Centre for the history of science and technology)

1998 Construction begins on the transport section on the Theresienhöhe
Reopening of the exhibition 'Bridges and Hydraulic Engineering'

2000 5 May Opening of the new pharmacological section
13 November Founders' meeting of the 'Freundes- und Förderkreis Deutsches Museum' (Friends and of the Deutsches Museum)

2003 11 May Opening of the first exhibition hall of the Deutsches Museum transport section
November opening of the Children's Department (Kinderreich)

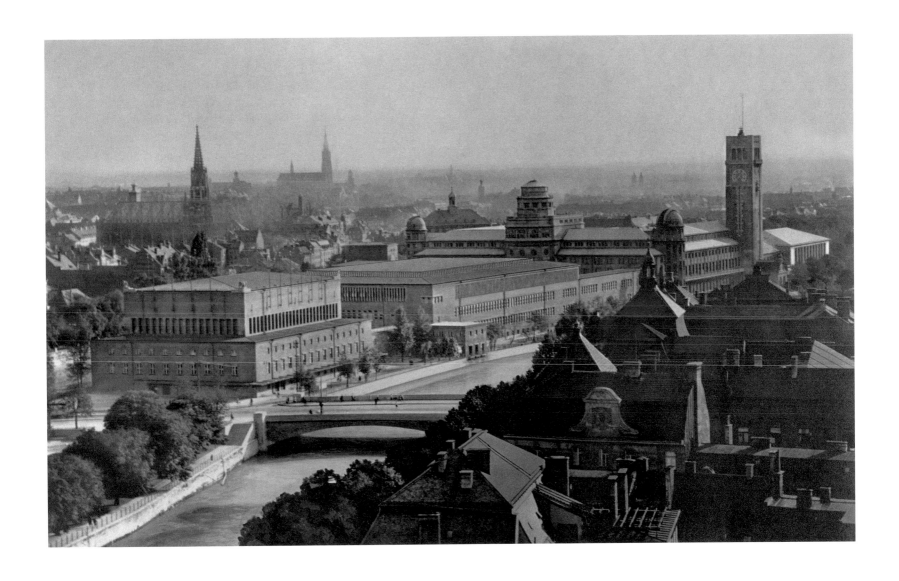

Bibliography

Becker, Franz Josef E. / Füssl-Gutmann, Christine / Teich-
mann Jürgen (Eds.): 'Lernen, Erleben, Bilden im
Deutschen Museum – Naturwissenschaft und Technik
für Studiengruppen', in *Public Understanding of Science:
Theorie und Praxis*, Vol. 3, Munich 2001

Bud, Robert / Finn, Bernard / Trischler, Helmuth (Eds.):
'Manifesting Medicine: Bodies and Machines', in *Arte-
facts: Studies in the History of Science and Technology*, Vol. 1,
Munich 2000

Bud, Robert / Finn, Bernard / Trischler, Helmuth (Eds.):
'Exposing Electronics', in *Artefacts: Studies in the History
of Science and Technology*, Vol. 2, Munich 2000

Chronik des Deutschen Museums 1903–1925, Munich 1927

*Deutsches Museum von Meisterwerken der Naturwissenschaft
und Technik*. Library catalogue, Leipzig 1907

Deutsches Museum – Bildarchiv. Register for microfiche
edition. Edited by the Deutsches Museum München,
revised by Wilhelm Füssl and Christiane Hennet,
Munich 1997

Dienel, Hans-Liudger: 'Technische Tips aus der Schublade
der Geschichte. Die Plansammlung des Deutschen
Museums', in *Wissenschaftliches Jahrbuch des Deutschen
Museums 1990,* Munich 1991, pp. 20–32

Dienel, Hans-Liudger: 'Die ideologische Botschaft des
Deutschen Museums 1903–1945', in *Ideologie der Objekte
– Objekte der Ideologie. Naturwissenschaft, Medizin und Tech-
nik in Museen des 20. Jahrhunderts*, Kassel 1991, pp.
105–113

Dyck, Walter von: 'Wege und Ziele des Deutschen Muse-
ums', in *Deutsches Museum, Abhandlungen und Berichte 1,*
Issue 1, Munich 1929

Fingerle, Karlheinz: 'Fragen an die Museumsdidaktik am
Beispiel des Deutschen Museums', in a lecture given on
11 March 1985 on the occasion of the meeting between
the Kommission Schulpädagogik, Didaktik der
Deutschen Gesellschaft für Erziehungswissenschaft in
collaboration with the Kerschensteiner Kolleg at the
Deutsches Museum, 4th revised Edition, Munich 1992

Folkerts, Menso (Ed.): *Gemeinschaft der Forschungsinstitute
für Naturwissenschaft- und Technikgeschichte am Deutschen
Museum, 1963–1988*, Munich 1988

Friess, Peter: 'Das Museum: Medium im Netz der Medi-
en', in Weitze, Marc-Denis: 'PUS im deutschsprachigen
Raum: Die Rolle der Museen', in *Public Understanding of
Science: Theorie und Praxis*, Vol. 1, Munich 2001

Friess, Peter: 'Deutsches Museum Bonn: ein Museum für
zeitgenössische Forschung und Technik', in Baumgärt-
ner, Ulrich / Schreiber, Waltraud (Eds.): 'Museums-
konzeptionen – Präsentationsformen und Lern-
möglichkeiten', in *Münchener Geschichtsdidaktisches
Kolloquium*, Issue 2, Munich 1999

Friess, Peter / Steiner, Peter M.: *Deutsches Museum Bonn –
Forschung und Technik in Deutschland nach 1945.*
Photographed by Hans-Joachim Becker, Munich 1995

Forschungsbericht 1994–1997. Ausstellungen / Sammlungen
– Archiv – Bibliothek – Forschungsinstitut –
Kerschensteiner Kolleg, not published, Munich n.d.

Füssl, Wilhelm / Mayring, Eva A.: *Eine Schatzkammer stellt
sich vor. Das Archiv des Deutschen Museums zu Naturwis-
senschaft und Technik*, Munich 1994

Graf, Berhard / Treinen, Heiner: 'Besucher im Technis-
chen Museum. Zum Besucherverhalten im Deutschen
Museum Munich', in Berliner Schriften zur Museum-
skunde, Vol. 4, Berlin 1983

Hlava, Zdenka: 'Kleine Zeitgeschichte, gesehen von der
Museumsinsel in der Isar', in *Kultur & Technik 5*, Issue
1/2, Munich 1984, pp. 9–98

Klemm, Friedrich: *Die Bibliothek des Deutschen Museums*,
Munich 1960

Knerr, Günter / Konietzny, Friedel / Rohrbach, Kurt: *Das
Münchener Modell. Fortbildung von Vorführern und Aufse-
hern im Deutschen Museum*, Munich 1999

Kuntz, Andreas: *Das Museum als Volksbildungsstätte. Muse-
umskonzeptionen in der deutschen Volksbildungsbewegung
1871–1918*, Marburg 1980

Lindqvist, Svante: 'An Olympic Stadium of Technology:
Deutsches Museum and Sweden's Tekniska Museet', in
Schroeder-Gudehus, Brigitte (Ed.): *Industrial Society and
its Museums 1890–1990*, Paris 1992, pp. 37–55

Matschoss, Conrad (Ed.): *Deutsches Museum. Geschichte,
Aufgaben, Ziele*, Berlin 1925

Miller, Oskar von: 'Technische Museen als Stätten der
Volksbelehrung', in *Deutsches Museum. Abhandlungen und
Berichte 1*, Issue 5, Munich 1929

Osietzki, Maria: 'Die Gründungsgeschichte des Deutschen
Museums von Meisterwerken der Naturwissenschaft
und Technik in München 1903–1906', in *Technik-
geschichte 52*, 1985, pp. 49–57

Panofsky, Walter: *Deutsches Museum München: Bilder und
Impressionen von einem Rundgang durch die Sammlungen*,
Munich 1960

Spickernagel, Ellen / Walbe, Brigitte (Eds.): *Das Museum.
Lernort contra Musentempel, Giessen 1976*, pp. 32–35

Stange, Albert: *Das Deutsche Museum. Historische Skizze*,
Munich, Berlin 1906

Wegener, Andrea: 'Das Unsichtbare sichtbar machen. Die
neue Ausstellung »Pharmazie« im Deutschen Museum',
in Weitze, Marc-Denis: 'PUS im deutschsprachigen
Raum: Die Rolle der Museen', in *Public Understanding
of Science: Theorie und Praxis*, Vol. 1, Munich 2001

Weinreich, Hermann: *Ratschläge für Schülerfahrten zum
Deutschen Museum in München*, Munich 1925

Der Wiederaufbau des Deutschen Museums, Munich 1953

Zenneck, Jonathan (Ed.): *Fünfzig Jahre Deutsches Museum
in München. Chronik*, Munich 1953

Museum Guides

Ausstellungsführer Deutsch, Munich 1997

*Deutsches Museum von A bis Z. Ein lustiger Bilderplan, für
Kinder und Jugendliche*, Munich 1992

Friess, Peter / Witzgall, Susanne (Eds.) / Becker, Hans-
Joachim (Image Ed.): *Meisterwerke aus dem Deutschen
Museum*, Munich 1997

Mayr, Otto (Ed.): *Deutsches Museum von Meisterwerken der
Naturwissenschaft und Technik*, Munich 1990

*Meisterwerke aus dem Deutschen Museum II, herausgegeben
vom Deutschen Museum*, Munich 1999

*Meisterwerke aus dem Deutschen Museum III, herausgegeben
vom Deutschen Museum*, Munich 2000

*Meisterwerke aus dem Deutschen Museum IV, herausgegeben
vom Deutschen Museum*, Munich 2002

*Museum für Luft- und Raumfahrt. Ein Führer durch die
Geschichte und die Sammlung der Flugwerft Schleissheim*,
Munich 1994

Special Guides to the Departments

Bauer, Friedrich L.: *Mathematisches Kabinett. Einladung
zur Mathematik. Führer durch die Ausstellung*,
Munich 1999

Benz-Zauner, Margareta / Müller-Beck, Hansjürgen /
Züchner, Christian: *Altamira. Höhlenmalerei der Steinzeit*,
Munich 1995

*Die Brücke im Raum. Die Besucherbrücke im Deutschen
Museum*, Munich 1999

Bühler, Dirk: *Brückenbau*, Munich 2000

Eckermann, Erik: *Automobile. Technikgeschichte im Deutschen
Museum*, Munich 1989

Glocker, Winfrid: *Glastechnik. Technikgeschichte im Deutschen
Museum*, Munich 1992

Hartl, Gerhard / Märker, Karl / Teichmann, Jürgen /
Wolfschmidt, Gudrun: *Planeten – Sterne – Welteninseln.
Astronomie im Deutschen Museum*, Munich 1999

Henkel, Hubert: *Musikinstrumente. Ein Begleitbuch zur
Ausstellung mit Mini-CD*, Munich 1998

Opizzo, Yves / Petzold, Hartmut / Tobin, Christian:
Sonnenuhrengarten. Führer durch die Ausstellung,
Munich 1999

Pharmazie. Die Ausstellung im Deutschen Museum,
Munich 2000

Schuster, Beate: *Neun Planeten und eine Sonne. Planetenweg vom Deutschen Museum zum Tierpark*, Munich 1995

Schletzbaum, Ludwig: *Eisenbahn. Technikgeschichte im Deutschen Museum*, Munich 1990

Weinhart, Karl (Ed.): *Mikroelektronik. Führer durch die Ausstellung*, Munich 1992

Weinhart, Karl (Ed.): *Informatik. Führer durch die Ausstellung*, 2nd Edition, Munich 1997

On Oskar von Miller

Alexander, Edward P.: *Oskar von Miller and the Deutsches Museum. The Museum of Science and Technology*, Munich 1983

Kristl, Wilhelm L.: *Der weissblaue Despot*, Munich 1965

Miller, Walther von: *Oskar von Miller. Nach eigenen Aufzeichnungen, Reden und Briefen*, Munich 1932

Miller, Walther von: *Oskar von Miller – Pionier der Energiewirtschaft – Gründer des Deutschen Museums*, 2nd revised Edition, with Hans Joachim Störig, Munich 1955

Nockher, Ludwig: *Oskar von Miller. Der Gründer des Deutschen Museums von Meisterwerken der Naturwissenschaft und Technik*, Stuttgart 1953

Pförtner, Rudolf: *Oskar von Miller*, Düsseldorf 1987

Magazines and Periodicals published by the Deutsches Museum

Deutsches Museum, Abhandlungen und Berichte, 1929 ff.

Kultur & Technik. Zeitschrift des Deutschen Museums, 1977 ff.

Kulturgeschichte der Naturwissenschaften und der Technik (Book series since May 1981)

Vorträge und Berichte aus dem Deutschen Museum, 1906–1928

Wissenschaftliches Jahrbuch des Deutschen Museums, 1989–1993

CD-ROMs

Deutsches Museum offline. Die Internetseiten des Deutschen Museums auf CD-ROM, Munich 1998

Deutsches Museum. Flugwerft Schleissheim. Multimedia CD-ROM für Apple und Windows, Munich 1999

Index

Index